WITHDRAWN FROM STOCK

Diana: A Life in Dresses

From Debutante to Style Icon

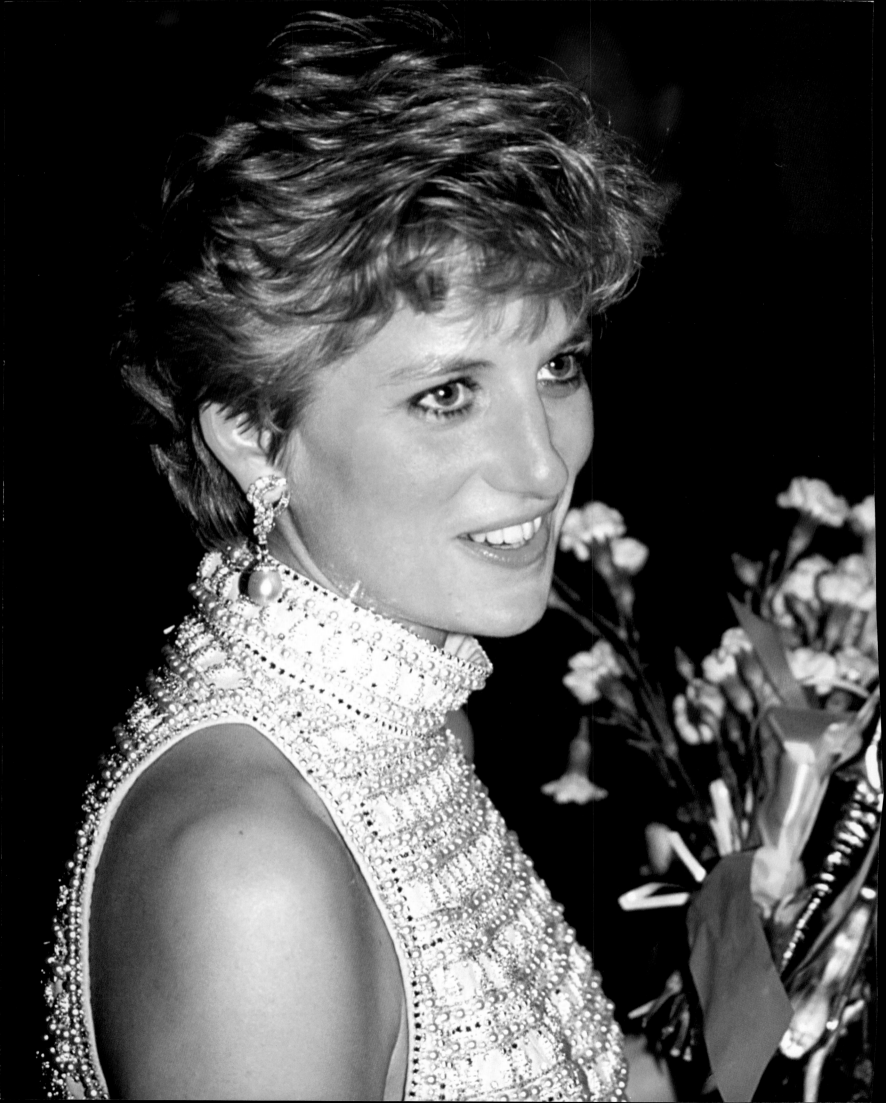

Diana: A Life in Dresses
From Debutante to Style Icon

Claudia Joseph

ACC ART BOOKS

Contents

Introduction
From Young Ingénue to Style Icon

When Prince Charles announced his engagement to Lady Diana Spencer on 24 February 1981, she was a 19-year-old debutante with the wardrobe of a Sloane Ranger. 'On the day we got engaged I literally had one long dress, one silk shirt, one smart pair of shoes and that was it,' she revealed in Andrew Morton's book, *Diana: Her True Story: In Her Own Words*. 'Suddenly my mother and I had to go and buy six of everything. We bought as much as we thought we needed but we still didn't have enough. Bear in mind you have to change four times a day and suddenly your wardrobe expands to something unbelievable.'

Diana's late mother, Frances Shand Kydd, took her daughter to Vogue House, where she was introduced to the late Anna Harvey. Then the magazine's 36-year-old fashion editor, Anna became Diana's stylist and confidante. Both Diana's older sisters – Lady Sarah McCorquodale, the self-declared 'cupid' who introduced the Prince and Princess of Wales, and Jane, Baroness Fellowes, whose husband Robert was assistant private secretary to The Queen – had worked at *Vogue* and were close friends of its beauty editor, Felicity Clark.

'I was summoned into the office of Beatrix Miller, then the editor of *Vogue*, where I was the fashion editor at the time,' explained Anna in an interview after Diana's passing, 'and she was sitting there with her mother, Frances Shand Kydd. We'd photographed Diana for a shoot on society girls and on the day the pictures came out, the royal engagement had been announced. Still, I wasn't sure why I had been called in. So when, after a little chat, they explained they were looking for shoes to match the "going away" outfit, I naïvely replied, "What is the 'going away' outfit?" Mother and daughter glanced at each other and paused. Then they both nodded, Diana pulled out of her bag a cutting of apricot silk about the size of a £2 coin today and our working relationship started.

'I trotted straight around to Manolo Blahnik and, without knowing the piece of fashion history he was working on, he made her shoes to match the silk. I later learnt that Diana and I had been set up, if you like, by Beatrix and Felicity Clark, who was close friends with Diana's sisters and had obviously briefed them that I was trustworthy and we would get on well together. It was a great mark of trust to confide in me so soon. But I guess they were right, because from there, Diana and I went on to work together on and off for 16 years.'

Anna's first job, after sourcing the shoes, was to help put together a wedding trousseau for the Princess, who was off on honeymoon on HMY *Britannia*, visiting different Mediterranean ports. 'There was a fantastic shop in those days on the Pimlico Road called Mexicana, where they did all those beautiful pleated white cotton Mexican dresses,' said Anna. 'We bought two or three of those and a few peasant blouses, which we packed together. I never saw her wear any of them but she wrote me the sweetest letter afterwards saying that everything had been perfect.'

Anna had a front row seat as Diana became more confident, introducing her to designers, going over to Kensington Palace with piles of clothes for her to try on and advising her on royal tour wardrobes. 'Once, she put on a beautiful black velvet dress with a grey taffeta skirt by Murray Arbeid. "Would you mind if I call in my husband to have a look?" she said. Prince Charles came in and stood there quite bemused, seeing her in this extraordinary dress and me on the floor pinning the skirt.'

By the time she died, 16 years later, Diana had become much more assured, regularly topping the best-dressed lists and posthumously named by *TIME* magazine as one of its 'All-*TIME* 100 Fashion Icons'. 'Of course, by then designers and fashion houses felt honoured to work with the Princess and would instantly come to the palace and do fittings,' added Anna. 'I would like to give them all a vote of thanks for all their hard work and absolute discretion. Everyone was always so nervous, but Diana put them at ease. She started off so shy and ended up so confident.'

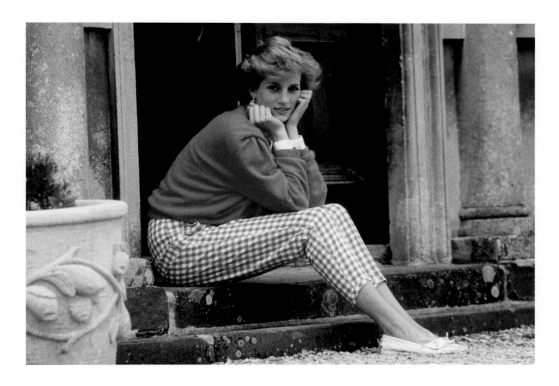

Diana sitting on a step at her home,
Highgrove House, in Doughton,
Gloucestershire, 18 July 1986.

The Christie's Auction

I t was one of the most anticipated auctions of the 20th century: a total of 1,100 people crammed into Christie's Park Avenue auction house in Manhattan, on 25 June 1997, to bid for a moment in history. While museums, fashion connoisseurs, haute couture collectors and Diana fans leafed through the glossy catalogues, cheers went up for the 79 successful bidders, who all walked away with at least one of Diana's iconic dresses. In addition, each was given a copy of a £1,250 leather-bound limited-edition catalogue signed by the Princess. Within two-and-a-half hours, the auction had raised £1.96 million for Diana's chosen charities: the Royal Marsden Hospital Cancer Fund and the AIDS Crisis Trust. Another £2 million was raised from the sale of catalogues and fundraisers such as the gala reception in London on 2 June, and a reception on 23 June in New York.

That evening in New York, clad in a pink-and-blue floral beaded Catherine Walker cocktail dress, Diana, who had been inspired to auction her wardrobe by Prince William, was guest of honour at a £150-a-ticket gala at the auction house. She made two circuits of the crowded hall, signing catalogues, greeting guests, and saying farewell to her dresses, which were displayed on mannequins in an 'English country garden' setting, complete with real geraniums. The late Liz Tilberis, then editor of *Harper's Bazaar*, who was an old friend, said at the time, 'This is a very momentous occasion. These dresses are a part of history. It is wonderful that money is being raised for charity. It is so like the Princess to do something like this.'

After the two-hour gala, Diana flew back to Kensington Palace, where she was woken to see a fax telling her the results of the auction, which had the motto 'Sequins Save Lives' – the Victor Edelstein dress she wore to dance with John Travolta at the White House had raised a staggering £133,835. Afterwards, she said, 'Words cannot adequately describe my absolute delight at the benefits which the results of this auction will bring to so many people who need succour and support. We should all share in the pleasure in being able to help in this way.'

So, where are Diana's iconic dresses now? And where can you go and see them?

Diana at Christie's New York, launching the auction of her dresses.

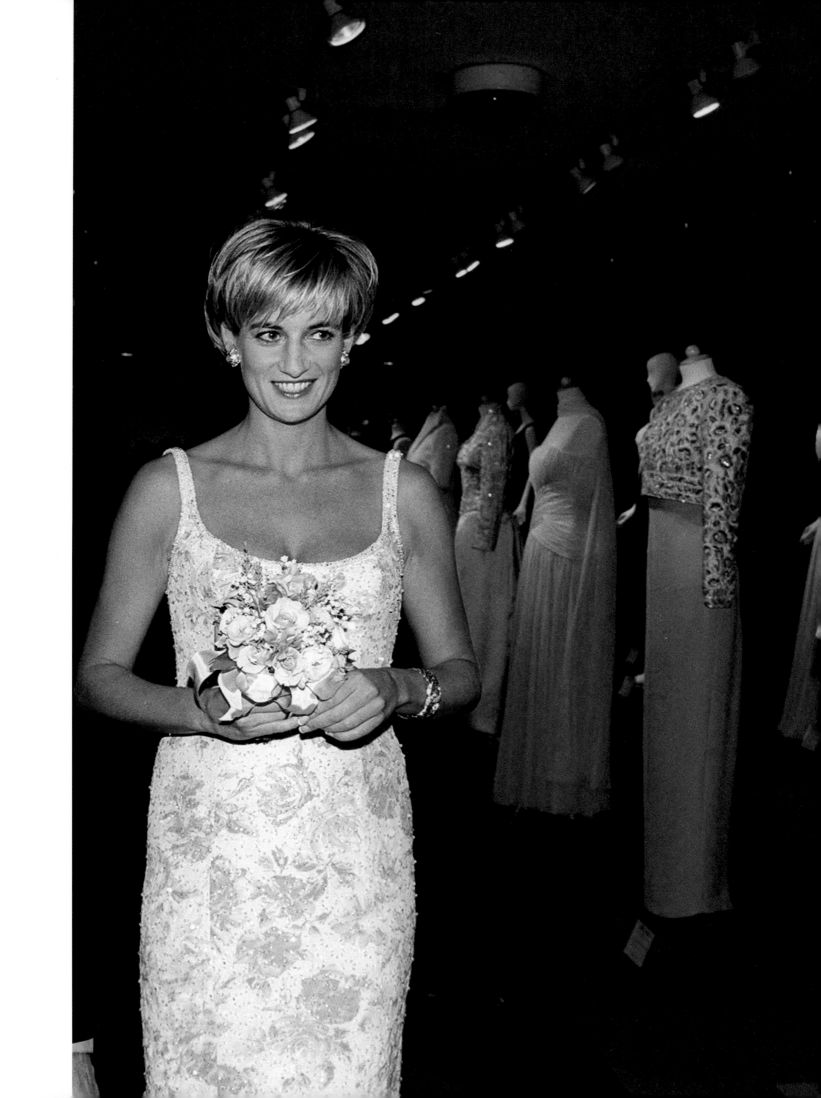

Regamus
The Debutante Dress

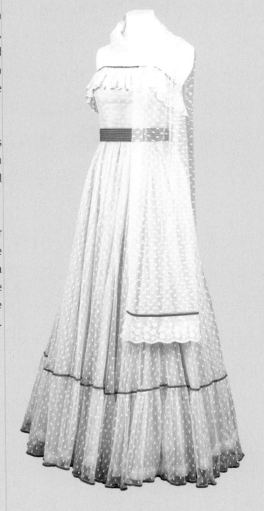

Although Diana was never a debutante, her parents hosted a ball to celebrate her 18th birthday on 1 July 1979 at her family's ancestral seat, Althorp, in Northamptonshire, now owned by her brother, Charles, the 9th Earl Spencer. She chose to wear an off-the-shoulder turquoise silk ballgown, overlaid with spot net and trimmed with turquoise velvet and lace, from the couture house Regamus, a favourite with British aristocrats. Diana and her mother, Frances Shand Kydd, found it on a last-minute shopping trip in the 'French Room' of Harrods, just before the ball.

When she got engaged to Prince Charles, Madame Tussauds requested a dress for her waxwork figure – as it was the only dress in her wardrobe, she gifted them her Regamus gown, which had a large brown stain on its hem where she had spilt perfume. After her wedding, it was replaced with a replica of her Emanuel wedding gown.

Madame Tussauds eventually auctioned off the dress through Cooper Owen Auctions on 7 December 2005 – eight years after Diana's death – and there was a frantic bidding war between Kensington Palace and an American neonatal intensive care nurse, Wendy Rogers-Morris, who was a keen collector of Diana memorabilia. The Oklahoma University graduate won the auction, bidding £7,637.50 for the dress. When she lent the frock to the 2017 exhibition 'Diana: Her Fashion Story' at Kensington Palace, it was repaired by the palace's expert textile conservators. It is now owned by the Fundación Museo de la Moda, in Santiago, Chile.

Above: The turquoise silk Regamus ballgown worn by Diana at the ball thrown to celebrate her 18th birthday.

Opposite: Diana in her Regamus dress, as photographed by her younger brother, Charles Spencer, 9th Earl Spencer.

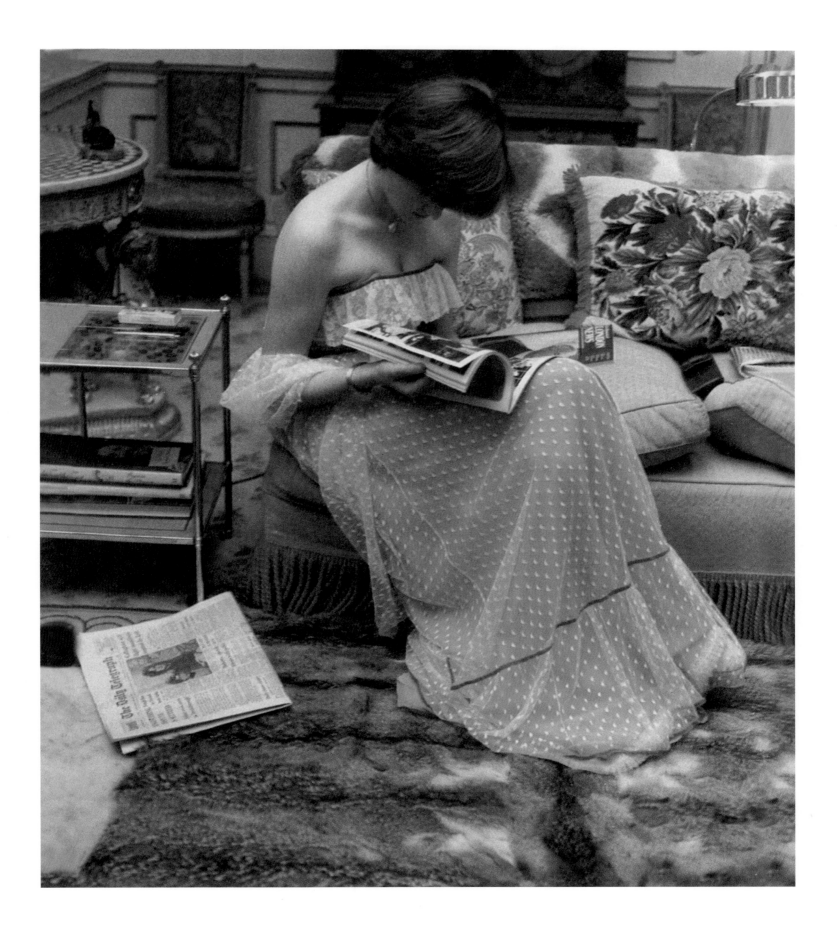

Cojana
The *Pretty Woman* Moment

When Lady Diana Spencer accepted Prince Charles's proposal, she knew that she would need an outfit for the official announcement on 24 February 1981, on the steps of Buckingham Palace – but she had nothing in her wardrobe. So, she popped into couturier Bellville Sassoon to see if she could find a sapphire blue dress – or suit – to match her engagement ring. Unfortunately, in a scene reminiscent of *Pretty Woman* (in which Julia Roberts's Vivian Ward was rebuffed in an exclusive boutique in Rodeo Drive, Beverly Hills) she was terrified by the vendeuse. Failing to recognise the future princess, and anxious to leave promptly at 5.30pm, the shop manager, who was a Romanov princess by marriage, gave Diana short shrift for having the temerity to arrive so late.

So, Diana went to Harrods, where she picked up an off-the-peg suit by Cojana, a label owned by Jacoby and Bratt that had been going since the turn of the 20th century and dressed county women. 'It was 5pm at night and this little girl came in and didn't know what she wanted,' recalled couturier David Sassoon. 'She [the vendeuse] said, "Do you want a dress? A suit?" She said, "I'm not sure." She showed her a few things and Diana didn't think they were right. So, she suggested Diana went to Harrods.

'The next day my partner Belinda Bellville came in, and the little girl in the showroom, who was assistant to the vendeuse, said, "You know, I think that Lady Diana came into the shop yesterday." So, Belinda said, "What do you mean?" And she said, "Well I think it was her." She checked with the vendeuse, who said, "I didn't know who she was. Anyway, I sent her to Harrods." And Belinda said, "You what?" She could not believe it. Anyway, she must have put the fear of God into Diana, because suddenly it was announced the Emanuels were making the wedding dress.' After the engagement announcement Diana never wore the suit again, and it is unknown what she did with it.

Prince Charles with his fiancée, Lady Diana Spencer, outside Buckingham Palace, after announcing their engagement, 24 February 1981.

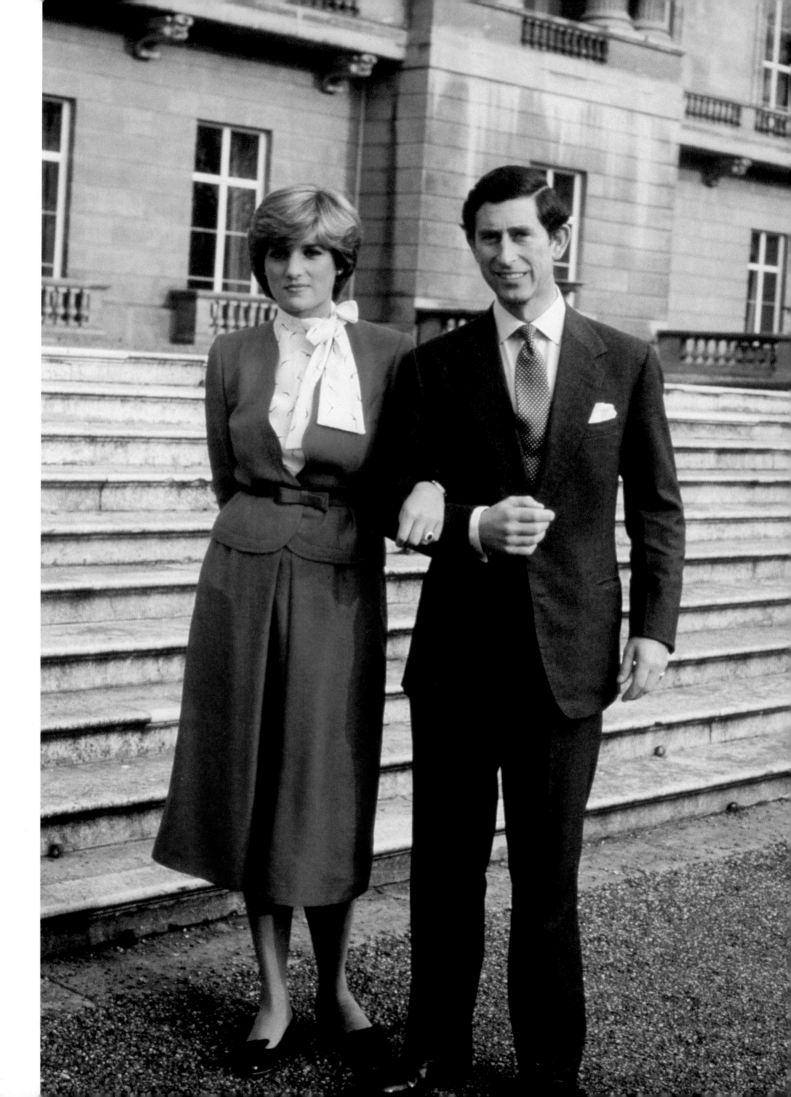

The Emanuels

I t was 4 March 1981, eight days after the Prince of Wales had got engaged to Lady Diana Spencer, when the phone rang at David and Elizabeth Emanuel's four-storey studio in Brook Street, in London's West End. Eventually, Elizabeth answered the call and had the conversation that would change her life.

'This is Diana. I was wondering, Liz, would you and David do me the honour of making my wedding dress?'

The couple, who had met and married at the Harrow School of Art in 1975, was stunned. Just four years earlier, they had become the first married couple to graduate from the Royal College of Art, with a Master's degree in fashion – the finale was Elizabeth's 'romantic frothy wedding dress' – and set up their studio in a property owned by The Queen's milliner, Frederick Fox, just a stone's throw from Vogue House, home of fashion bible *Vogue*. Their graduation collection of eveningwear, designed by Elizabeth, and daywear, by David, was spotted by *Vogue* fashion editor Anna Harvey, who featured them in a six-page black-and-white spread, and was picked up by Joan Burstein, owner of the legendary boutique Browns, who had an eye for new talent and put one of their dresses in the window. Bianca Jagger wore this dress to a white-themed party hosted by fashion guru Halston for her 32nd birthday at Andy Warhol's club, Studio 54; she was photographed with singer Liza Minnelli, releasing white doves.

But it was only when the couple, whose clients included the Duchess of Kent and Princess Michael of Kent, was chosen to design Diana's wedding dress, that they became household names. 'It was such an exciting time for us: we were barely out of college and suddenly we had become flavour of the month,' the couple, who separated in 1990 after 15 years of marriage, wrote in their book, *A Dress for Diana*.

Four months later, on 29 July, both had ringside seats at the ceremony. They arrived at The Queen Mother's residence, Clarence House, earlier that day, to find Diana in a white towelling dressing gown, having her make-up done by Barbara Daly and her hair styled by Kevin Shanley, while her five bridesmaids – Princess Margaret's daughter, Lady Sarah Chatto; Prince Charles's goddaughters India Hicks and Catherine Cameron; Sarah-Jane Gaselee, daughter of racehorse trainer Nick Gaselee; and Clementine Hambro, a pupil at the Young England Kindergarten where Diana had worked – watched television.

'Despite the fact that it was such an important occasion, and we were all really nervous, the atmosphere at Clarence House that morning felt surprisingly relaxed,' the couple wrote. 'There was an ad for Cornetto, and Diana was singing along as we all had our orange juice and biscuits. First, Diana had to get into her petticoat, then put on her shoes. And then finally we slipped her into the dress. Then suddenly Elizabeth asked, "Did you do up the double hook on her petticoat?" The petticoat was an enormous crinoline tulle affair which we had spent ages trimming very carefully to ensure that it was exactly the right length so that Diana wouldn't

trip on it. None of us could remember having done up the hook and we had awful visions of her walking down the aisle and the petticoat coming adrift. There was only one thing to be done: David, dressed in his frockcoat, had to get underneath all Diana's skirts to check the hook. As he resurfaced, the door to the room opened and Diana coolly asked, "David, have you met The Queen Mother?"'

Elizabeth and David were driven to St Paul's Cathedral with a police escort for the 11.20am ceremony, where they greeted Diana on the steps of the church and smoothed out the creases in her 25-foot train. They left the service as Kiri Te Kanawa was singing 'Let the Bright Seraphim' to get to Buckingham Palace for the wedding photographs.

'It had been an early start and a long and tiring – though incredibly exciting – day for us,' they said. 'We had been at Clarence House, St Paul's Cathedral and at the Throne Room at Buckingham Palace, from where we had a unique vantage point of the famous royal kiss and the millions of people behind the gates. It had been very emotional and very draining. After all the months of build-up to the royal wedding and then the excitement of the day itself, we understandably felt somewhat deflated by the time that the girls began to make their own way home. And then the phone rang. It was late enough for us to wonder who on earth would be calling us at that hour. It was Diana! We didn't know where she was, but she was calling to thank us for making her wedding dress and said she wanted to tell us how beautiful it was and how wonderful she had felt wearing it. That was the sort of sweet, kind, and thoughtful girl Diana was.'

The Engagement Blouse

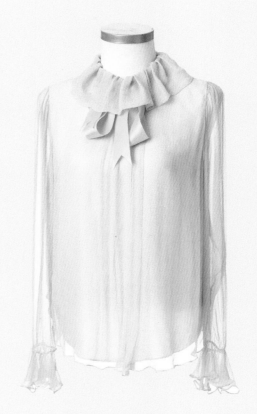

The phone call from *Vogue*'s beauty editor Felicity Clark came on 28 January 1981. She told them she was doing a shoot for the magazine on English Roses and wanted something 'very romantic' for 'someone very famous'. Hanging in their studio was the perfect garment: a pale pink silk chiffon blouse with a soft floaty collar and pink silk satin bow. They sent it round the corner to *Vogue*, and photographer Lord Snowdon, then divorced from Princess Margaret, shot Diana in the blouse for the feature on 'Upcoming Beauties'. The engagement was announced on the day of the magazine's release and Diana chose the image for her official engagement photograph.

In their book *A Dress for Diana*, David and Elizabeth Emanuel wrote, 'It was this blouse that was hanging up in our studio when we suddenly received the phone call from *Vogue* requesting something which had a high neck and was very romantic. It was only later that we discovered that the blouse had been worn by Lady Diana (whose sisters both worked at *Vogue*). The fashion team had assembled a large collection of clothes from several designers for her to try, just as you would for any fashion or beauty shoot. When she saw our blouse on the rack, she fell in love with it, asked who had made it and was directed to us. That was the beginning of our relationship with Diana.'

The blouse was sold for £27,500 by Kerry Taylor Auctions on 8 June 2010, and is now in the Museum of Style Icons in Newbridge, County Kildare, Ireland.

'It was this blouse that was hanging up in our studio when we suddenly received the phone call from *Vogue* requesting something which had a high neck and was very romantic. It was only later that we discovered that the blouse had been worn by Lady Diana.'

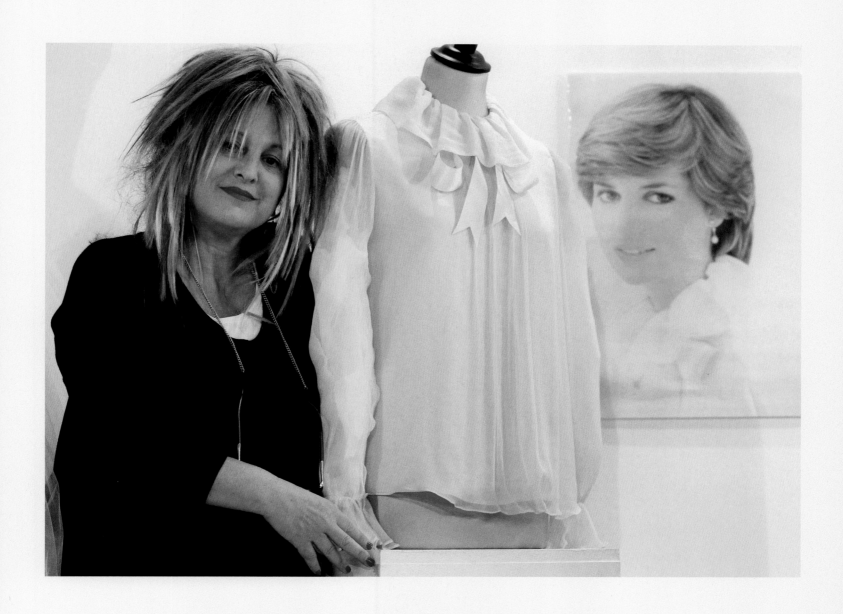

Above: Designer Elizabeth Emanuel poses with the chiffon blouse worn by Lady Diana Spencer for her engagement portrait by Lord Snowdon.

Opposite: Diana's engagement blouse.

The Black Ballgown

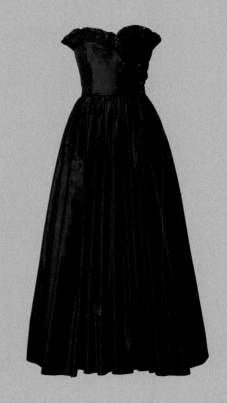

The Emanuels first met Diana on 4 March 1981, when she popped into their studio to talk about her wedding dress. Five days later, she had her first official public engagement with Prince Charles. She tried on one of their samples – a black silk taffeta ballgown, embroidered with sequins, with a tight corseted bodice and full gathered skirt, which had previously been worn by actress Liza Goddard – and fell in love with it. When she arrived at London's Goldsmith's Hall on 9 March, she emerged out of the limousine in a frenzy of flash bulbs. She ended up shifting the budget off the front page and scandalising staid palace courtiers, as royals only wore black for mourning.

'When we put her in that black dress, we had no idea that it was going to cause such a furore,' the Emanuels wrote in their book, *A Dress for Diana*. 'In fact, that dress had started its life as one of our samples and it was just hanging on a rail. We had already lent it out to the actress Liza Goddard, so it wasn't even new. But Diana saw it, loved it and tried it on. The transformation was incredible. She had arrived looking like the nursery schoolteacher she was, but now she looked like a movie star…We hadn't considered the fact that when Diana bent over – as she would have to do when getting out of the car – she would show quite a lot of cleavage. We just thought she looked just fabulous.'

'I remember my first [royal] engagement so well,' Diana told Andrew Morton, as related in his book, *Diana: Her True Story*. 'So excited. I got this black dress from the Emanuels and I thought it was OK because girls my age wore this dress. I hadn't appreciated that I was now seen as a royal lady, although I'd only got a ring on my finger as opposed to two rings. I remember walking into my husband-to-be's study, and him saying, "You're not going in that dress, are you?" I replied, "Yes, I am." And he said: "It's black! But only people in mourning wear black!" And I said: "Yes, but I'm not part of your family yet." Black to me was the smartest colour you could possibly have at the age of 19. It was a real grown-up dress. I was quite big-chested then and they all got frightfully excited.

'I learned a lesson that night. I remember meeting Princess Grace and how wonderful and serene she was – but there was troubled water under her, I saw that. It was a horrendous occasion. I didn't know whether to go out of the door first. I didn't know whether your handbag should be in your left hand or your right hand. I was terrified really – at the time everything was all over the place. I remember that evening so well. I was terrified – nearly sick.'

In the weeks before her wedding, Diana returned the dress, which had a bust size of 34 inches and a waist of 26 inches, for altering, as she had lost so much weight, but the Emanuels made another version and shoved the original in a black bin bag. There it remained for 19 years until they rediscovered it. It was sold for £200,000 on 8 June 2010, by Kerry Taylor Auctions to the Fundación Museo de la Moda, complete with its black tulle petticoat, the original Elizabeth Emanuel pencil sketch and the initial invoice, reading £517.50.

Above: Diana's black ballgown.

Opposite: Lady Diana Spencer and Prince Charles at their first public engagement at Goldsmith's Hall, London, 9 March 1981.

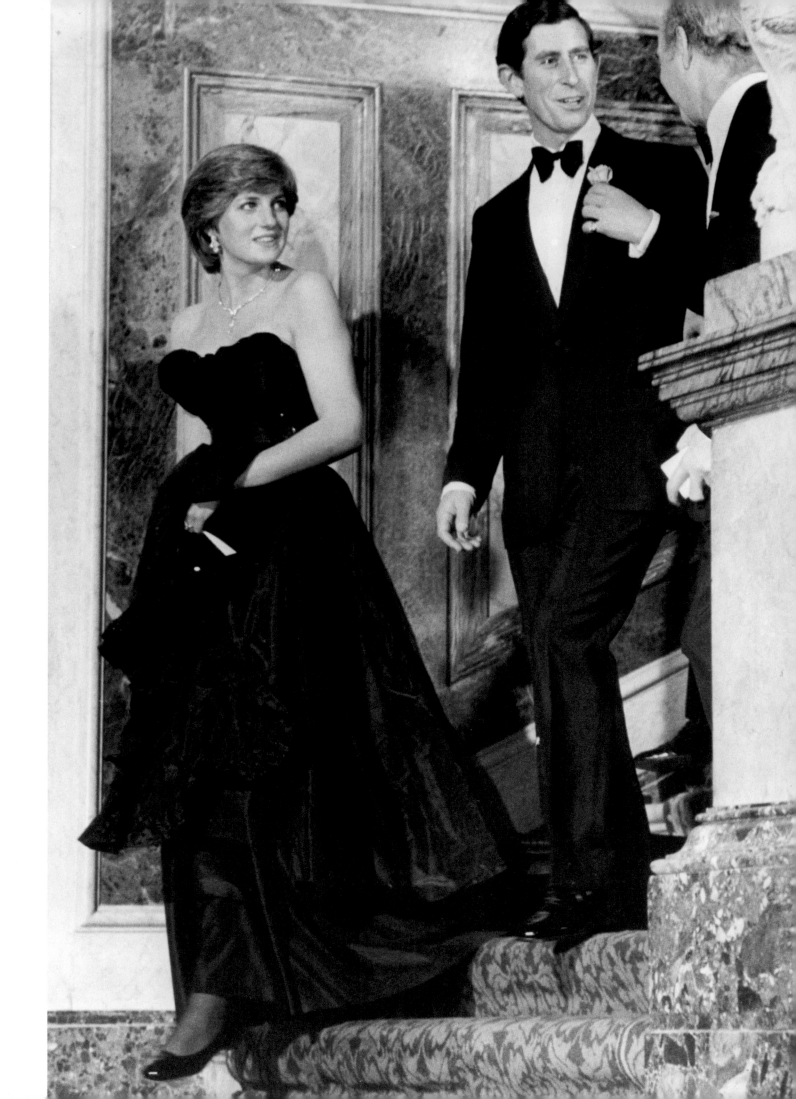

The Wedding Gown

I t is one of the most anticipated – and iconic wedding dresses – in history: when Lady Diana Spencer walked down the aisle of St Paul's Cathedral, on 29 July 1981 in her Emanuel gown, more than 750 million people in 74 countries were glued to their televisions, setting the record for the largest TV audience for a wedding ceremony. Costing her mother, the late Frances Shand Kydd, 1,000 guineas – or £1,050 – the dress was also one of the best-kept secrets. From the moment that Buckingham Palace officially announced the makers of the gown at midday on 10 March 1981, photographers were camped outside the Emanuels' studio. They immediately bought roller blinds for the windows and installed a safe, in which to keep the sketches, toiles, taffeta and lace.

The Emanuels had little more than four months to make the dress, from 4 March, when Diana arrived at the studio to try on samples. 'She was terribly excited to be trying on huge bouffant petticoats, satin skirts and boned bodices, and she loved every minute of it,' recalled the Emanuels in their book, *A Dress for Diana*. After settling on a template, the couple drew up 50 designs, based on the same silhouette – a boned bodice, full skirt and a 25-feet train, the longest in history. They presented their designs to Diana and her mother Frances, sitting on the showroom floor. 'The carpet was literally covered in our pencil drawings,' they wrote. 'It must have been quite a daunting sight for the future princess and her mother, who sat stunned and speechless for the first few minutes before they began to examine the sketches.'

After making a pattern, one of their team cut out a calico toile – the first of many, because Diana kept losing weight. 'Diana, like many nervous brides, must have lost about a stone and a half in weight during the run-up to the wedding – so we made lots of toiles, each bodice a size smaller,' the Emanuels explained. The silk taffeta was woven in Suffolk by the oldest silk weavers in Britain, Stephen Walters & Sons, which was founded in the 18th century and has a long history of weaving silk for the royal family: they created the silk lining for The Queen's coronation gown and for Princess Anne's wedding dress. It was ordered in two colourways – white and ivory – so that the weavers wouldn't know the colour of the dress, which featured a fitted bodice overlaid at the centre with panels of antique Carrickmacross lace that had originally belonged to Queen Mary, the groom's great-grandmother. The remainder of the lace was made by Roger Watson Laces in Nottingham. 'When we explained the significance of this lace to Diana, she was genuinely touched,' added the Emanuels.

Finally, the couple – who also created a back-up dress in case the design was discovered, and an overskirt to be fitted over the top, in case Diana spilt something on the day – hand embellished the garment with pearls and sequins, a process that took so long Elizabeth Emanuel asked her mother to help. The couple commissioned jeweller Douglas Buchanan to make a tiny gold horseshoe from 18-carat Welsh gold to sew into the label and Clive Shilton to handmake Diana's pumps. Five-hundred-and-two mother-of-pearl sequins

Lady Diana Spencer, soon to become Diana, Princess of Wales, walks down the aisle of St Paul's Cathedral with her father, Earl Spencer.

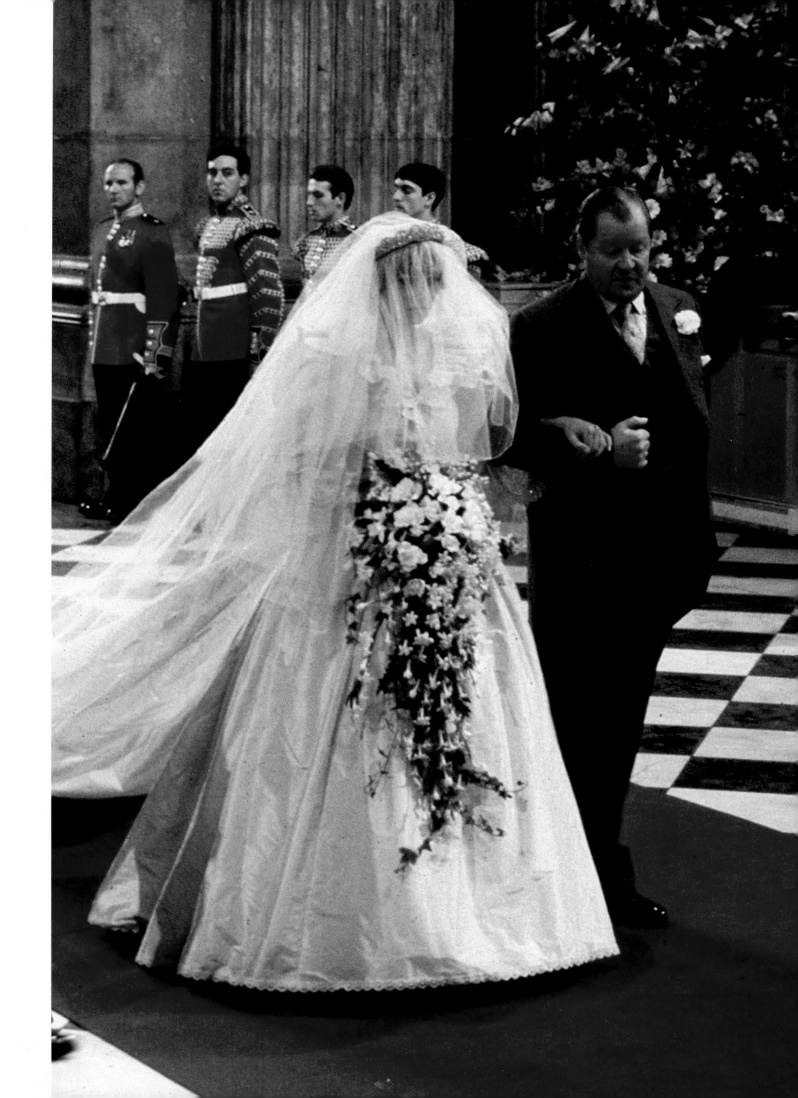

were sewn on each shoe, each one knotted by hand, and a heart was attached to the front of each shoe. In a charming twist, Shilton engraved hearts, along with a C and D, on the soles of the shoes, which were dyed to match the dress. He also made a miniature pair of shoes, which he presented to Diana as a wedding present in a blue velvet box.

At the same time, the Emanuels made five bridesmaids' dresses for Lady Sarah Armstrong-Jones, India Hicks, Sarah Jane Gaselee, Catherine Cameron and Clementine Hambro. 'They would rush in, fling their arms around Diana and kiss her, and we had quite a job getting them to stand still,' the Emanuels recalled. 'On one particular day, they all arrived on roller-skates, which they insisted on wearing with their toiles during the fittings. It was total chaos.'

Afterwards, the Emanuels made a duplicate dress for Madame Tussauds. The original belongs to Princes William and Harry and was recently displayed at Kensington Palace.

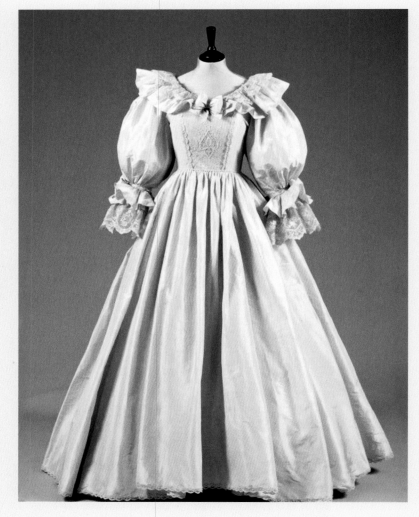

Above: Toile for Diana's wedding dress, by the Emanuels. Currently in the Fundación Museo de la Moda.

Opposite: The newly married Prince and Princess of Wales emerge from St Paul's Cathedral to greet the crowds.

Following pages: Sketches showing Lady Diana Spencer's wedding accessories, and front and back views of her wedding dress.

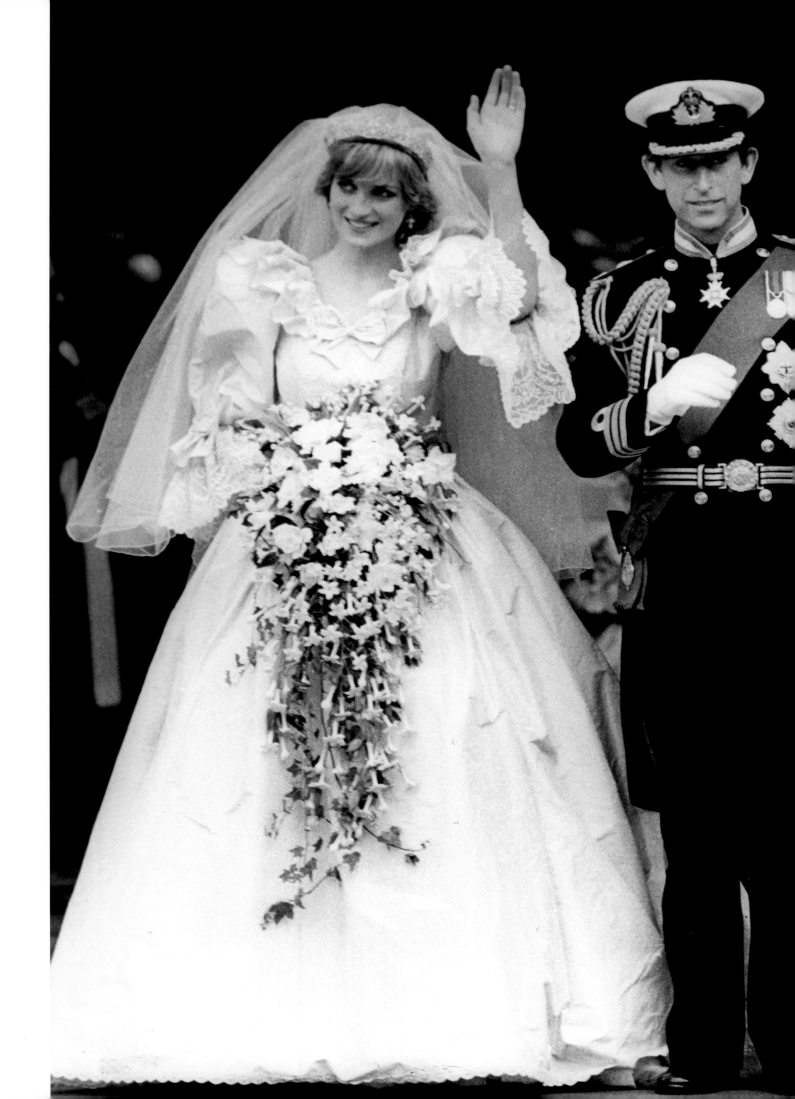

The wedding slippers —

Tiny golden horse shoe
studded with diamonds —
sewn into the dress
for good luck

The wedding umbrella
 ~ in case of rain
Made of the same fabric as
wedding dress and trimmed
with lace, hand embroidered
with sequins and pearls.

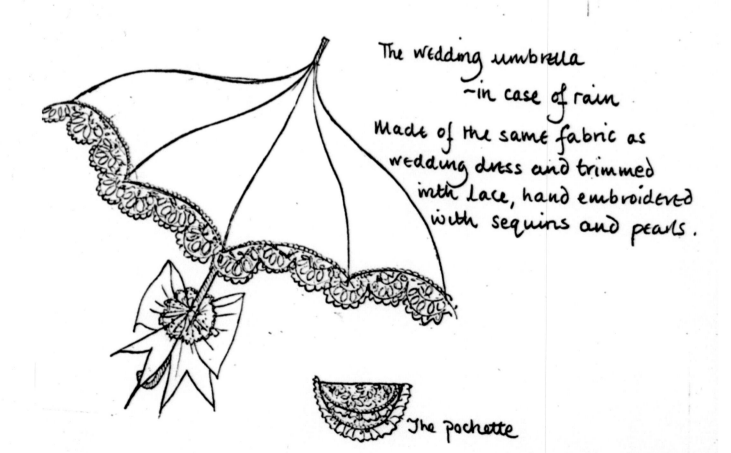

The pochette

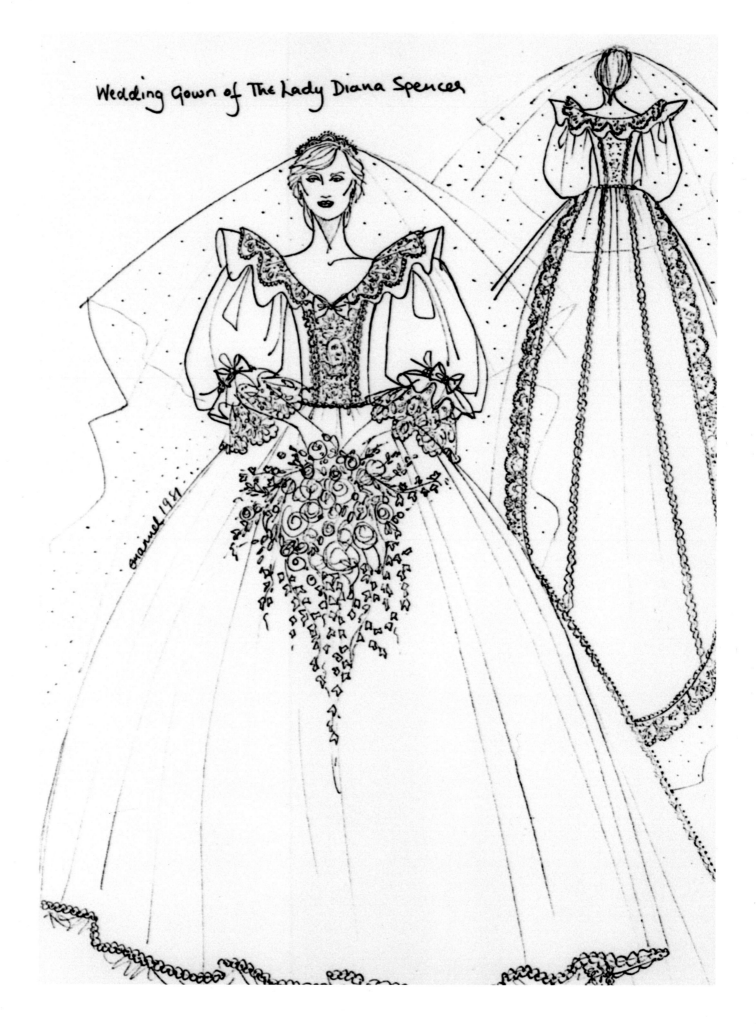

Wedding Gown of The Lady Diana Spencer

emanuel 1981

Diana, Princess of Wales, in the Throne Room at Buckingham Palace after her wedding on 29 July 1981.

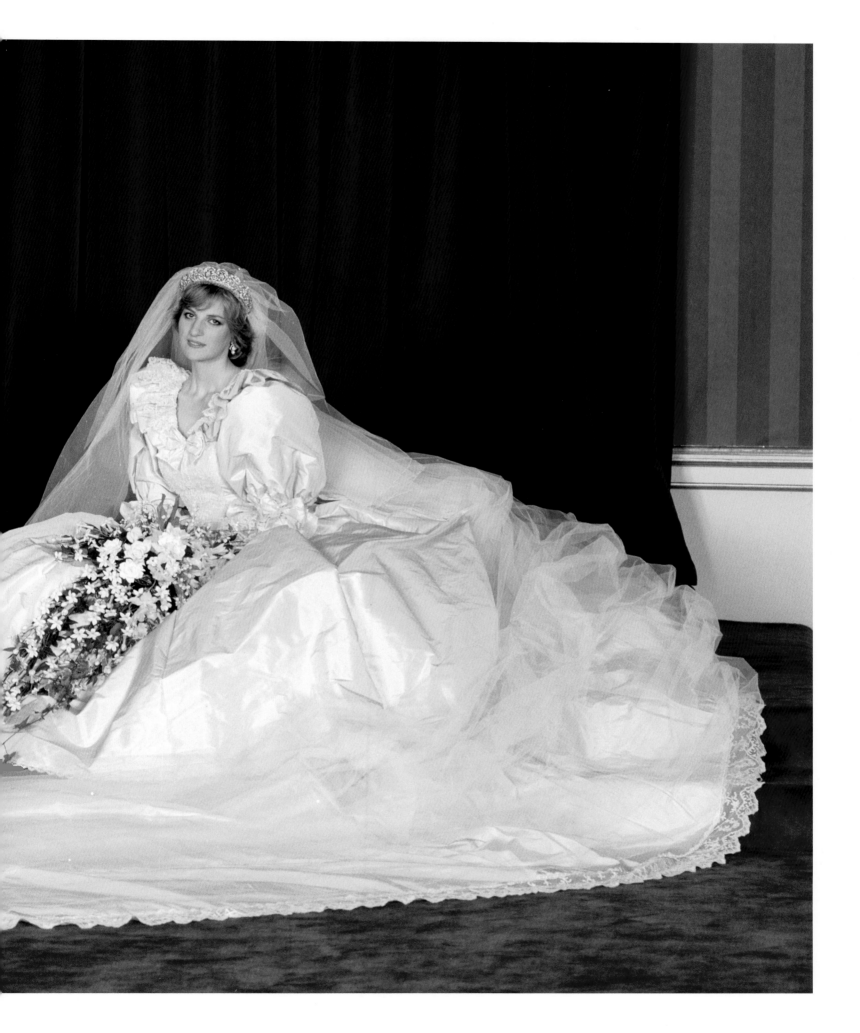

The Tartan Suit

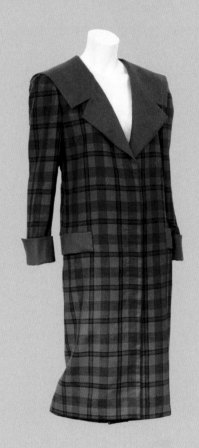

When Diana wore this teal tartan wool ensemble on an official visit to Italy on 5 May 1985, she received mixed reviews – some writers likened it to a 'horse blanket'. She teamed the coat, with its wide sailor collar and padded shoulders, with a matching skirt, simple white camisole, and a string of pearls for a ride on a gondola with her husband and a visit to the airport to collect Prince William and Prince Harry.

The coat ended up in a pile taken to a designer dress agency in Hampshire by Sarah Ferguson's mother, Susan Barrantes. It was sold by Kerry Taylor Auctions for £11,250 on 14 June 2016 and was bought by Historic Royal Palaces for their Royal Ceremonial Dress Collection.

Above: Diana's Tartan Suit at the Passion for Fashion auction at Kerry Taylor Auctions in South London.

Opposite: Princess Diana in Venice, Italy.

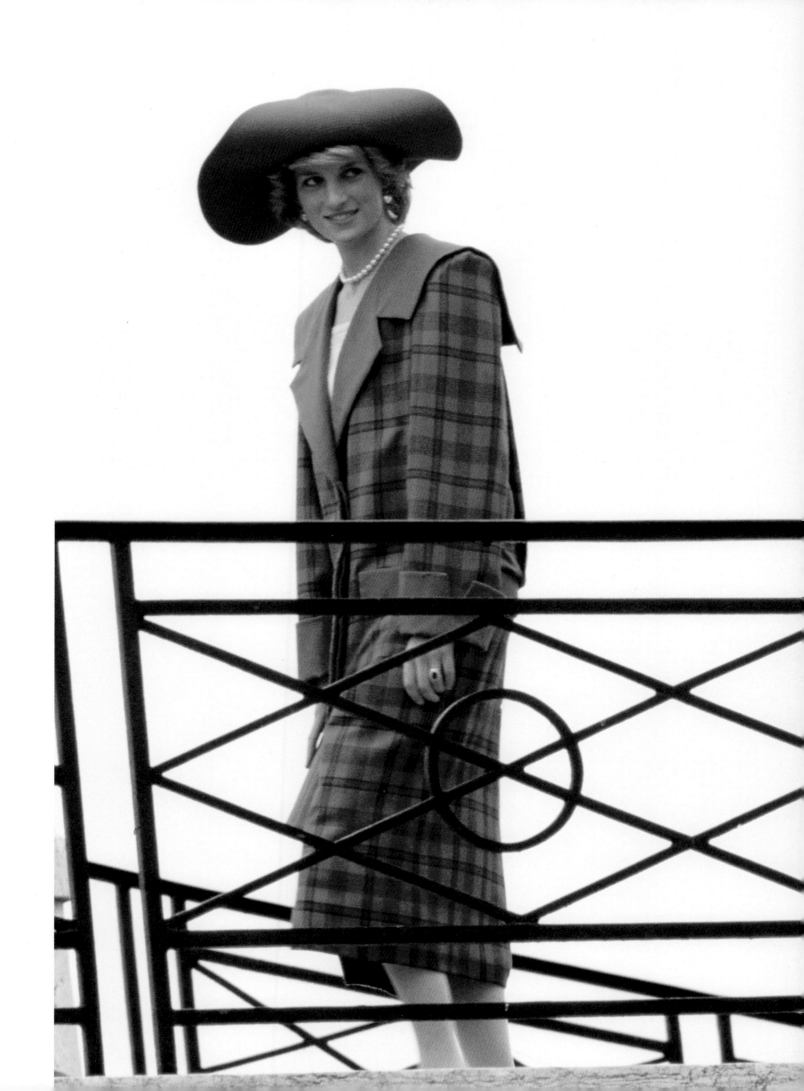

The Fairytale Ballgown

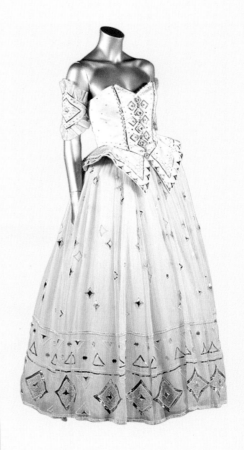

nspired by Léon Bakst, a Russian painter and costume designer who worked for Diaghilev and the Ballets Russes, Diana first saw this dress at a Red Cross benefit fashion show during the summer of 1986 and selected it from the 12 glittering gold and white creations that the Emanuels had sent for the occasion. Its ivory satin strapless bodice with pointed peplum, worn over a white organza skirt that was embroidered in gold thread and decorated with large gilt paillettes and gilt and pearl beads, appealed to Diana's love of ballet. She wore it on 4 July 1986 for a banquet at the German Ambassador Richard von Weizsäcker's London residence, to the Royal Opera House on 22 July for a performance of *Ivan the Terrible* by the Royal Ballet and to the première of the Bond movie *The Living Daylights* on 29 June the following year.

American society hostess Fontaine Minor, from Richmond, Virginia, bought the dress from the Christie's sale on 25 June 1997 for £15,218, to raise money for charity, and because it came from the same designer as Diana's wedding dress. She met Diana at the gala the night beforehand. 'I told her she was the most beautiful girl in the world and she returned the compliment by saying my yellow satin ballgown was just like one she had,' she said. Afterwards, Fontaine invited David Emanuel to a fundraiser on 23 October that year in aid of the Richmond Ballet. Her daughter Heather wore the dress, which had its own bodyguard. 'David came over for a week,' she recalled. 'He sang at the Saturday night dinner at the Commonwealth Club. He could have been as successful a singer as he was a designer. America just loved him. He's got a beautiful voice.'

'She'd bought the white and gold dress Diana wore for the Bond première of *The Living Daylights* and she'd heard that I was having voice training,' David said afterwards. 'She kept faxing me and, before I knew it, I was singing on a stage on the lawns of a place that looked like the White House.' When her husband Philip died in 2008, Fontaine sold the dress through Kerry Taylor Auctions for £106,250. It now resides in the Fundación Museo de la Moda, in Chile.

Above: The ballgown Diana first spotted at the Red Cross benefit fashion show, 1986.

Opposite: Diana attends the première of the James Bond film *The Living Daylights* in London, June 1987.

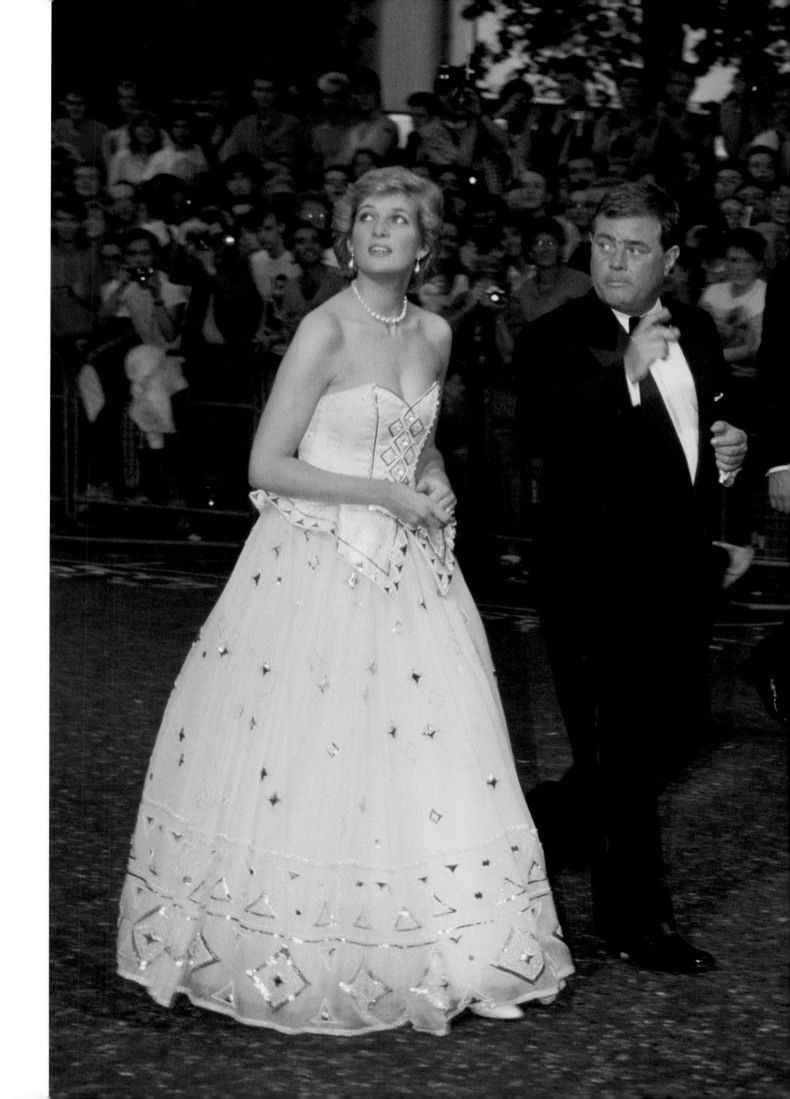

The Bahrain Day Dress

When the Prince and Princess of Wales arrived at Bahrain Airport on 16 November 1986, during their six-day tour of the Arabian Gulf States, the late Emir, Sheikh Isa Bin Salman Al-Khalifa, breached protocol to greet them. Diana was wearing an Emanuels navy-and-white ensemble – a white Bianchini silk dress with a blue-and-white-striped silk coat.

The unique dress, which was designed specifically for the Princess, was sold by Kerry Taylor Auctions on 17 June 2019, for £106,250 and is now in the Fundación Museo de la Moda.

Diana on the royal tour of the Gulf States, November 1986.

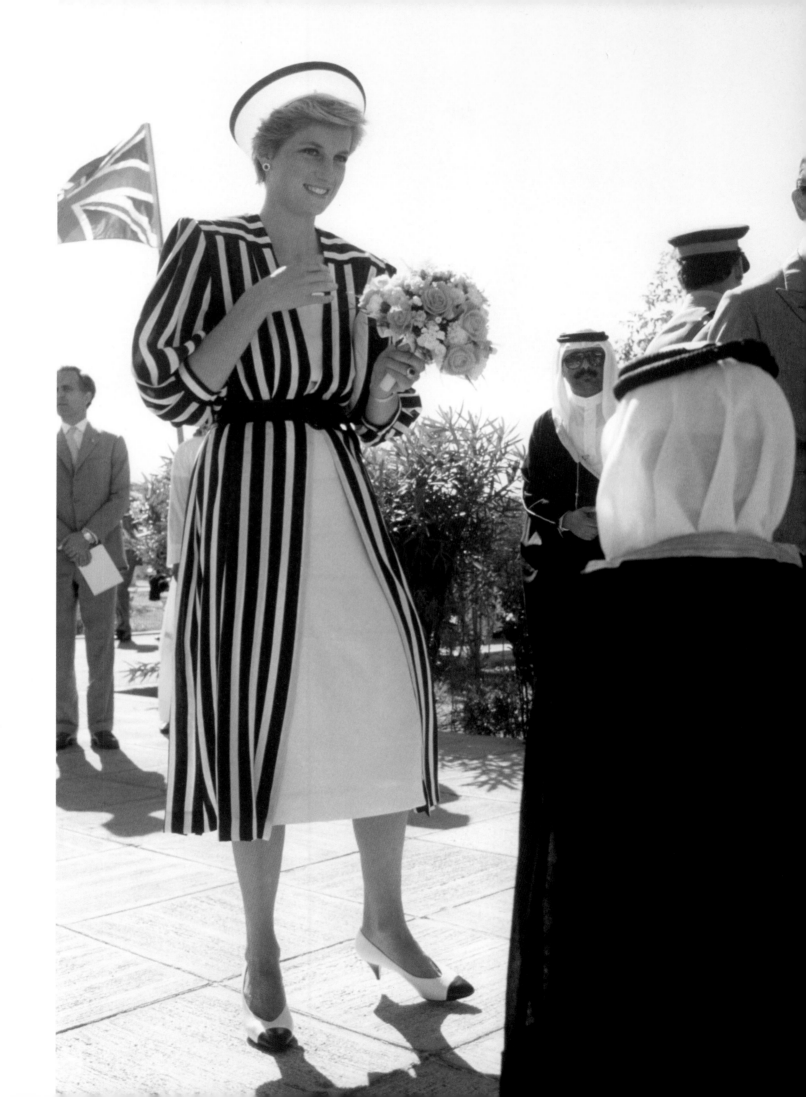

The Bahrain Evening Gown

Wearing this ivory silk moss crêpe evening gown, designed by the Emanuels, Diana captivated the Emir, who hosted a lavish banquet in her honour on 16 November 1986. Diana teamed the dress, with its draped bodice panel, leg-of-mutton sleeves and cockade on the shoulder, with the Spencer family tiara. The Emir later recounted his conversation with the Princess. She asked him what he would think if his son were to marry a tall, blonde English woman? He replied that he would be very jealous.

Diana is believed to have given the dress to her childhood friend, Caroline Twiston-Davies, who lived at Mynde Park in Herefordshire. Diana was a regular guest at the estate – she had a cottage in the grounds specially reserved for her use – and was godmother to Caroline's daughter Antonia. Her housekeeper, Mrs C Brinton, took the dress into the Chameleon second-hand shop in Hereford on 10 July 1996, and one of the part-time sales assistants bought it for £200 on 3 December, intending to wear it to a hunt ball. Instead, it remained unworn, packed away in a box, until the sales assistant realised its significance and took it to Kerry Taylor Auctions. They sold it for £162,500 on 10 December 2018, to the Fundación Museo de la Moda.

Opposite and following pages: Diana, wearing the white dress designed by David and Elizabeth Emanuel with the Spencer Tiara, attends a State Banquet in Bahrain on 16 November 1986.

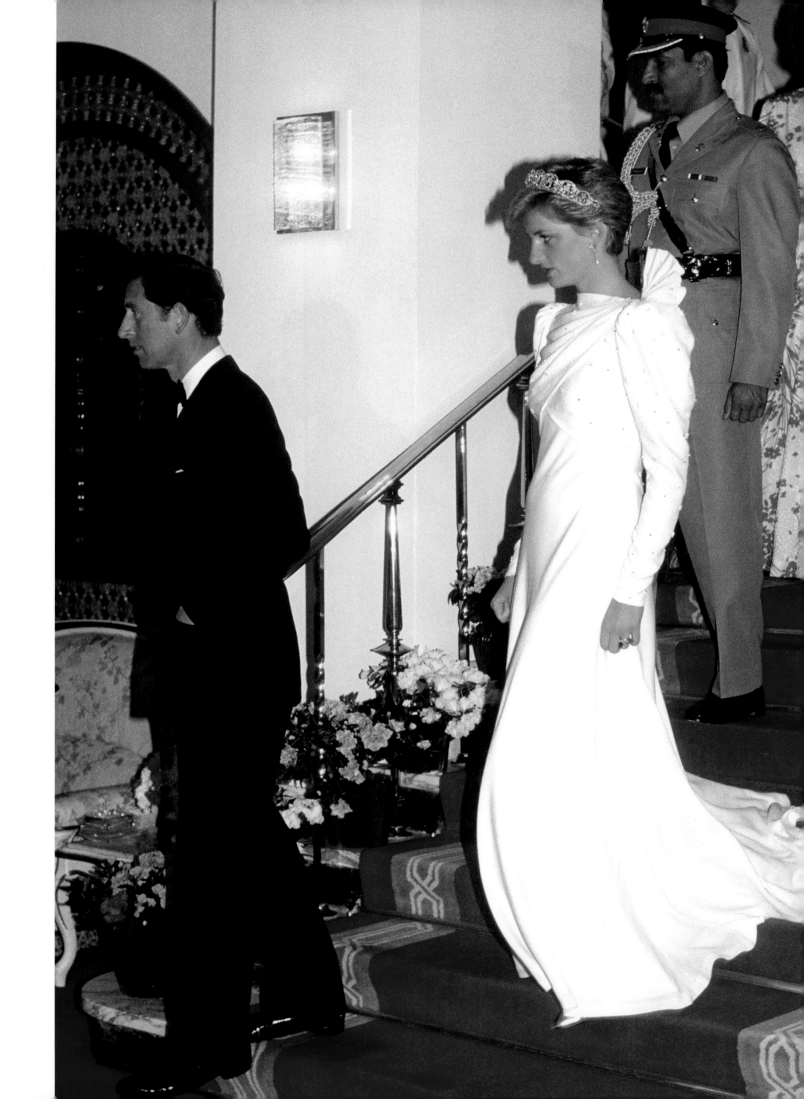

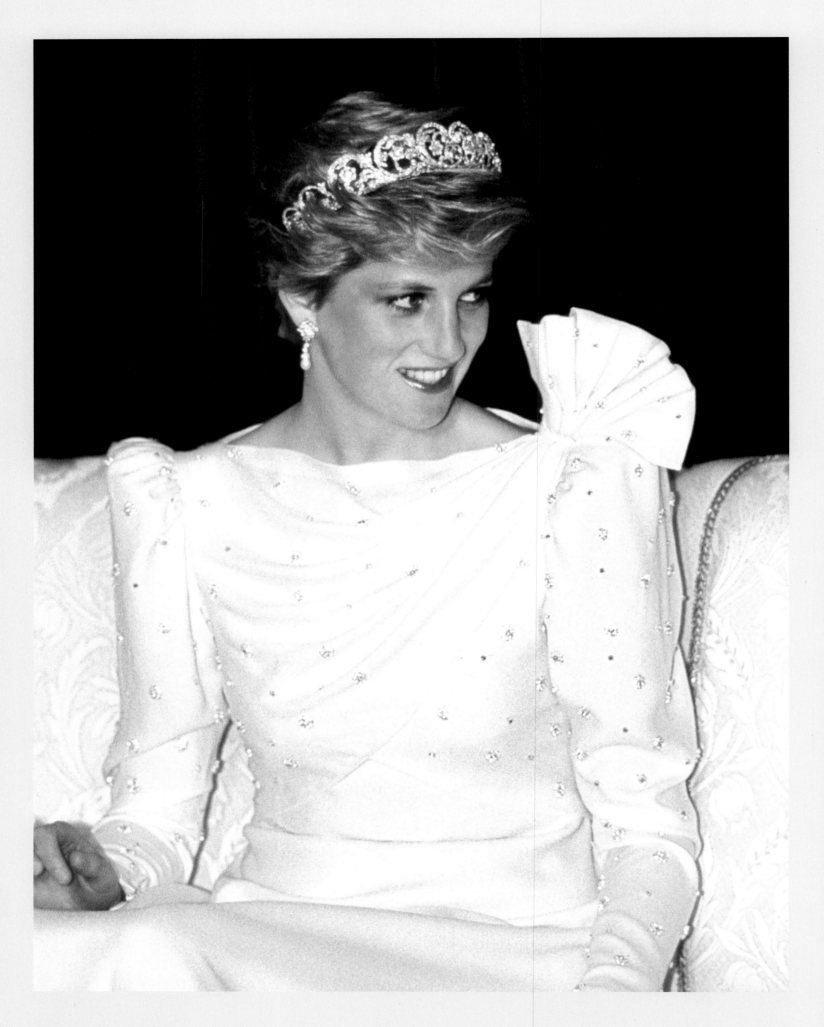

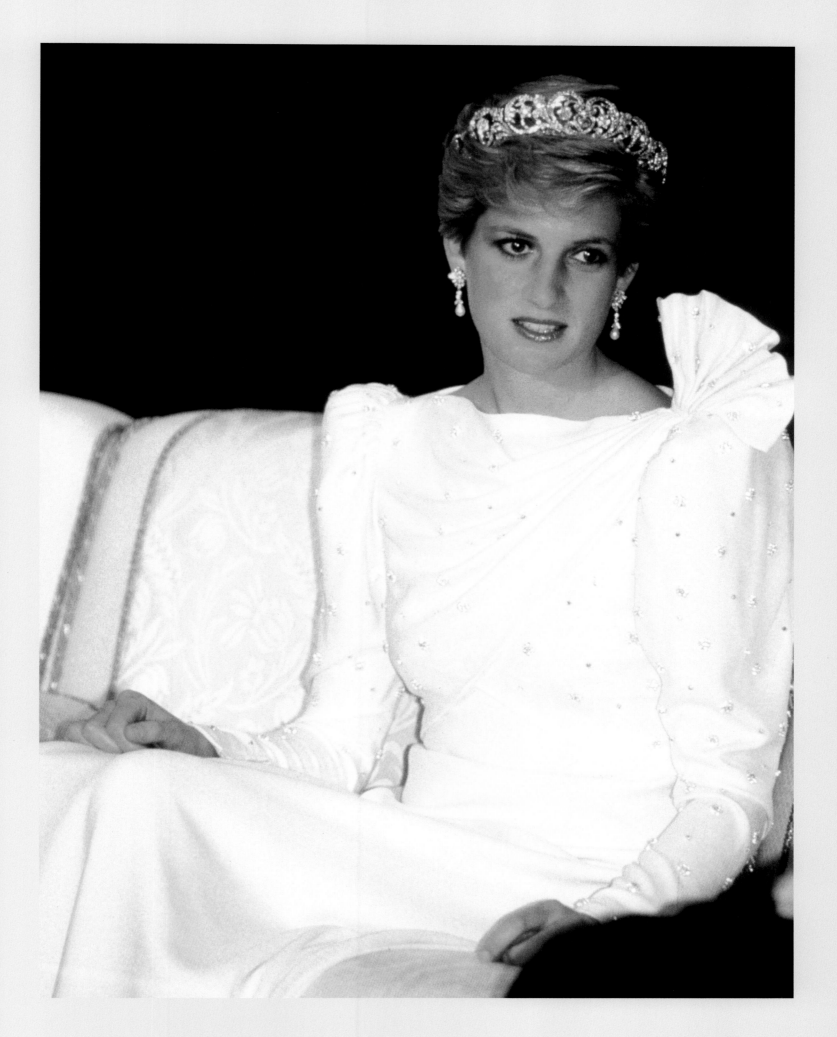

Bellville Sassoon

Shortly after announcing her engagement, on 24 February 1981, Lady Diana Spencer waltzed back into the Bellville Sassoon studio in London's Sloane Street with her mother Frances Shand Kidd to get her wedding trousseau, including her going away outfit. It was a novel experience for Diana, who had once been scared off by the vendeuse. 'Before she came to us for her trousseau, Diana had rarely had anything specially made – it was a whole new experience for her,' recalled designer David Sassoon, who has dressed every senior female member of the royal family apart from The Queen. 'Her mother, Frances Shand Kidd, who had been a client of ours, dragged her in about three weeks later to get some clothes for her trousseau.

'Belinda wasn't there – she was on the verge of retiring because her husband wasn't very well – and I dealt with her. We got on terribly well. So, the next time she came, she said: "Would you like to make my going away outfit?" And I said: "I would absolutely love it." So, she said: "Please don't call me Lady Diana, call me Diana." So, I called her Diana until she got married and then I called her Lady Diana, or ma'am, or whatever. From then on, whenever Diana appeared, we kept the vendeuse out of the way.'

By then, Belinda Bellville and David Sassoon were one of *the* London couturiers. David had joined Belinda in 1958, after graduating from the Royal College of Art – she hired him on the strength of his graduation show and invited him to become a partner in 1970. Together they dressed debutantes, aristocrats, and royalty. They counted Audrey Hepburn, Elizabeth Taylor, Jacqueline Kennedy Onassis, Julie Christie, Helen Mirren and Catherine Deneuve amongst their clientele, as well as Princess Margaret, Countess of Snowdon; Princess Anne; Katherine, Duchess of Kent; her daughter Lady Helen Taylor and Princess Alexandra.

David's first encounter with the royal family came when he was sent to supervise the fitting of a dress for Princess Anne – the nine-year-old was one of the bridesmaids to Lady Pamela Mountbatten and David Hicks. In those days, he and the fitter were shown to the tradesman's entrance. 'We stepped into a lift with a liveried page who took us to the nursery floor,' he recalled. 'There were ink stains on the carpet and toys all over the place. Princess Anne was wearing Clarks sandals and had braces on her teeth. The nanny put her into the bridesmaid's dress and Prince Charles came in wearing short grey flannel trousers, holding his hands behind his back, and walked round his sister inspecting the dress.

'Then The Queen appeared. In those days you had to walk backwards in the presence of royalty, so I took a step back to make a bow and my foot went into one of the corgis' bowls, which was full of water that splashed all over my shoes. The Queen pulled a cord by the side of the fireplace and up came a liveried page to wipe my shoes. The funny thing was the bridesmaid's dress was a beautiful white organdie and The Queen's only concern was whether it would wash.'

Diana wears a Bellville Sassoon dress to attend a charity concert at the Barbican Centre in London, September 1989.

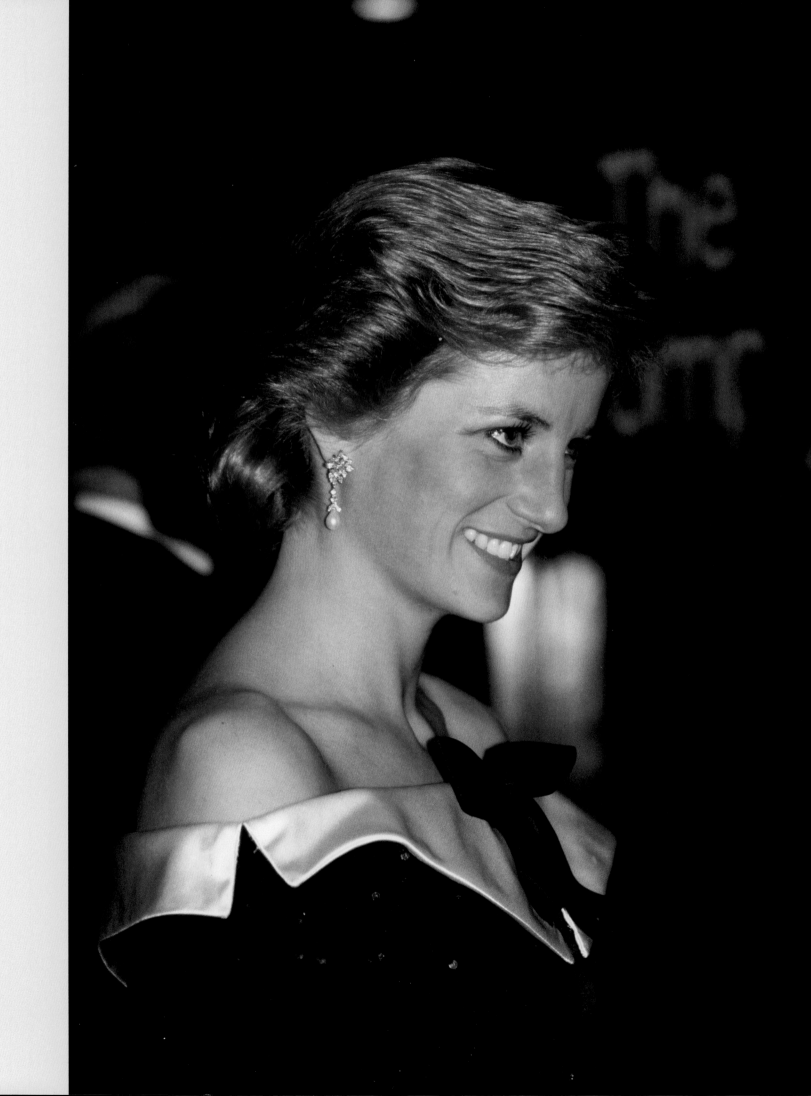

Two decades later, after being a guest at the wedding of the decade, he found life at the palace more informal. 'Previously, Diana had always come to us; now we went to her at Kensington Palace,' he said. 'However, Diana didn't go in for the normal formalities of royal protocol and at fittings, after the initial "Good morning, your Royal Highness", the appointment would progress in a very informal atmosphere. She managed to strike a balance. The Princess could be charming and chatty, but nevertheless expected to be treated with the appropriate respect due her royal station. After she was married, either the Princess or her lady-in-waiting, Anne Beckwith-Smith, would ring up with a brief regarding an event and ask for sketches. We would send a batch round and they would come back to us with Diana's pencilled comments, usually, "Yes, please!"'

Over the next 13 years, David made more than 70 outfits for the princess for some of the most significant events in her life: her first official press photograph with The Queen, the engagement portrait for the Royal Mail's celebratory stamps, her first solo engagement and the christening of Prince William. She even wore a Sassoon creation to host a reception for foreign buyers and press on 19 March 1985 during London's Fashion Week: a brightly-coloured 'dressing gown' robe, which was in vogue at the time – although she didn't wear the matching royal blue trousers. 'She appeared with Prince William and everyone was wondering what she would wear,' recalled David. 'All my other co-designers were there and she suddenly walked in wearing my design. I couldn't believe it. The press went wild and came running up to me. It was the fashion look of the season. I was just a little disappointed that she didn't go the whole hog and wear the matching trousers.'

But only once did she turn her hand to designing – while David created the white gown that Diana teamed with the Queen Mary's Lover Knot Tiara for the State Opening of Parliament on 4 November 1981, it began as a sketch by Diana. 'She sent me a piece of paper, torn out of her notebook, with a little pencil drawing and she said: "Could you make a dress something like that?" So, we re-drew variations on what she had done. She then sent me a charming letter saying it was exactly what she wanted.'

'Dear David,' she wrote on 17 September that year. 'How terribly clever of you to draw the exact thing I wanted! Could the back be the same pattern as the front? Many thanks for redoing the sketch. Its [sic] going to look lovely, I'm sure... Yours very sincerely, Diana.'

'It was the only time that she ever independently designed a dress that she would like us to have made,' added Mr Sassoon. 'It had a satin bodice, white organza embroidered with little silver trees dotted all over it on the actual puff sleeves. I didn't think it was one of the most successful dresses we have ever made for her. I don't think she felt in the long run it was quite as good as it could have been. That was her one and only effort. She never designed a dress again.'

On most occasions, when David would go to Kensington Palace to fit Diana he arrived at the front entrance. 'The hall and stairs were carpeted in apple green with the Prince of Wales's feathers woven in cream, and the walls were pale peach with the plasterwork picked out in white,' he said. 'We fitted the Princess in her sitting room, which was decorated in turquoise. It was a friendly, personal room with an unframed photograph of the Prince of Wales carrying his baby son.'

On one occasion, he almost changed the course of history. 'I arrived at the Princess's apartment with my fitter, Nives, and we were ushered upstairs by the Princess's maid,' he recalled. 'I knocked on the door of her sitting room and then threw the door open wide for Nives, who was following behind me with an armful of dresses, we were about to fit. To my horror, I knocked over three-year-old Prince William, who was standing behind the door. All I could think was: "Oh my God, I've killed the future King of England. I'll be put in the Tower." Diana rushed forward to cuddle and soothe him and assured me all was well – the only damage was a bump on his head.'

However, Diana did make surprise visits to the shop. One afternoon in August that year, she arrived with Lady Sarah Chatto, who had been a bridesmaid at her wedding. 'They had come to choose a balldress for Lady Sarah to wear at Balmoral Castle,' recalled David. 'It was to be her first long dress and Diana was going to help her choose, as she wanted it to be special. They had the shop to themselves, since it was officially closed for the August holidays, so it was quiet and private. Diana helped Lady Sarah try on all the long dresses and there was much giggling from the dressing room. In the end Lady Sarah settled on a scarlet taffeta strapless dress and they both left together like excited schoolgirls. Lady Sarah obviously adored Diana and listened to all her fashion advice. What struck me was the lovely gesture, typical of the Princess of Wales – she bought the dress as a gift for her young friend.

'The last time I saw Diana was at the London preview of the Christie's auction. She looked wonderful – relaxed, suntanned, glamorous. I asked her what had happened to the going away outfit, and if she planned to sell it. "No, I've still got it," she replied, "I want to keep that." I feel blessed and privileged to have been part of Diana's story. Tragically, when I attended her wedding, I never dreamt that I would also attend her funeral.'

David, who has written an autobiography, *The Glamour of Bellville Sassoon*, still has the box from the piece of wedding cake that Diana sent him after the wedding – but no longer has her priceless sketch. 'I stupidly threw her sketch away after I had redrawn it,' he admitted. 'At the time I suppose it was torn out of a notebook she had scribbled on.'

The Going Away Outfit

I t was the second-most-precious outfit in her wardrobe – after her wedding gown – and Princess Diana hung onto it until the day she died. Diana wore her Bellville Sassoon cantaloupe silk day dress and matching bolero jacket with white organza collar to board the train to her honeymoon on 29 July 1981. She wore the long-sleeved version to visit a war memorial in Canberra on 25 March 1983, during her first Australian tour, and the short-sleeved version to unveil a plaque at Grimsby Hospital on 26 July 1983. It was in her wardrobe on the day she died and now belongs to Princes William and Harry.

'Diana was quite definite about what she wanted to wear, and she herself chose the dress and bolero-style jacket as well as the colour, which we called cantaloupe,' recalled David. 'Diana was also adamant that the dress had to have a straight skirt, as she felt this was very grown-up, and the outfit was purposely trimmed with her trademark romantic ruffles. To cover all eventualities, there were two versions of the jacket: one with long sleeves in case the weather wasn't good, and the original version with short sleeves, which the Princess wore on the day [of the honeymoon]. Diana chose a jaunty tricorne hat from milliner John Boyd to wear with her going away outfit, and one day she came to us straight from her final hat fitting with a take-away coffee, and she couldn't stop laughing. "I went in to get my cup of coffee," she explained, "and the girl behind the counter said to me, 'You look just like Lady Di.'" The Princess had instinctively replied: "That's the nicest thing anyone's ever said to me!" and the girl had been thrilled. Diana had kept her secret to herself, and she'd been giggling about it all the way to our fitting.'

As the wedding day approached, Diana became increasingly stressed, arriving at her final fitting in tears. 'I sat her down and tried to comfort her. She had just come from the wedding rehearsal at St Paul's Cathedral and it was all getting too much for her. She told me she was worried because she hadn't thought about a handbag to go with our outfit, and now felt she should have one. So, I offered to get one made in the same cantaloupe silk fabric. She was so relieved she gave me a hug. When the bag was ready, I put a handwritten card in the mirror compartment which simply said: "Much happiness in your marriage and lots of luck on your great day." The Princess later told me that when she got off the train on the way to her honeymoon her hair got blown in the wind, so she took out her mirror and the card fell out. She was very touched by it.'

After Diana's death, David had a retrospective exhibition and went to St James's Palace to borrow back some of his designs. 'There was a lot of kerfuffle about it,' he said, 'because nobody had been allowed to do that, so I managed to do it. So, I went along to St James's Palace and they said: "What are you looking for?" And I said: "Well, one of the things I would like to have is the going away outfit that I made for Princess Diana to wear on her wedding day." And they said: "Oh, we don't have that. But we do have a salmon-coloured dress and jacket." So, they take it out of a polythene bag and I say: "Oh my God. This is the going away outfit." And they said: "What do you mean?" The collar, which was made of white organdie to keep it clean, was tucked inside – so when I took the long sleeve jacket off, the short sleeve jacket was underneath, and I pulled the collar out over the coat and there it was.'

Opposite: Diana visits Canberra, Australia, on 25 March 1983, wearing a dress by Bellville Sassoon and a peach archer-style hat designed by John Boyd.

Following pages, left: The original Bellville Sassoon sketch for this outfit.

Following pages, right: Diana walks next to Australian Prime Minister Bob Hawke in Canberra, Australia, on 25 March 1983.

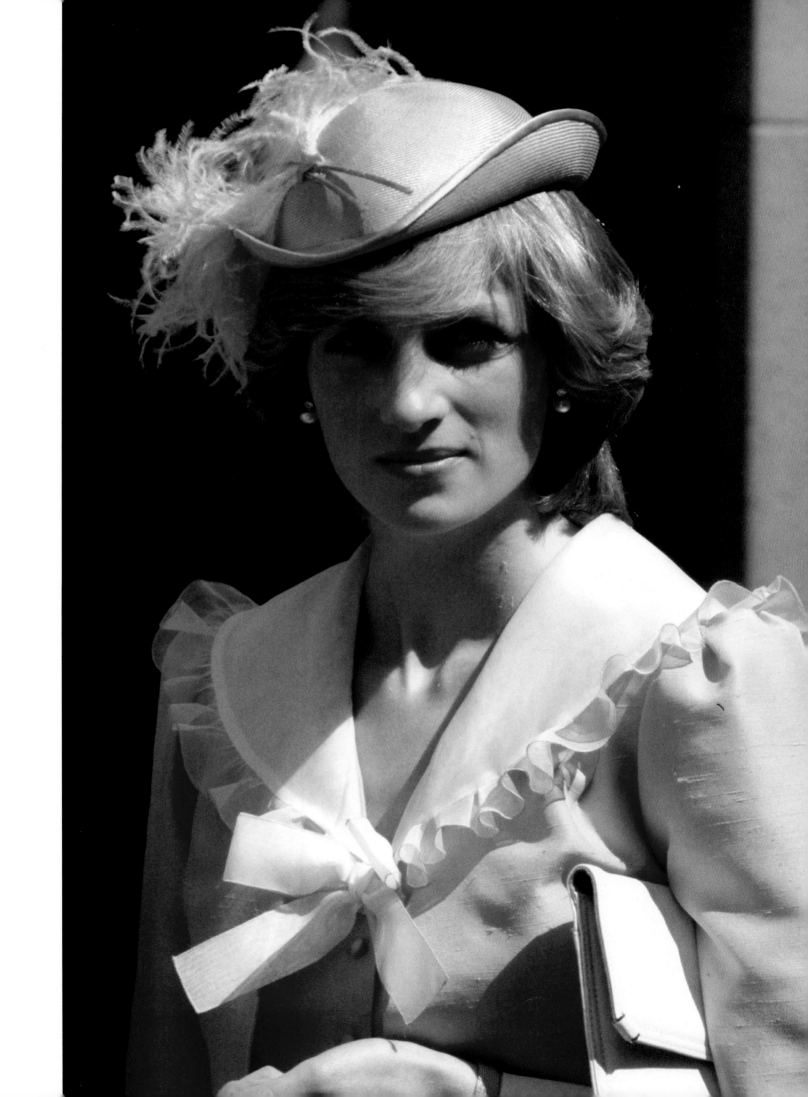

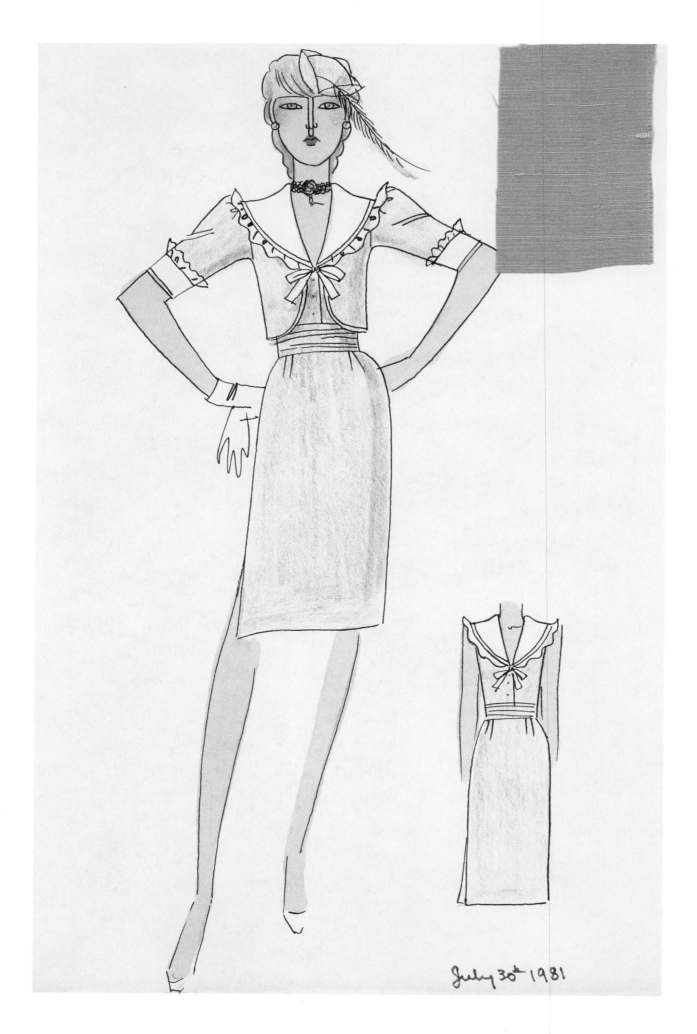

July 30th 1981

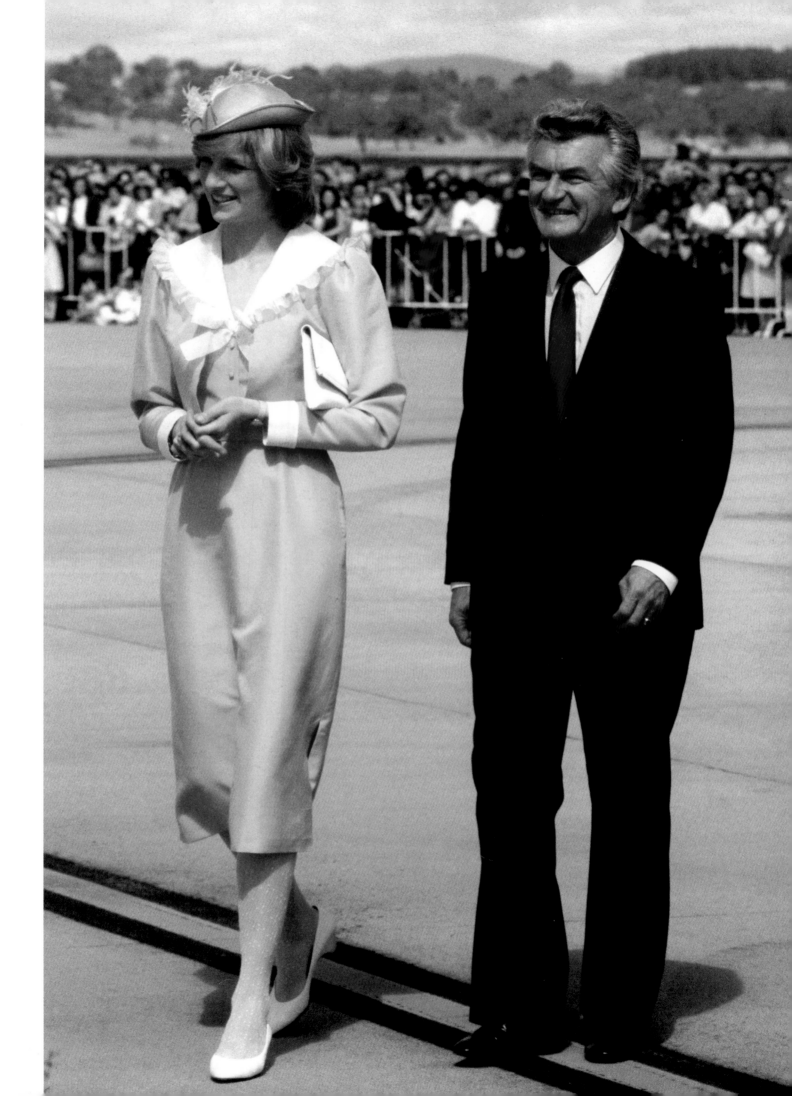

The Caledonian Ballgown

Although she was a style icon, Diana did not enjoy shopping and was always delighted when she could buy something off-the-peg: at size ten, she was the perfect sample size. So, when she needed a dress for her first Caledonian Ball, on 18 May 1981, she popped into Bellville Sassoon. She later wore the dress at a State Banquet for Queen Beatrix and Prince Claus of the Netherlands, at Hampton Court Palace on 17 November 1982. It now belongs to the Duke of Cambridge and the Duke of Sussex.

'On one occasion, Diana came in and wanted a long white dress,' David said. 'I picked one out. She put it on and was delighted – it fit perfectly and didn't need altering. It was her favourite type of clothes shopping – in a very short time she had picked a dress and had it dispatched to her. She later wrote me a charming letter to tell me it had been for a ball at Balmoral and said: "Everybody up here went wild about the long white dress!"'

'On one occasion, Diana came in and wanted a long white dress. I picked one out. She put it on and was delighted – it fit perfectly and didn't need altering. It was her favourite type of clothes shopping – in a very short time she had picked a dress and had it dispatched to her.'

The Princess of Wales at a banquet given by Queen Beatrix and Prince Claus of The Netherlands at Hampton Court Palace. The Princess wears the sash of the Order of the House of Orange, presented to her by Queen Beatrix.

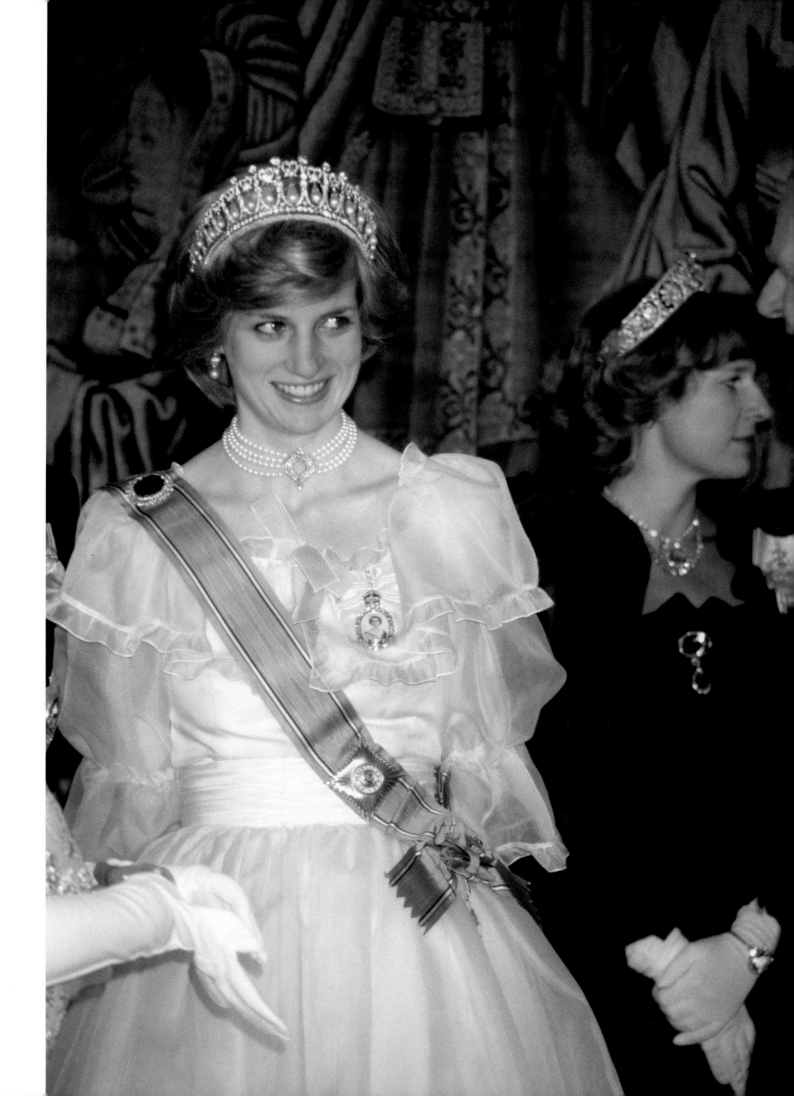

The Black Watch Frock

Designed by David Sassoon for Diana's trips to Scotland and inspired by a traditional kilt, with its long bodice and lace collar and cuffs evoking the jacket, lace jabot and pleated skirt, Diana, known as the Duchess of Rothesay north of the border, wore her Black Watch tartan frock on multiple occasions, proving she was as thrifty as The Queen. She initially wore the dress on 22 August 1987, for the Bute Highland Games in Rothesay – Prince Charles was chieftan that year – arriving on one of the last voyages of the frigate HMS *Rothesay*.

Diana also wore this dress on 7 September of the same year for a visit to an Edinburgh drug treatment facility, and on 20 September at the first Festival of National Parks at Chatsworth. On 9 September 1988, she teamed it with a Freddie Fox hat for the Braemar Games and on 17 August 1989, she wore it on a trip to Aberdeen. The dress, which belongs to her two sons, was displayed in 2014 at the Fashion Museum in Bath, as part of their exhibition of the Bellville Sassoon archives.

Opposite: Diana at Chatsworth House, Derbyshire, in 1987, wearing her Scottish-inspired frock by Bellville Sassoon.

Following pages, left: The original Bellville Sassoon sketch for this dress.

Following pages, right: Diana attends the Rothesay Highland Games on the Isle of Bute, Scotland, 22 August 1987.

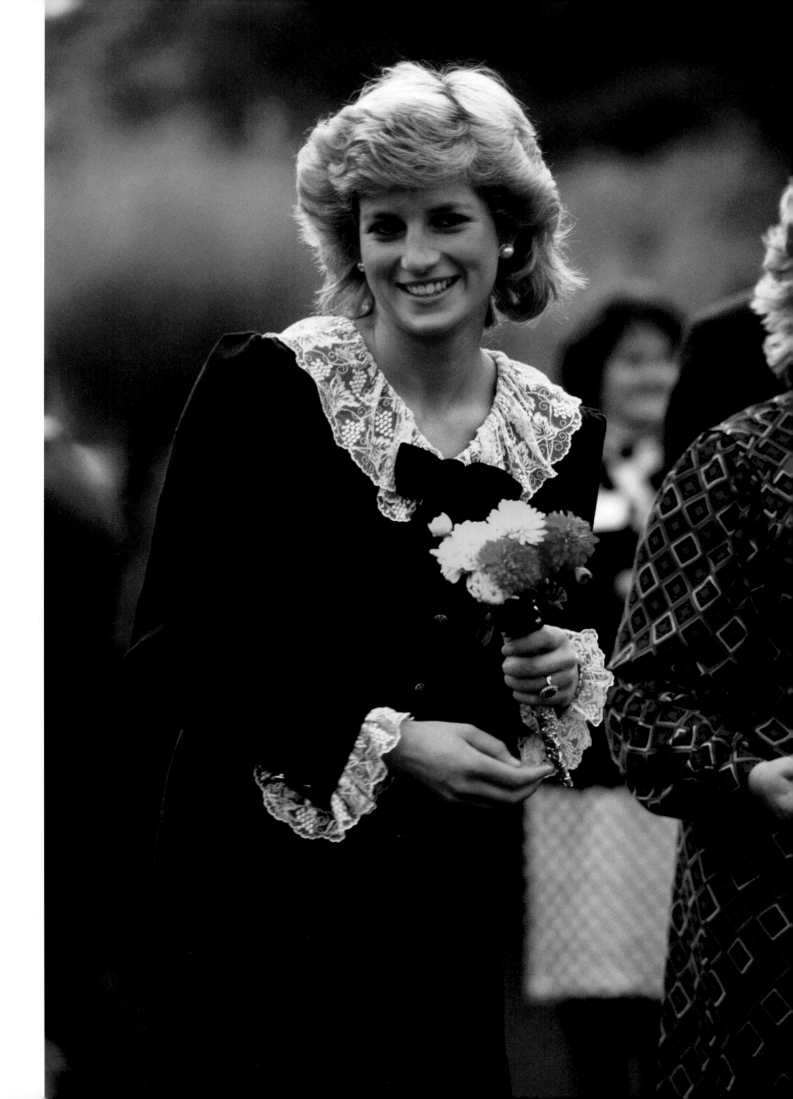

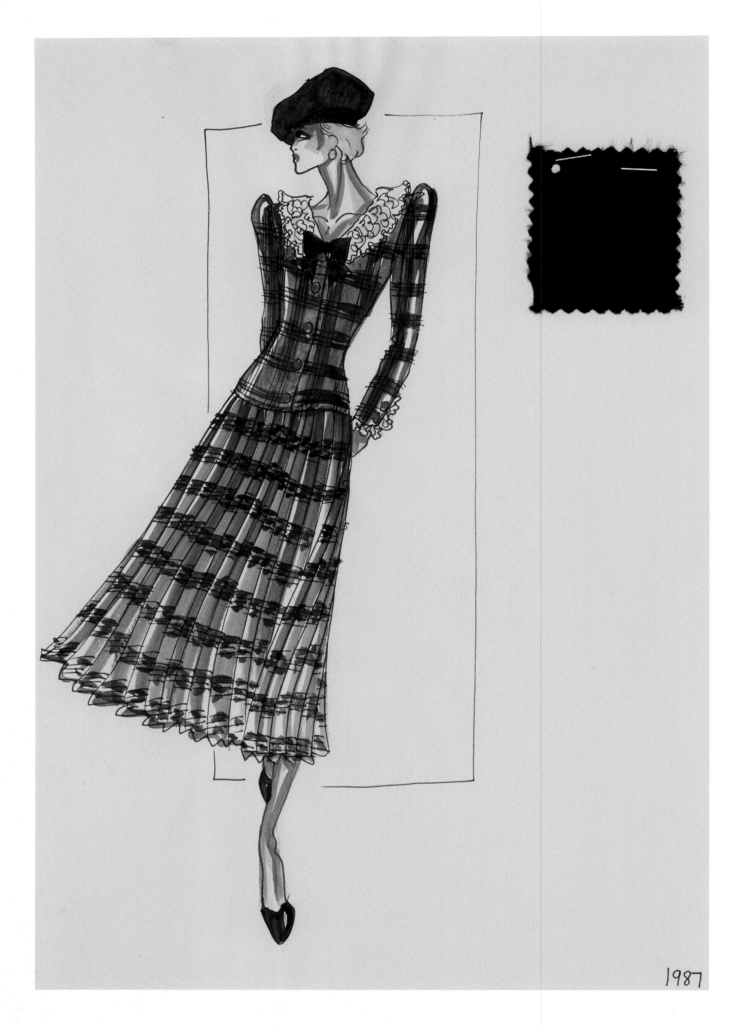

1987

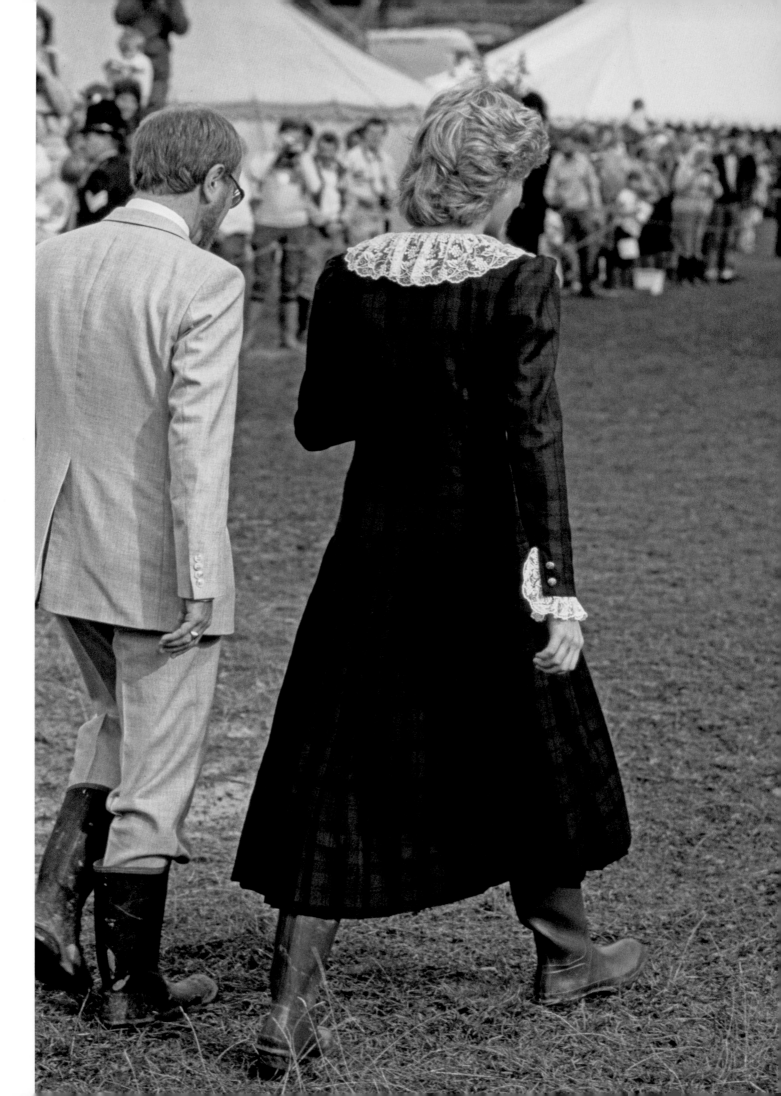

The Cocktail Dress

When the black cocktail dress designed by Bellville Sassoon and Lorcan Mullany – who temporarily replaced Belinda after she retired in 1982 – was auctioned by Christie's in 1997, it was sold to *Paris Match* magazine for £26,286. Diana had worn this dress to a concert at London's Barbican Centre on 29 September 1989, for a gala performance of *Ananzi* by the Chicken Shed Theatre Company at Sadlers Wells Theatre on 17 October 1990, and the Children of Eden Gala at the Prince Edward Theatre on 15 January 1991. *Paris Match* later gave the black cocktail dress away in a competition.

Nine years later, on 26 June 2006, Kerry Taylor Auctions sold this dress for £18,750. Its wide neckline was cut to reveal Diana's neck and shoulders, embroidered with black sequins and trimmed with a black bow, ivory satin collar and cuffs. The dress is now in the Fundación Museo de la Moda.

Above: Diana's black cocktail dress, designed by Bellville Sassoon and Lorcan Mullany.

Opposite left: Diana attends a charity concert at the Barbican Centre in London, September 1989, wearing this dress.

Opposite right: The original Bellville Sassoon design sketch of Diana's dress.

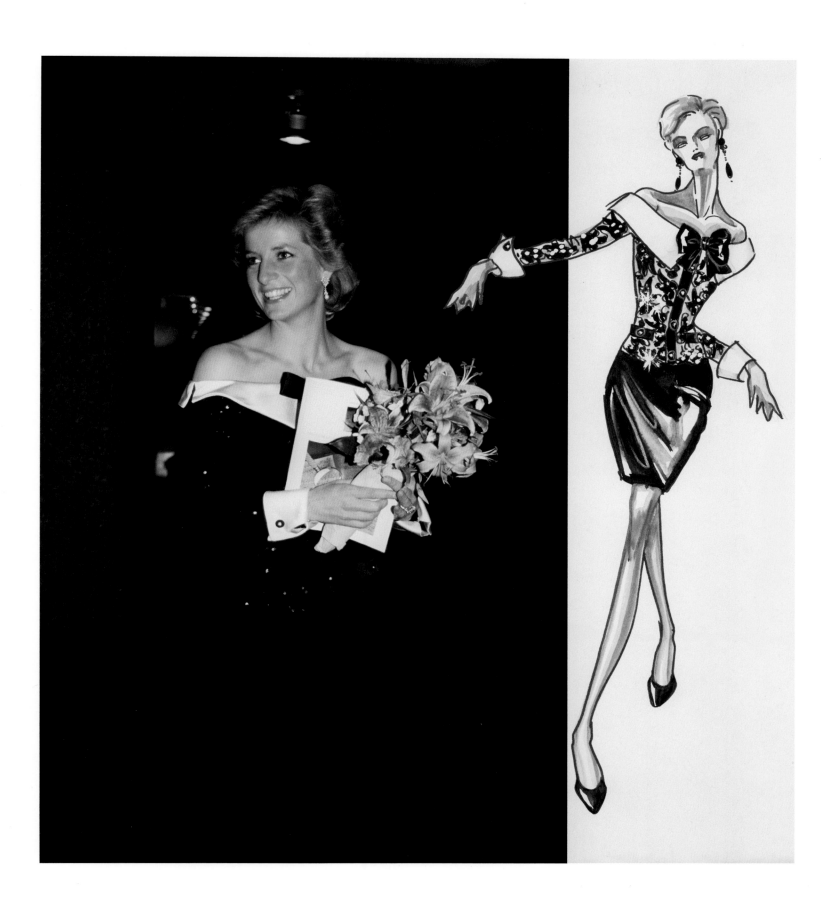

Gina Fratini

A favourite of Hollywood stars and royalty, Gina Fratini was one of the designers Diana turned to after marrying Prince Charles – *Vogue's* beauty editor, Felicity Clark, called in some of her fairytale creations for the Snowdon shoot on 'Upcoming Beauties'. By then, Gina, the daughter of the Honourable Somerset Butler, a colonial service officer who was the son of the 7th Earl of Carrick, had become the darling of the fashion industry.

After graduating from the Royal College of Art, she launched her own company in 1964 and went on to dress the cream of British society, including Princess Margaret, Princess Anne, Princess Alexandra and Princess Michael of Kent. In 1975, she won Dress of the Year – an annual fashion award run by Bath's Fashion Museum – for a cream silk organza wedding gown decorated with mimosa flowers. She went on to create screen legend Elizabeth Taylor's colourful tie-dye dress for her second marriage to actor Richard Burton on the banks of the Chobe River in Botswana, on 10 October that year.

'I like movement,' the late designer once said. 'There's nothing more fascinating than a woman flowing instead of walking.'

After closing her fashion house in 1989, Gina became a guest designer at Norman Hartnell. She famously designed Diana's white chiffon gown trimmed with pearlised sequins and beads, which became Lot 1 at the Christie's 1997 auction. This dress, which Diana wore for an official portrait by Terence Donovan in 1990 and for a visit to the ballet in Rio de Janeiro, Brazil on 26 April 1991, sold for £45,113 to a private buyer.

Diana wore another of Fratini's designs, a cream silk organza ballgown, for a banquet at the Sheraton hotel in Auckland, New Zealand, on 29 April 1983. It was clearly one of her favourites at this time, as she wore it again at an official dinner given by the Prime Minister of Canada, Pierre Trudeau, on 15 June that same year, as well as to the State Opening of Parliament on 6 November 1984.

Diana attends a banquet on 29 April 1983 in Auckland, New Zealand, wearing a cream satin dress by Gina Fratini, with the Queen Mary Lover's Knot Tiara.

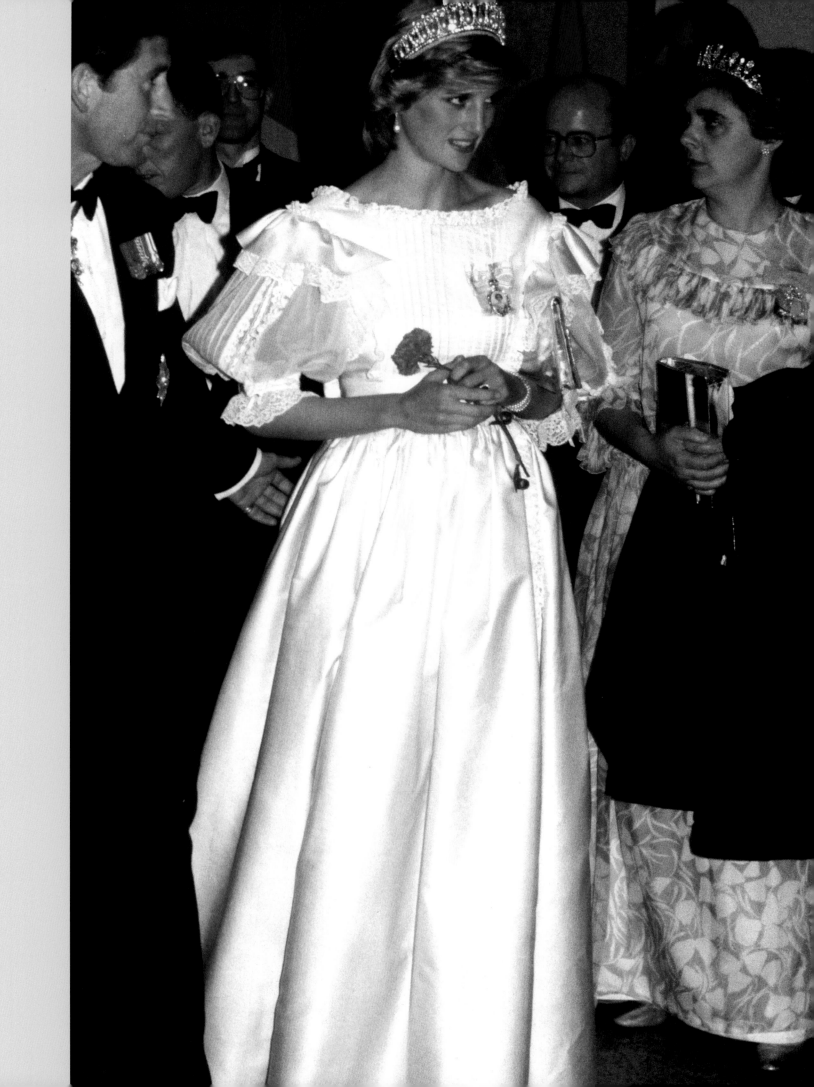

The Black Polka Dot Number

P rince Andrew's 21st birthday party was held at Windsor Castle on 19 June 1981 – four months after his actual birthday, which he had been absent for while attending a helicopter training course to become a Royal Navy officer. Diana chose to wear a handmade black velvet polka dot dress by Gina Fratini. She wore the dress on two further occasions: for a reception celebrating the unveiling of Michael Noakes' portrait of Prince Charles, given by King Edward VII's own Gurkha's Rifles at London's Ritz Hotel on 8 February 1984; and when the couple attended a reception in honour of the Commonwealth Youth Exchange Council, hosted by Prime Minister Margaret Thatcher, on 11 February 1985, when she wore it with a bright red coat.

The dress was auctioned by the Mid-Hudson Galleries in New Windsor, New York, on 21 November 2020, for £26,962.65 and is now owed by The Princess & The Platypus Foundation – it is on display in the Princess Diana Museum, an interactive 3D museum.

Diana walks down the steps of the Ritz Hotel, London, in February 1984.

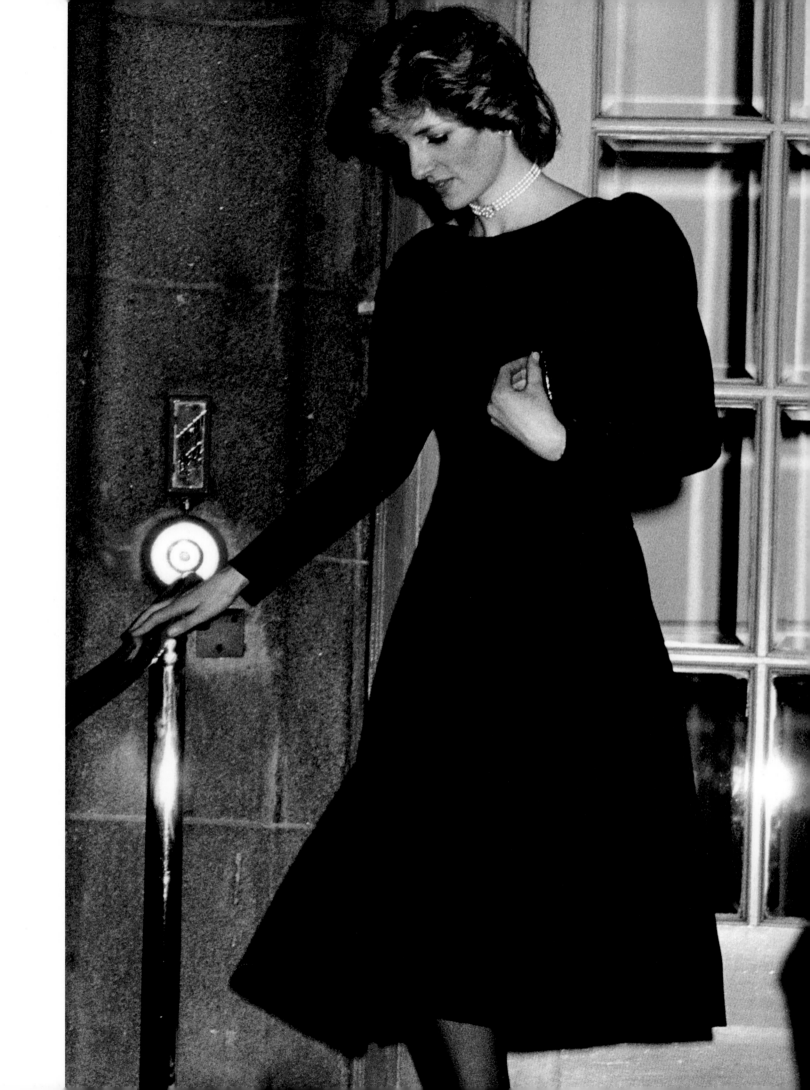

Bill Pashley
The Honeymoon Suit

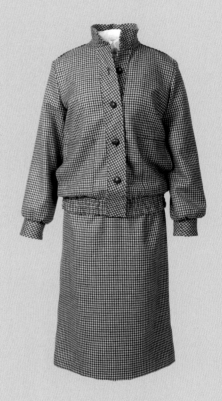

Posing with her new husband by the River Dee, on 19 August 1981, while honeymooning in Balmoral, Scotland, Diana wore a tweed wool suit by the late fashion designer Bill Pashley, who died in 2014. The Princess had asked Bill, who grew up in a farming family in Rotherham, Yorkshire, and gained a scholarship to the Royal College of Art, to make two versions of the suit – she chose to wear the larger one on honeymoon so that she had more shoulder room for country pursuits.

It was the second time that Diana had worn a Bill Pashley design on a public occasion: she memorably wore a blue floral number a month before her wedding, when she appeared on the Buckingham Palace balcony after the Trooping the Colour ceremony. After the wedding, the Princess and the designer – who was openly gay, and had met his partner Gilbert Olliffe at a Halloween party in 1963 – found much hilarity in the fact that royal etiquette meant he could never see her in her lingerie.

But Diana later revealed to author Andrew Morton that she was unhappy on her honeymoon. 'Went off to Balmoral – everyone was there to welcome us and then the realisation set in,' she said. 'Charles used to want to go for long walks around Balmoral the whole time when we were on our honeymoon. His idea of enjoyment would be to sit on top of the highest hill at Balmoral and read Jung to me. [That made him] blissfully happy.'

The suit was acquired by Historic Royal Palaces from the designer in 2008 and is now in their Royal Ceremonial Dress Collection.

Above: The tweed wool suit by Bill Pashley that Diana wore on her honeymoon.

Opposite: Prince Charles kisses Princess Diana's hand during their honeymoon at Balmoral, Scotland.

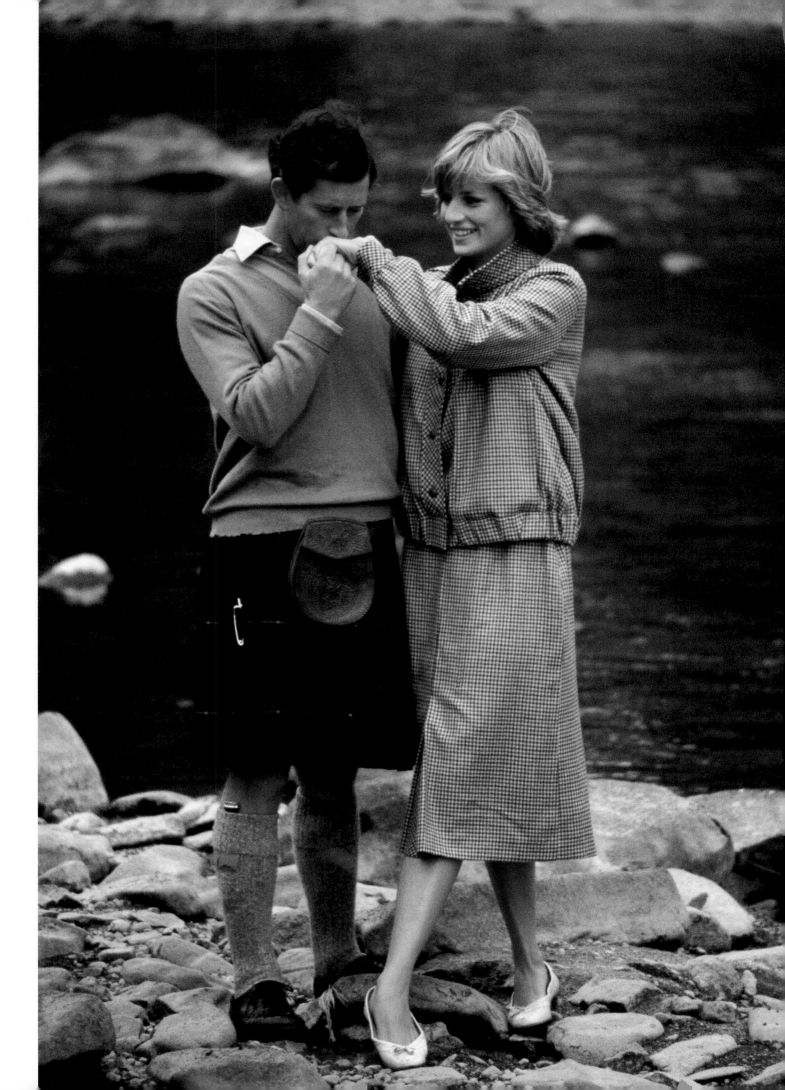

Jasper Conran

It was the hottest ticket of the year in the fashion calendar: designers, buyers and press descended on London's Lancaster House on 19 March 1985 for a reception hosted by the Princess of Wales, who turned up with Prince William; she was wearing a daring David Sassoon and Lorcan Mullany 'dressing gown' robe. Walking through the packed reception, the 23-year-old princess suddenly stopped, smiled and said: 'Why, Jasper, you've cut your hair.' It was a telling moment that highlighted the close relationship between Diana and the designer in question – Jasper Conran – who had been creating clothes for her since her engagement was announced four years earlier: she wore a white mohair jacket designed by Jasper when she returned from holidaying in the Bahamas with Prince Charles on 27 February 1982.

Conran went on to be named Designer of the Year by the British Fashion Council in 1986. He designed the wedding dress for The Queen's niece, Lady Sarah Armstrong-Jones, when she married artist and actor Daniel Chatto at St Stephen's Walbrook on 14 July 1994, and was named an OBE in 2008. 'Designing Sarah Chatto's wedding dress was one of my career highlights,' he said, after her death. 'Working with Princess Diana was quite heady, too. She used to arrive with a posse of press and police at her heels, the poor thing. Wherever she went there was noise. I liked her very much and enjoyed working with her a lot. She was tall and willowy and very pretty. It doesn't get better than that.' However, he was the soul of discretion: when the paparazzi found out Diana was at Jasper Conran's shop one day, he sent his team of girls out to flirt with the snappers to distract them as the Princess slipped out. 'She really laughed about that!' he recalled.

By that time, Conran was something of a design prodigy. The second son of the late retail magnate Sir Terence Conran and his wife Shirley, author of the best-seller *Lace* – though the couple divorced when Conran was a toddler – he dropped out of boarding school at the age of 15 after winning a scholarship to New York's prestigious Parsons School of Design, where he was the youngest student that they had ever had. He remained in the Big Apple for three years, launching his first collection for Henri Bendel in New York City and partying with Grace Jones, Andy Warhol and Truman Capote, but he returned to London after being held up one night in a lift by a man with a gun.

In 1979, at the age of 19, he set up his own womenswear label. *Vogue* featured his second collection in the magazine and he was soon selling his wares in Harvey Nichols, Selfridges and Harrods. It wasn't long before he attracted the attention of the Princess of Wales. 'She's so charming, nice and friendly,' he said at the time.

After Diana's death on 31 August 1997, he revealed that he believed she would have become a 'serious' documentary maker, had she lived. 'I know exactly what she was planning with her life,' he said in an interview with the *Daily Telegraph*. 'After the trip to Angola to support the banning of landmines she knew she could take serious issues and tackle them. She was learning how to present and how to speak in front of a camera – all aspects of journalism, in fact. And she would have been making films and documentaries, using them as a platform to support her campaigns. She intended to be a serious person and use her influence.'

Prince Charles and Princess Diana arrive at Heathrow Airport, London, after a holiday in the Bahamas on 27 February 1982. Diana wears a white mohair jacket by Jasper Conran.

The Red Suit

D esigned for the princess, Diana wore her bright red coat to stand out from the crowd for the official naming ceremony of the P&O cruise liner *Royal Princess*, christened in her honour, on 15 November 1984. She teamed the suit – with its single-breasted jacket, gilt buttons cast with anchors and matching skirt with four kick-pleats at the front – with a jaunty red beret. On 22 February the following year, she wore the same outfit to visit Cirencester Police Station in Gloucestershire, swapping the beret for a red felt boater and wearing a white shirt with a wing collar and a black bow tie.

The suit was bought on 17 June 2019 from Kerry Taylor Auctions for £62,500 by Historic Royal Palaces. It is now in their Royal Ceremonial Dress Collection.

Opposite: Diana aboard the new P&O Cruise Liner *Royal Princess*, named in her honour, on 15 November 1984.

Following pages: Diana arrives at the naming ceremony of the *Royal Princess*.

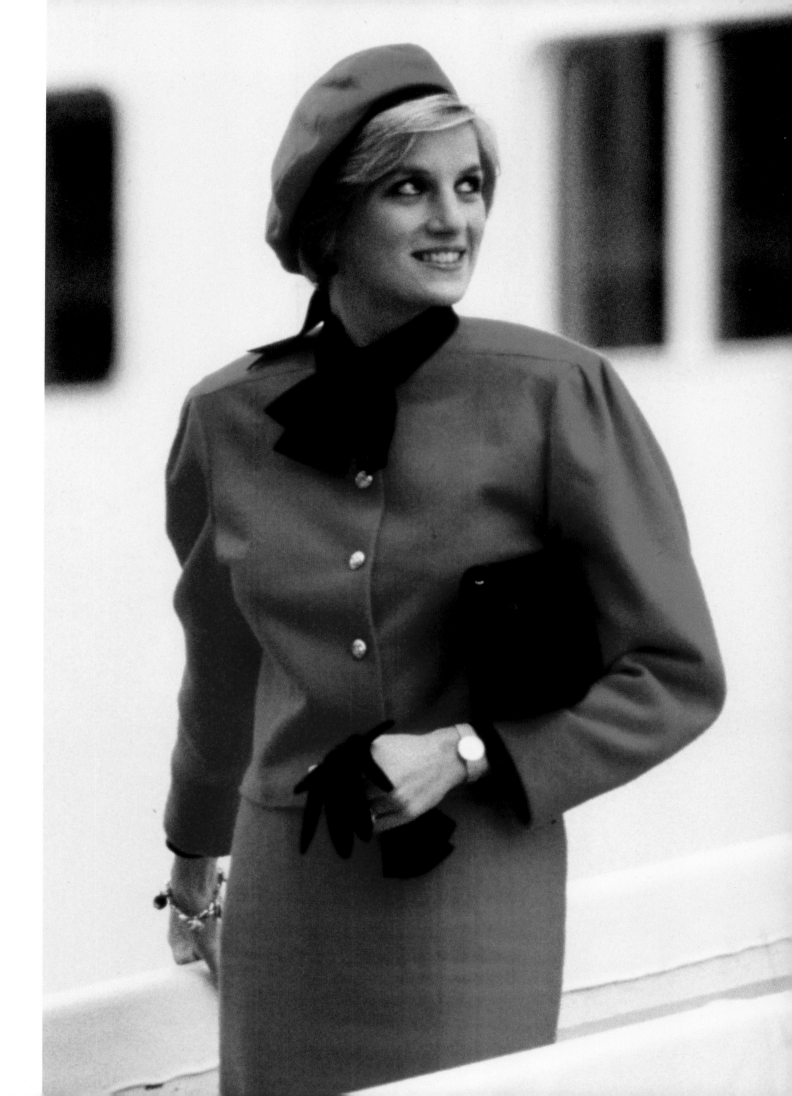

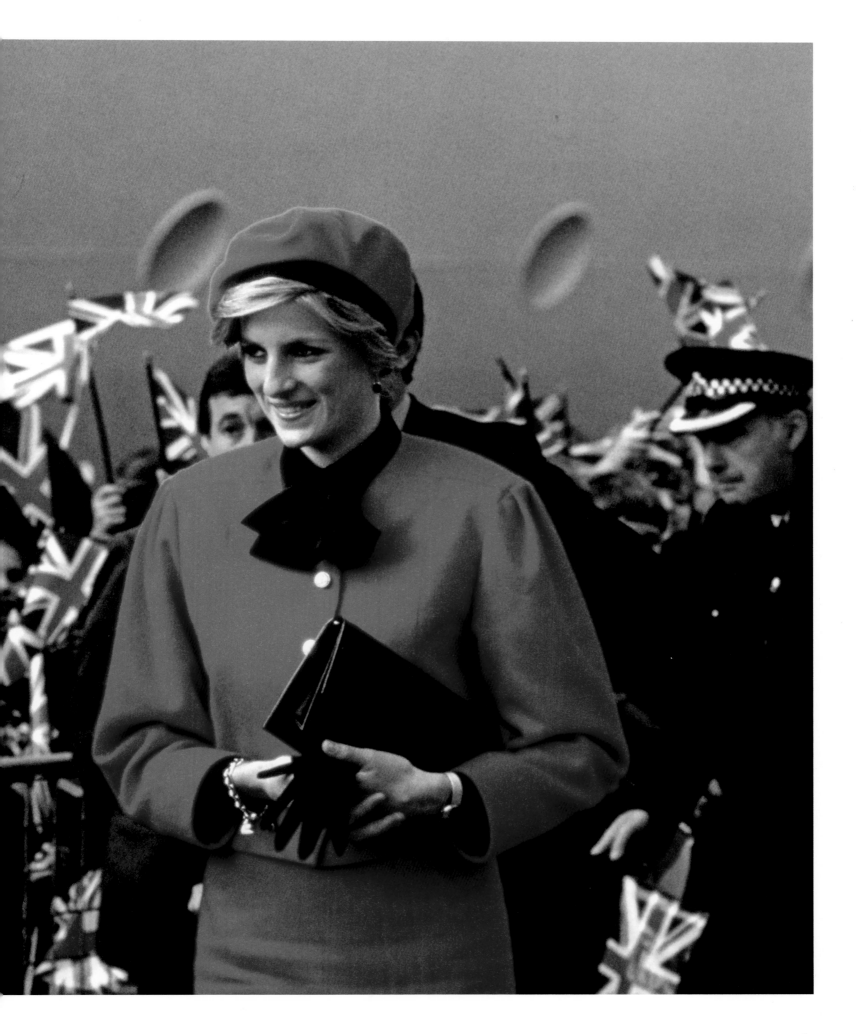

Caroline Charles

It is one of London's most iconic streets – and was a favourite of the Princess of Wales. Packed with restaurants – including San Lorenzo, a trattoria owned by her confidante Mara Berni – it was home to designers such as Caroline Charles and Bruce Oldfield, as well as Sweeney's, a fashionable hairdressing salon for models and popstars. So, when Diana went shopping with her mother Frances Shand Kydd after her engagement, it was only natural that they wandered down Beauchamp Place.

'In the spring of 1981, the beautiful Lady Diana Spencer and her mother came to visit us in our Beauchamp Place showrooms and chose clothes from the collection,' recalled Caroline in her book *Caroline Charles: 50 Years in Fashion*. 'It was a very happy meeting with lots of jokes and easy confidences and it was the first of many visits. Later on, as The Princess of Wales, she would bring her friend and lady-in-waiting Anne Beckwith-Smith on shopping outings, and the two of them would choose her clothes and giggle a lot!'

By the time Diana discovered Beauchamp Place, Caroline had been working in the industry for almost two decades. She started her design company in 1963, making samples in a Chelsea attic after working at Mary Quant's shop Bazaar, which was the place to go for Britain's youthquake. Discovered by the *Sunday Times*, who sent photographer Lord Snowdon, then married to Princess Margaret, to photograph her, she also designed suits for The Beatles' drummer Ringo Starr for his engagement to hairdresser Maureen Cox, his first wife and mother of his three children, and hosted a talk show on Pirate radio station Radio Caroline. It was a star-studded fashion house: Jean Shrimpton's sister Chrissie was one of their house models, and Caroline made her boyfriend Mick Jagger – then an aspiring popstar, yet to make his name in the Rolling Stones – a corduroy suit.

'It was a stroke of luck to be starting a small dress design company at this moment,' she wrote. 'London was humming and just about to break into song with its own small group of creative people: new playwrights, artists, photographers, film makers, designers, actors, dancers and, most attention-grabbing, new pop musicians. I managed to be part of a group of young London designers who were coming up behind Mary Quant.'

By 1970, Caroline had set up shop in Beauchamp Place and began a 'made-to-measure' and wholesale business. With a mirrored desk, the shop, which was painted in pale pink with a frieze of roses and lilies, was 'pretty precious'. By the time, Diana arrived a decade later, Caroline was firmly on the map, hiring supermodels such as Marie Helvin and actress Joanna Lumley to walk the catwalk in her fashion shows. She had even opened a second shop on Rodeo Drive, Beverly Hills, Los Angeles.

'With the Princess of Wales, it was a working uniform that she needed,' added Caroline. 'She was very professional and I loved that about her. I think the whole way through we have taken women with us, women and their daughters and granddaughters, because the clothes fill a need.'

The princess even – inadvertently – helped Caroline seal a business deal. 'The Caroline Charles wedding dress licensees from Kyoto came over for meetings and a proposal for another design project,' she explained, 'this time to make a dress collection for Burberry, who were keen to develop their womenswear business, particularly in Spain. The manufacturer was Gordon Morgan and we went out to discuss the plan in San Lorenzo. It just so happened that the Princess of Wales was lunching in a secluded corner of the same restaurant and waved to say hello…and like magic, the Burberry deal was done!'

The Braemar Dress

When Prince Charles and Princess Diana attended the Braemar Games in Scotland on 4 September 1982, with The Queen and the Duke of Edinburgh, Diana chose a Caroline Charles day dress with an ivory grosgrain collar and black braid outlining the yoke. The outfit made a nod to protocol, while modernising the trend for the royal family to wear tartan in Scotland.

'A particular tartan suit was made for her to wear to the Braemar Games in the summer after her wedding,' wrote Caroline. 'The suit had also been pictured in *Vogue* and so the press picked up on our name and we were known from then on as one of her designers.'

Afterwards, Sarah Ferguson's mother Susan Barrantes took the dress, which was unique to Diana, to a dress agency in Hampshire. It was later sold by Kerry Taylor Auctions on 12 December 2016 for £6,875 to Historic Royal Palaces, for their Royal Ceremonial Dress Collection.

'A particular tartan suit was made for her to wear to the Braemar Games in the summer after her wedding. The suit had also been pictured in *Vogue* and so the press picked up on our name and we were known from then on as one of her designers.'

Diana attends the Braemar Games in the Scottish highlands.

The Burgundy Dress

When Diana visited the Milan Asian Community Playgroup in London on 6 December 1982, she chose a Caroline Charles wool coat dress in a festive burgundy to meet the children. On 8 March the following year, she was snapped at Aberdeen Airport in the same dress, carrying eight-month-old William off the plane. British film producer Caroline Gibson, who had met the Princess at a British Red Cross function, bought the dress after she and her father, author Ted Harrison, produced a documentary in 2006 about the owners of Diana's dresses.

She later sold it through Julien's Auctions on 5 December 2014 for £103,702.50, to The Princess & The Platypus Foundation. It is now on display in the Princess Diana Museum, an interactive 3D museum. Owner Renae Plant, an Australia, who met Diana on her royal tour of Australia in 1982, said: 'My husband Livinio and I had saved some money and were about to invest it in a restaurant with a local business owner. But once I saw that the dresses were up for auction, Livinio and I agreed that owning 100% of a piece of history would be a better investment than owning 5% of a restaurant.

'The Caroline Charles dress was the first to go to auction. I gravitated to this dress as it was not a dress that had been auctioned at the 1997 Christie's auction – it was a little rare in that it came from a private collector. Not only that; this was the dress that Diana was photographed in carrying Prince William in 1982...the same year I met her in Australia! The bids kept going and going, but luckily the other bidder eventually stopped, and I heard "SOLD" to paddle 186. That was me! I fell on the ground as the auction house applauded. I was shaking.'

Opposite: Diana carries Prince William after arriving at Aberdeen Airport, Aberdeen, Scotland, on 8 March 1983.

Following pages, left: Initial sketch of the burgundy dress that Caroline Charles created for Princess Diana.

Following pages, right: The burgundy dress.

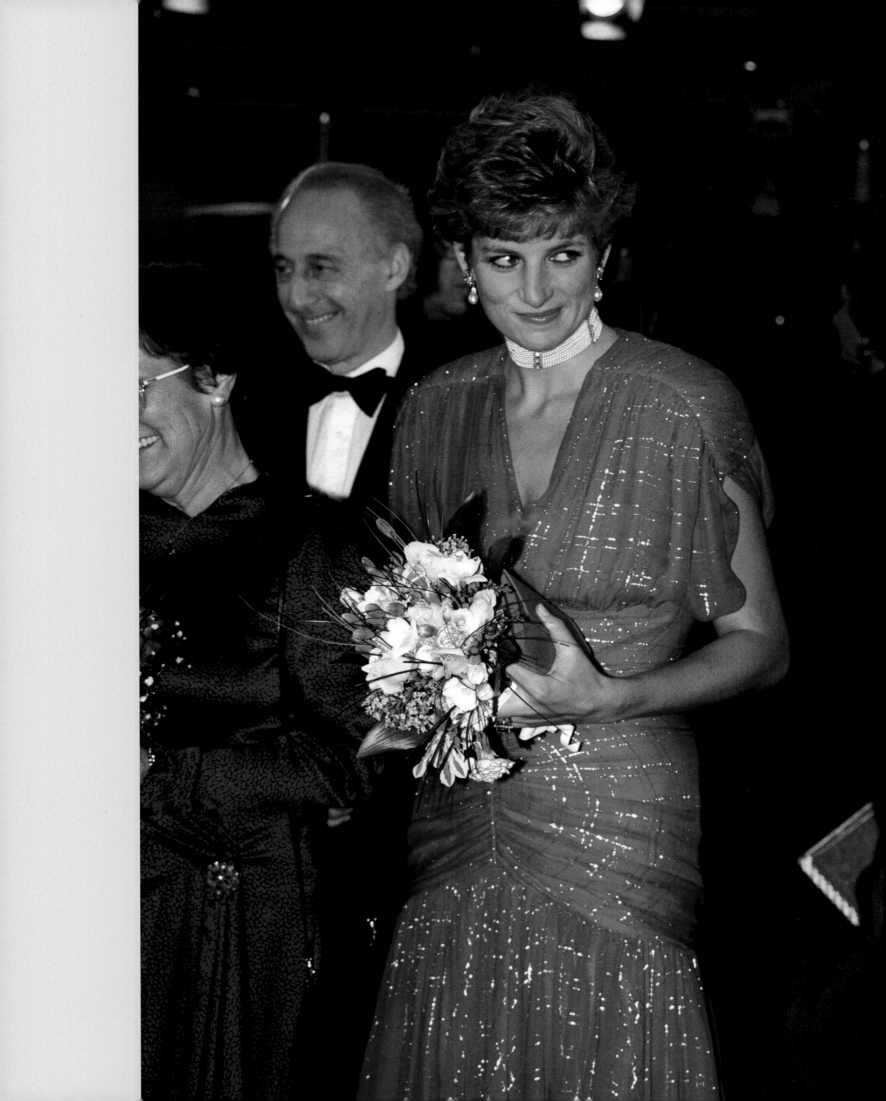

The next gown that Bruce created was the blue off-the-shoulder number she wore to the Birthright Fashion Show at London's Guildhall, on 30 November 1982. But it was the Barnardo's charity gala and fashion show that Bruce hosted on 26 March 1985, at London's Grosvenor House Hotel, that proved 'a red-letter day' for the designer. 'It marked the tenth anniversary of the opening of my business,' he wrote. 'The Princess of Wales was President of the charity and guest of honour, as well as being a friend and client of mine, and I was an ex-Barnardo's boy made good. My career and credibility rested on that evening. Months of planning had gone into it. At the end of the previous December, we had been told officially by the Palace that the Princess would attend. As a photo opportunity it suited everyone: an ex-Barnardo's boy – poor, Black, and illegitimate – sitting next to the future Queen.'

Diana arrived in a showstopping silver-blue lamé dress that Bruce had designed, and Bruce introduced her to a line-up of celebrity guests including Joan Collins, Charlotte Rampling, Shirley Bassey and Dame Edna Everage – all in Bruce Oldfield dresses. After dinner, there was a fashion show, followed by speeches – Dame Edna orchestra spotted the tombola – and then Bruce and Diana took to the dancefloor to Kid Creole and the Coconuts. 'The cameras popped and everyone was happy,' he added. 'Leading the Princess down to dinner was an especially proud moment. Being with the most idolised woman in the world made me feel pretty grand.

'As we walked down the steps, she whispered she had a present for me. When we got to the table, she opened her bag and gave me twenty Benson & Hedges. I hadn't brought mine since royal protocol prohibited smoking. Exactly what I needed to calm my tattered nerves. We always got on well and sat together chatting over dinner about quite private things. The atmosphere was fabulous. Every table was intimately lit with candles and decorated with simple displays of white tulips. After dinner, there came the fashion show followed by speeches. Mine was made with the Princess surreptitiously pinching my bum to make me keep it short so we could get to the dancing more quickly.'

The following day, Diana dropped into the shop to thank the workroom. 'Her readiness to give thanks where due was something I always liked about her and, of course, it made her very popular in the workroom,' he added. 'The letters that arrived over the following days were testament to the hard work that had gone into making the evening a truly memorable event.'

Bruce would regularly visit Kensington Palace to do fittings. 'The first time we went, we weren't sure about the form so decided to go to the tradesmen's entrance at the back,' recalled Bruce. 'We were met by kitchen staff who then informed the butler, an enormous man with a big booming voice. "Mr Oldfield," he intoned, "a man of your distinction and talent must never use the back door to this palace again." So, we never did.

We'd do the fittings in her sitting room, dumping everything on the three-seater sofa and putting up the long, portable mirror. The room was very light and comfortable, lit by the long windows behind her desk. To the side there was a smaller round table that held her collection of china.

'Our appointments always had to be held when she wasn't fetching the children from school. Then she'd give us an hour and a half – long enough for three fittings, a coffee and a chat. Once when I had left the room so the Princess could dress, I was sitting on a window seat in the drawing room when I heard the unmistakeable voice of Prince Charles in the corridor. I had to resist the urge to step behind the voluminous curtain and hide. Another time he interrupted one of the fittings, looking at his wife and asking me: "Have you seen the Stubbs exhibition at the Tate?" "No Sir". He disappeared for a few minutes, returning with the catalogue of the exhibition. Pointing at a duchess astride a horse, he wondered: "Do you think my wife would look good in something like that?" A full 17th century riding outfit? It wasn't quite what we had in mind. "I'll see what I can come up with Sir."'

Charles and Diana attended the Barnardo's Ball on 1 November 1988, when Marie Helvin and Jerry Hall strutted down the catwalk, and French and Saunders did the raffle. By this time, both the royal marriage and Diana's relationship with Bruce were drawing to a close. By 1990 Bruce had stopped getting calls. 'We had been making less and less for her as the 1980s drew to a close,' he wrote. 'Although she did continue to use British designers, she was also beginning to include some of the international line-up too. I imagine she wanted a change – quite understandable. It happens.' Even so, he was invited to her funeral. 'Like everyone in the world, I was terribly shaken by it,' he said, adding: 'It was an extraordinary occasion, though not enhanced for me by Elton's song or Earl Spencer's speech.'

The White Lace Gown

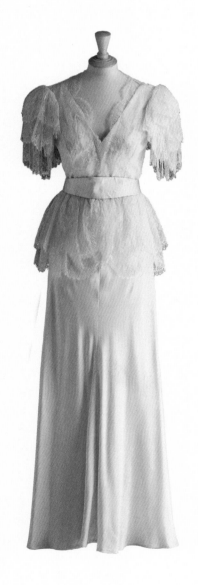

When Diana attended the Courtauld Institute of Art's gala evening at London's Somerset House on 5 July 1990, she wore an ivory satin evening dress inspired by the 1930s, with a matching lace jacket designed by Bruce Oldfield. She wore the dress, with its three lace frills and two deep flounces, again a year later for a state dinner at Buckingham Palace, given for President Mubarak of Egypt, who arrived in Britain for a four-day state visit on 23 July 1991.

It was bought for £17,985 by Wendy Morris-Rogers and her mother Loretta Olsen, who was a breast and lung cancer survivor, to raise money for charity. It is now in the Fundación Museo de la Moda.

Above: The Bruce Oldfield ivory satin gown.

Opposite: Diana at the Courtauld Institute of Art's gala evening at Somerset House on 5 July 1990.

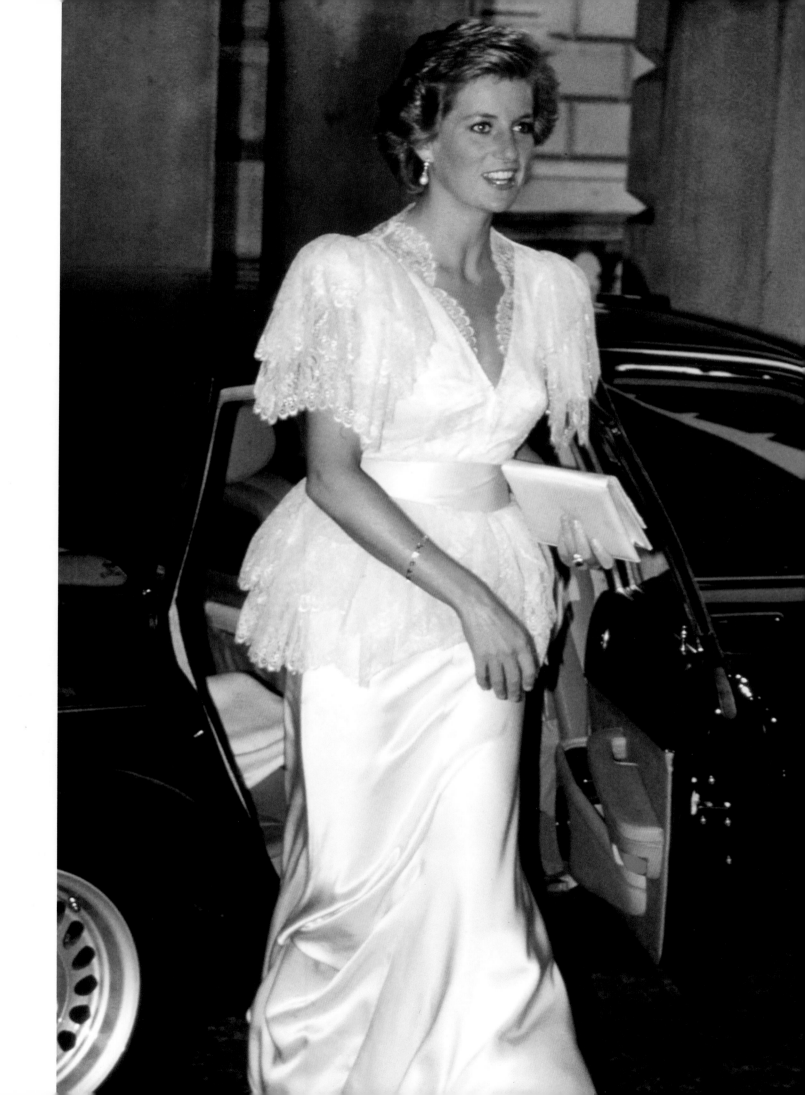

The Black Velvet Ballgown

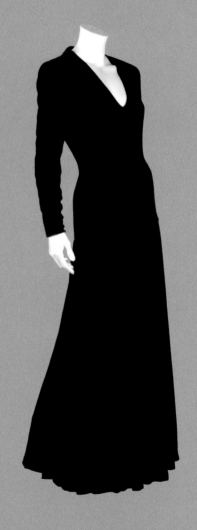

Despite royal protocol dictating that black was worn for mourning, it was a favourite colour of the Princess, and she often flouted convention. So, when she was posing in front of an Italian tapestry for Lord Snowdon, ahead of her 17-day royal tour to Italy, which began on 19 April 1985, she chose a black velvet dress with a plunging neckline and deep 'v' back. In order to ensure it was held in place, a band was placed at the neck of the dress, disguised with a black velvet rose. She later wore the dress for the first night gala opening of the stage show *Les Misérables* on 10 October 1985, at London's Palace Theatre.

The dress was bought by Boston businesswoman Barbara Jordan for £22,135 — one of three dresses she bought at Christie's on 25 June 1997. She later sold it to millionairess Maureen Rorech, from Tampa, Florida, who auctioned it on 19 March 2013 through Kerry Taylor Auctions. It was bought by Historic Royal Palaces for £52,500 and is now in their Royal Ceremonial Dress Collection.

Above: The Bruce Oldfield black velvet ballgown.

Opposite: Diana at the Barbican for a perfomance of *Les Misérables*.

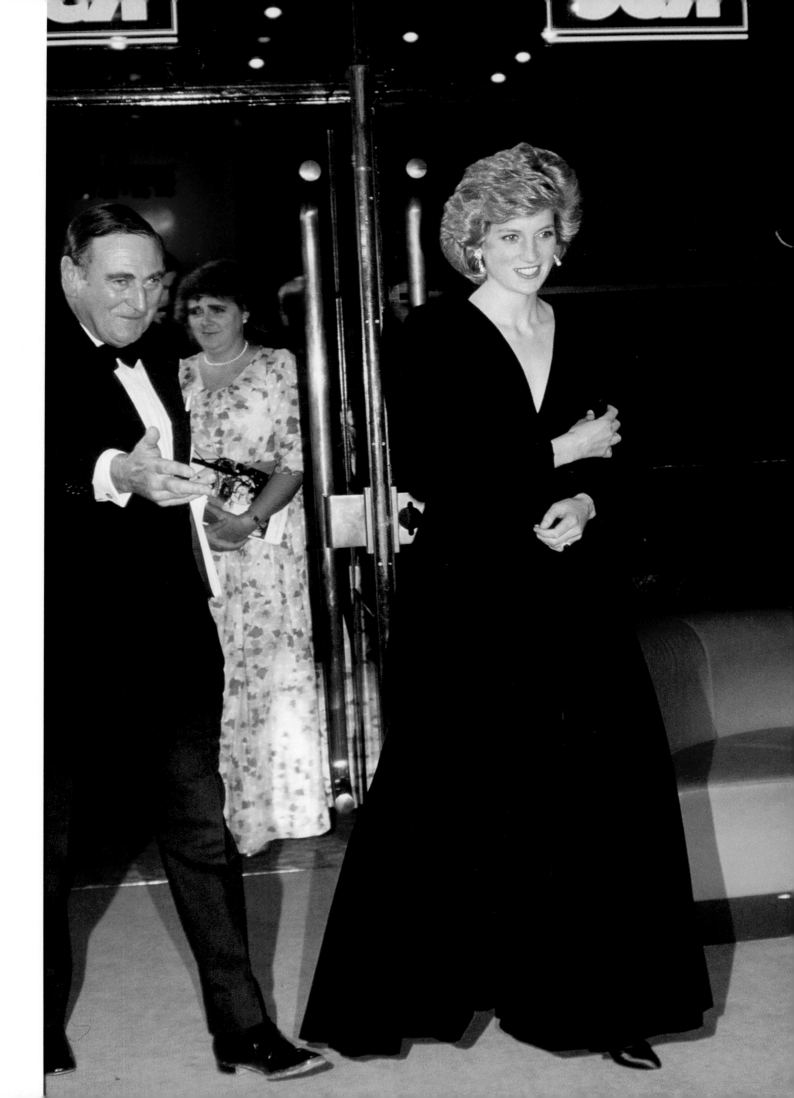

The Crushed Velvet Gown

When Diana was photographed by Terence Donovan in 1986, she chose a purple crushed velvet Bruce Oldfield dress with a cowl collar and train attached to the hip. She later teamed this ballgown with the Spencer tiara, which she had worn on her wedding day, wearing both together for a banquet hosted by Portuguese President Mario Soares at the Ajuda Palace in Lisbon, on 11 February 1987. She also wore this combination for the film première of *The Last Emperor* on 25 February 1988, to raise money for the Prince's Trust. The dress's last outing was at the second Barnardo's Ball, on 1 November 1988. When the Royal Mail released commemorative stamps after her death, they chose the Terence Donovan photograph for the 26 pence stamp.

The dress was bought from the 1997 Christie's auction for £15,910 by Donna Coffin, the wife of a Chicago computer consultant, who felt an affinity with Diana because they were married the same summer. Donna, who served as a hostess at the 1984 Los Angeles Olympics, also met Prince Philip when she escorted him to his seat. The dress has since changed hands twice and was finally sold to the Fundación Museo de la Moda for £56,250 by Kerry Taylor Auctions on 12 December 2016.

Opposite: Diana wears a velvet evening dress designed by Bruce Oldfield at the Grosvenor House Hotel on 1 November 1988.

Following pages: Diana and Bruce Oldfield at a gala dinner in aid of the charity Barnardo's.

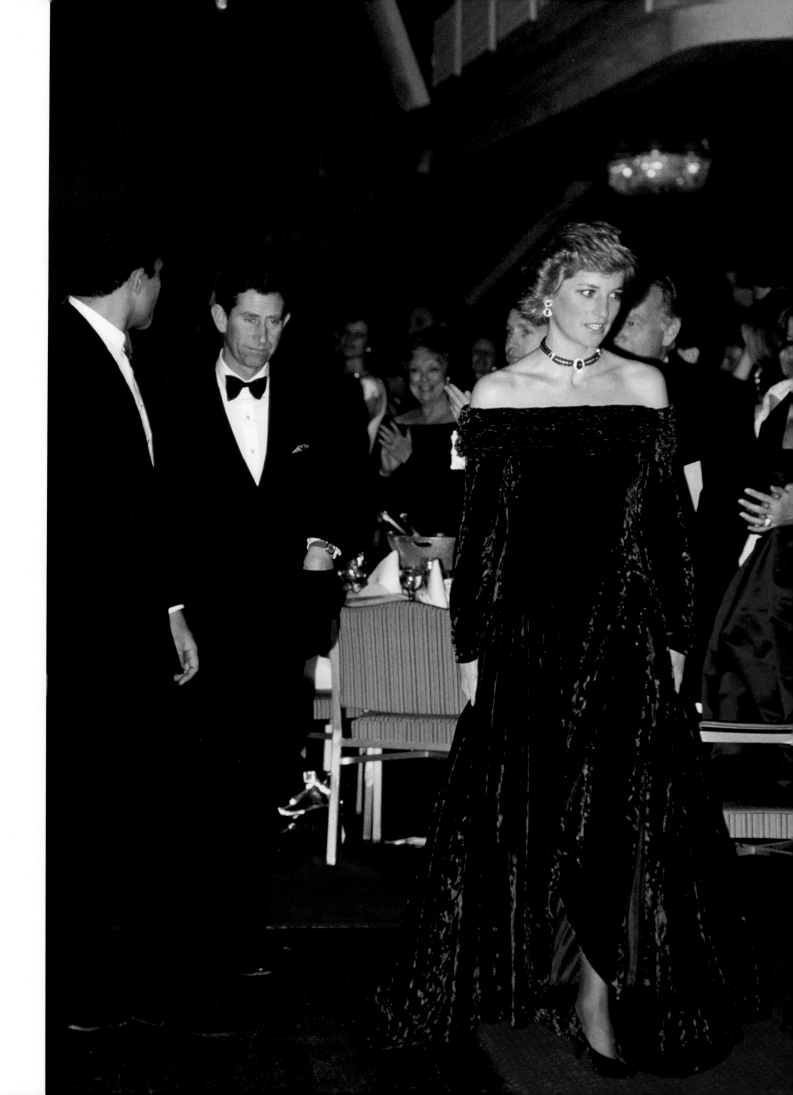

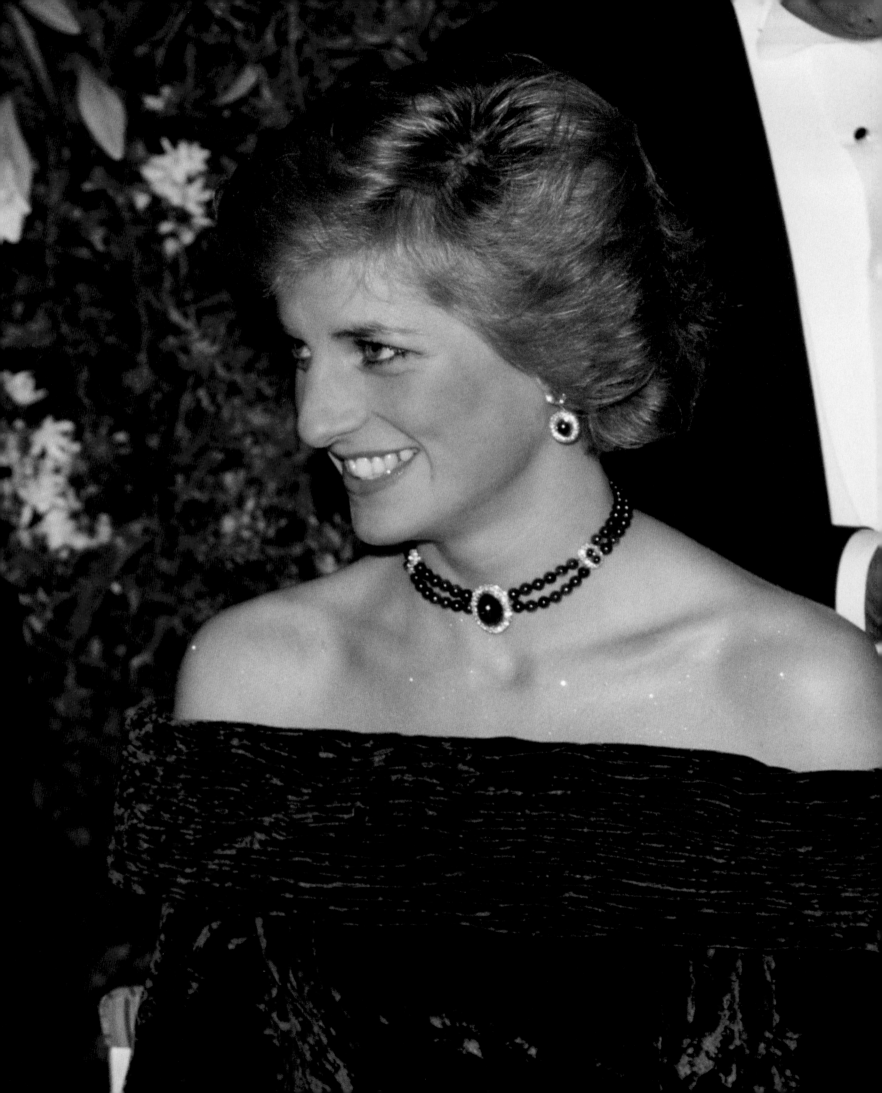

Catherine Walker

I t was an image which went around the world, catapulting its designer to global fame. After giving birth to Prince William on 21 June 1982, Princess Diana left St Mary's Hospital in Paddington wearing a green-and-white silk crepe de chine polka-dot smock dress, designed by the late French designer Catherine Walker. The previous November, Catherine had received a phone call from *Vogue*'s fashion editor Anna Harvey, asking her to make some maternity outfits for the Princess. It was the start of a relationship that would last 16 years.

Catherine made more than 1,000 pieces for Diana, including many of the outfits for her overseas tours and the oyster silk satin façonné shirtwaister Diana wore for her official portrait with William, released on her first wedding anniversary, 29 July 1982. 'I remember standing outside the shop in the rain after the first order had been delivered thinking: "I wonder where this is going to lead,"' she wrote in her book *Catherine Walker: An Autobiography by the Private Couturier to Diana, Princess of Wales*. 'My career had only just begun and I was very aware of how little I knew about couture.'

Catherine's route to royal couturier was unconventional. Widowed at the age of 30, and alone in a foreign country with two young daughters, Naomi and Marianne, after her first husband, English solicitor John Walker, was killed in a tragic accident, she bought a sewing machine after winning a bet to give up smoking and began making clothes. Although she had no formal training — she graduated with a doctorate in philosophy from Lille University — she took design classes at night school at the Chelsea Art School, where she met her second husband, Said Cyrus, who was her lecturer.

The couple opened the Chelsea Design Company in 1976, in a townhouse on Chelsea's Sydney Street, initially selling children's clothes before branching out into maternity wear, including smocks for the Princess. However, in February 1982, her career took a new direction when Diana popped into the shop. 'I recall our first meeting,' she wrote. 'It was a wintry February morning at Sydney Street. Anne Beckwith-Smith, the Princess's lady-in-waiting, had telephoned me to ask if it would be convenient for the Princess to pay us a visit within the hour. A few minutes later, before we had time to become nervous, she walked in wearing one of my designs in pistachio green wool. The visit, on the face of it, was to thank me for the care I had taken in making her maternity dresses. But when she arrived, I immediately sensed that it was in fact to take a discreet look at me and where I worked.'

That autumn, Catherine received a call from Diana's lady-in-waiting asking her to design some coats for Diana. The red coat that Diana wore on 9 December 1983, when she visited the Charlie Chaplin adventure playground for disabled children in Kennington, south-east London, was Catherine's first tailored piece. 'I didn't know it at the time but this was the beginning of a long love affair between me and tailoring and, of course, a long professional relationship and friendship with the Princess of Wales,' she added.

Gradually, the relationship between the designer and the Princess grew as Diana popped into the Chelsea Design Studio every few weeks. After a year, Catherine went to Kensington Palace to fit her and show her drawings and pieces from her collections. 'She was the easiest and most trusting of clients, and we had tremendous fun. Sometimes she would sit on the carpet correcting drawings, and I remember her delight if she loved something – she would make a noise a little like you make if you are enjoying chocolate! Over time, the "Yes please", became "It's different", and later on, when her understanding of clothes became more European, "It's smart". Later still, when she started dressing more sexily, it was: "Eat your heart out, Brazil".'

Catherine's client list read like a Who's Who of the royal family as well as the rich and famous: the Countess of Wessex, the Countess of Snowdon, the Duchess of Kent, the Duchess of Westminster, Lady Helen Taylor, Queen Noor of Jordan, Shakira Caine, Darcey Bussell, Joely Richardson, Shirley Bassey and Selina Scott were all customers, reassured by the fact that Catherine was notoriously discreet – when interviewed for the first time by a journalist she turned the framed photographs of her famous clients to the wall and she is one of the few – if only – designers to hire a public relations firm to prevent publicity. 'When Diana attended a film première in a white lace dress I had designed for her, I was puzzled to see Anne Diamond reveal on her programme the next day that I had made it,' she said. 'I told Diana I had no idea where the information had been leaked. Diana said: "I told her and I told her to make sure she said it was a Catherine Walker dress."'

However, in 1995, at the age of 49, Catherine was diagnosed with breast cancer and decided to cut back on her hours. She went to Kensington Palace planning to tell Diana that she couldn't go on designing for her but couldn't go through with it. The last conversation she had with Diana was five days before she died. Her butler Paul Burrell rang requesting a dress for Diana to be buried in. 'While it was undoubtedly the saddest and most difficult commission of my life,' she added, 'just being asked to do it made me feel relieved and immensely grateful. Paul's reaction to my dress was: "She will be covered in love."'

'Diana, Princess of Wales, was a very real woman in a unique situation,' Catherine went on to write in the foreword to her autobiography. 'There was no precedent that she could look to for guidance. She had family and friends who loved her dearly, but ultimately nobody could tell her what to do or how to do it. She was lonely at times, but she turned her fears and vulnerability into beauty and love and made so many people happy. She had the guts to remain true to herself – she walked tall with true spirit and style. I am immensely proud to have worked with her for all those years but mainly I feel very privileged to have known her as a real person. It is the idiosyncrasies of our friends that make them thankfully less perfect but so much more lovable, and she was very lovable.'

The New Zealand Ensemble

Rubbing noses with local dignitaries in the traditional Māori greeting, Diana wore a Catherine Walker slubbed turquoise ensemble on 22 April 1983. This was during her first tour of Australia and New Zealand, when she visited the Te Poho-o-Rawiri Marae Meeting House, in Gisborne, on the North Island.

The dress and matching jacket was later handed into a designer dress agency in Hampshire by Sarah Ferguson's mother, Susan Barrantes, and was sold to Historic Royal Palaces on 12 December 2016 by Kerry Taylor Auctions for £5,250. It is now in their Royal Ceremonial Dress Collection.

Opposite: Diana visits Te Poho-o-Rawiri Marae on 24 April 1983 in Gisborne, New Zealand.

Following pages: Diana does the traditional hongi with a Māori woman in Wellington, New Zealand on 22 April 1983.

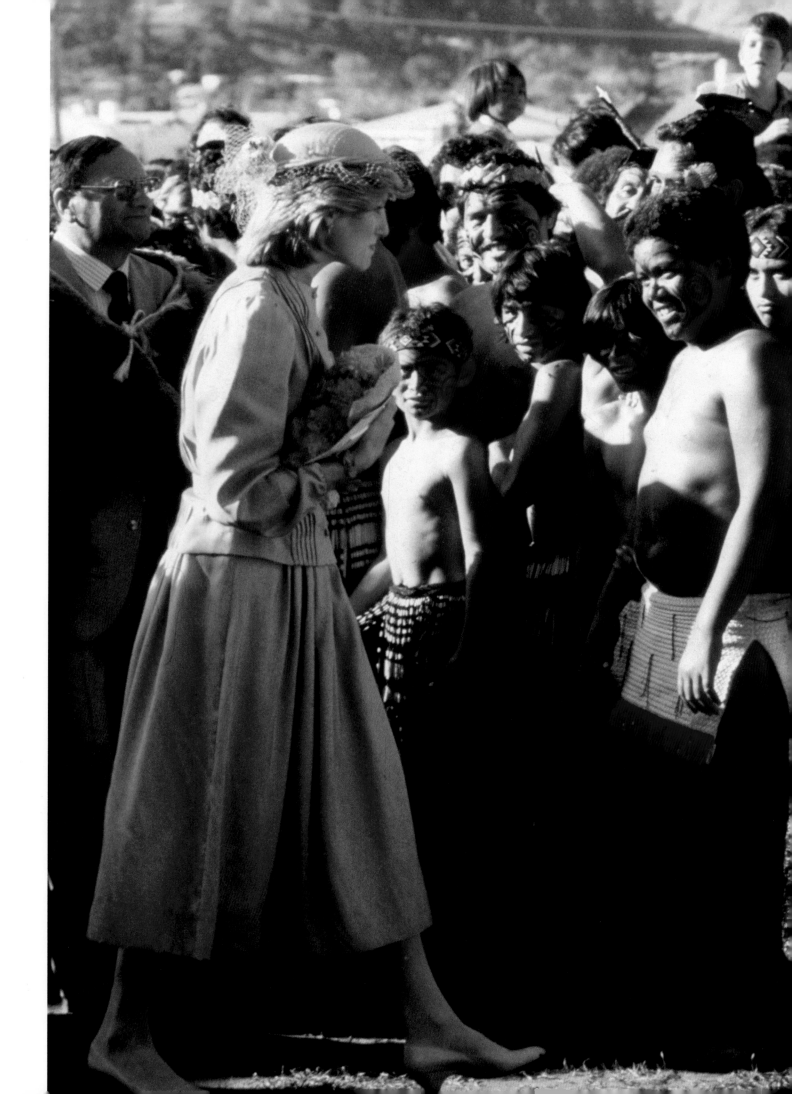

The Back to the Future Gown

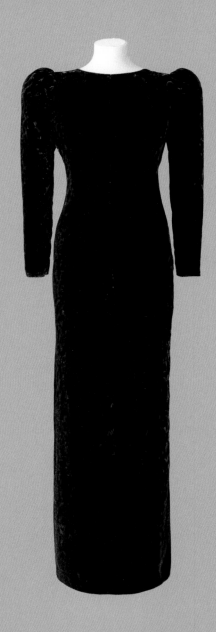

Diana's Catherine Walker burgundy crushed velvet gown, with its low-cut back and large shot-silk taffeta bow, had two outings. The first was on 7 November 1985, when she teamed it with the Spencer tiara for a state dinner at Government House in Canberra, Australia. On 3 December that same year, she accessorised it with a string of pearls knotted at the back for the movie première of *Back to the Future* – though she would afterwards complain that the necklace dug into her back during the film.

Bought by Maureen Rorech at the Christie's Auction on 25 June 1997 – she paid £15,910 – it was sold by Kerry Taylor Auctions on 19 March 2013 for £112,500 and is now in the Fundación Museo de la Moda.

Above: The burgundy crushed velvet gown by Catherine Walker.

Opposite: Diana attends the film première of *Back to the Future*, 3 December 1985.

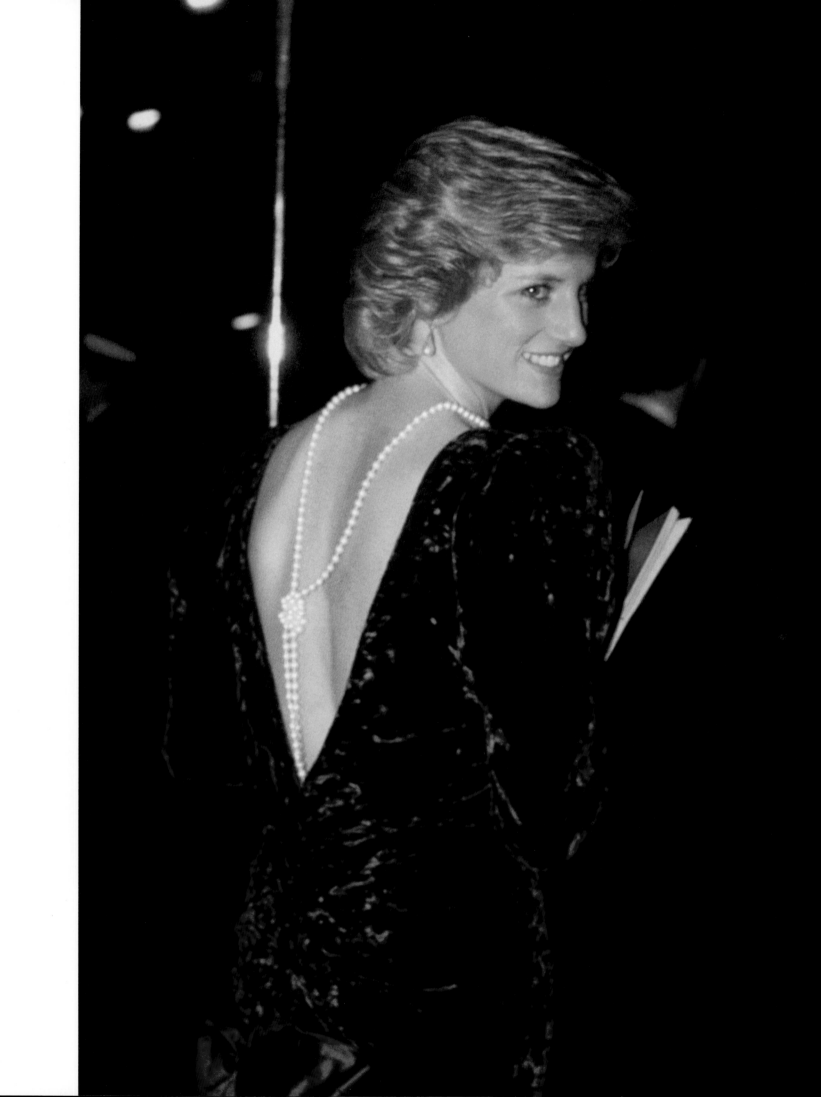

The Mermaid Dress

ooking as if she had stepped out of TV hit *Dynasty* in a sea-green, sequinned, figure-hugging dress by Catherine Walker, Diana sparkled at a gala performance of Congreve's restoration comedy *Love for Love*. She saw this performance at the Vienna Burgh Theatre on 14 April 1986, when she visited Austria with Prince Charles. She teamed the dress with a diamond and emerald choker given to her by The Queen Mother.

By this stage, Diana was so confident that Catherine knew what she wanted that she didn't even ask to see a sketch. She later outshone the stars of *Biggles* during its royal charity première at the Plaza Cinema, in London's Lower Regent Street, on 23 May 1986. A firm favourite, she also wore the gown, embroidered by Jakob Schlaepfer, on 17 May 1989 for a charity ball in aid of the British Paraplegic Sports Society at London's Osterley Park House, and for the Diamond Charity Ball at London's Royal Lancaster Hotel on 4 December 1990.

Another dress purchased by Maureen Rorech at the 1997 Christie's Auction – this for £14,526 – it was sold by Kerry Taylor Auctions on 14 June 2016 for £100,000 to Historic Royal Palaces. The garment now resides in their Royal Ceremonial Dress Collection.

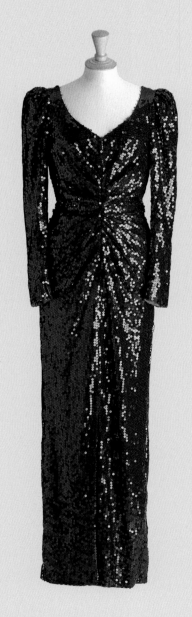

Above: The sea-green sequinned dress by Catherine Walker.

Opposite: Diana attends the Diamond Charity Ball at the Royal Lancaster Hotel, London, on 4 December 1990.

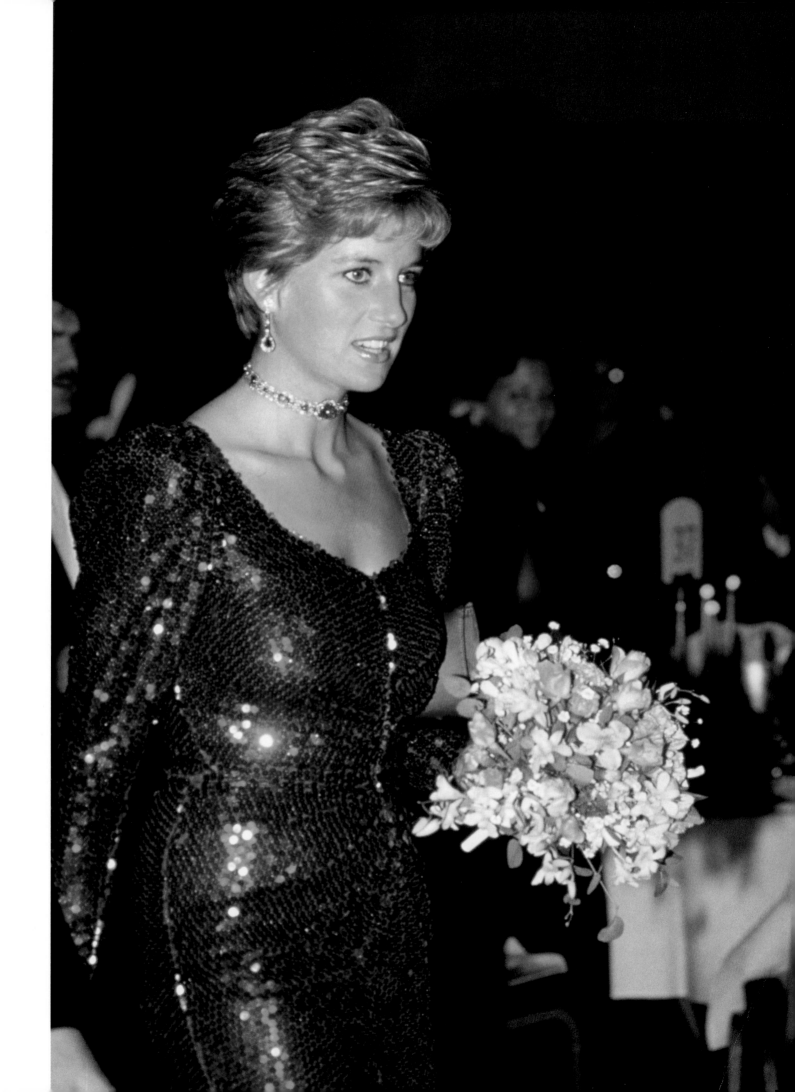

The Grace Kelly Gown

When Diana wore her Catherine Walker pale blue silk chiffon strapless gown and matching stole to the Cannes Film Festival on 15 May 1987, she sparked comparisons to movie star Grace Kelly, the star of Alfred Hitchcock's 1955 classic *To Catch A Thief*, who went on to become Princess Grace of Monaco. Diana and Prince Charles were attending a gala in honour of the actor Sir Alec Guinness, but Diana was secretly dating James Hewitt at the time, a dashing former cavalry officer in the British Army.

Diana loved the dress and went on to wear it for the Leicester Square film première of *Superman IV: Quest for Peace* on 23 July 1987, and a Royal Gala Performance of *Miss Saigon* at the Theatre Royal Drury Lane on 19 September 1989. She also chose it for a 1987 shoot with the late photographer Terence Donovan – the image is on the wall of the National Portrait Gallery.

However, Diana fans were appalled when an American cable TV station, WE tv, bought the Grace Kelly gown at Christie's for £42,526, along with two other dresses, and took it on a 'Dresses to Die For' shopping centre tour. After Diana's death they stopped the tour, before sending out the dresses under a new title, 'Legacy of Love'. The Grace Kelly Gown was finally sold on 8 May 2011, by Julien's Auctions in Beverly Hills, California, for £114,072.75, to the Fundación Museo de la Moda in Santiago, Chile.

Above: The pale blue silk chiffon gown by Catherine Walker.

Opposite: Prince Charles and Princess Diana at the Cannes Film Festival in May 1987.

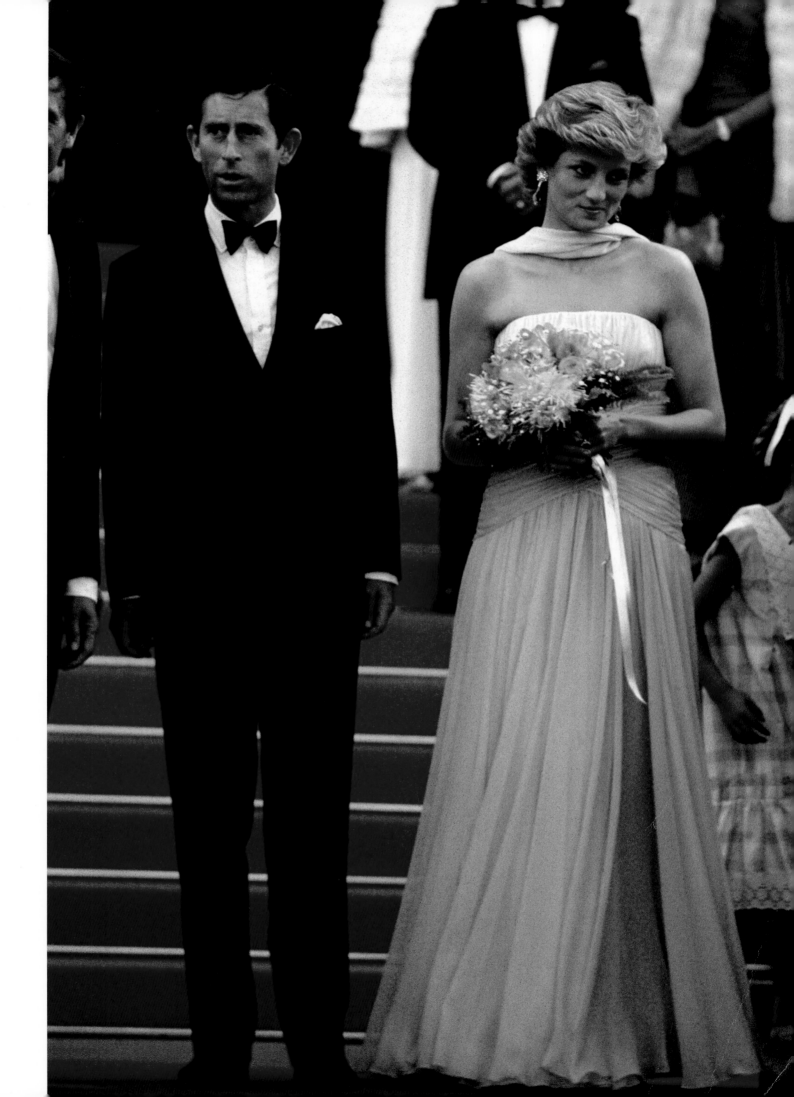

The Stately Gown

Designed by Catherine Walker for an official portrait of the Prince and Princess of Wales in 1987, Diana, now a mother-of-two, wanted a dress that would hold its own next to Charles' ceremonial uniform. So, Catherine created a stately off-the-shoulder evening gown in a rose-pink satin with raw silk on the collar and cuffs. A favourite of the Princess, Diana wore this gown on at least three occasions before she separated from Prince Charles: for a Gala Performance of the Royal Ballet on 1 November 1987, at the Berlin Opera House; for the charity première of *Who Framed Roger Rabbit* in aid of the British Lung Foundation, of which she was patron, on 21 November 1988; and for a formal banquet given by Indian President Sri Ramaswamy Venkataraman on 5 April 1990, during his state visit to Britain.

The dress was bought for £17,293 at the 1997 Christie's Auction by Melissa Downey Scripps, who lived in the British Virgin Islands. It was acquired by Historic Royal Palaces in 2018 for their Royal Ceremonial Dress Collection.

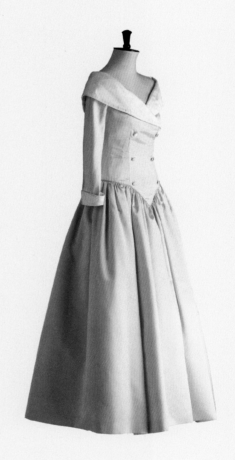

Above: A picture of the dress Catherine Walker designed for an official portrait of Diana, from the Christie's sales catalogue.

Opposite: Diana attends the charity première of *Who Framed Roger Rabbit?* in London, on 21 November 1988.

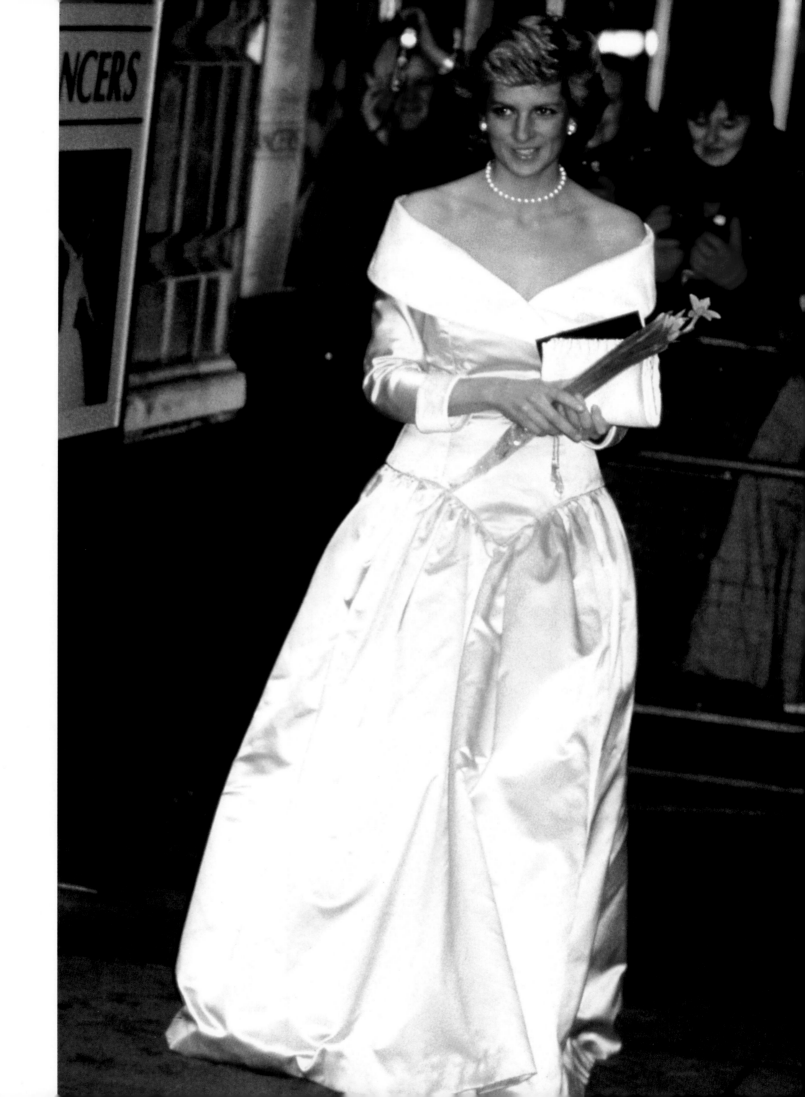

The Bangkok Ballgown

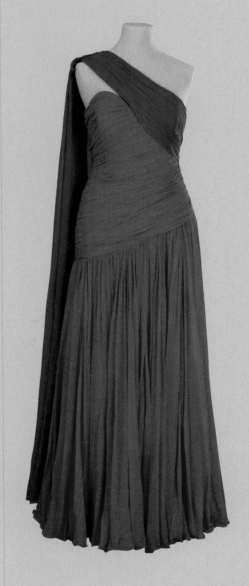

Wearing orchids entwined in her hair as a nod to her host country, and a fuchsia and purple Catherine Walker gown, Diana and Charles were guests at a banquet hosted for them on 4 February 1988 by Thailand's Crown Prince Vajiralongkorn and Princess Sirindhorn. It was the couple's first visit to the country and Diana's sari-style gown with its purple sash, forming a single shoulder strap that descends into a trailing stole at the back, was perfect for the occasion.

The silk chiffon dress was sold by Christie's on 25 June 1997 for £29,053, to the *Daily Mirror*'s late royal correspondent James Whittaker. 'I became the world's luckiest bidder last night when I secured a glamorous Princess Diana gown in the glittering New York auction, billed as the Sale of the Century,' he wrote at the time. 'After hours of nail-biting suspense, I successfully outbid the rich and famous to pledge £29,053 for Lot Number Five – one of Di's favourite dresses.' James took it back to the newspaper's London office, who gave it away in a competition. The winner sold it at Kerry Taylor Auctions on 10 July 2007 for £63,750, and it is now in the Fundación Museo de la Moda.

Above: The fuchsia and purple chiffon Catherine Walker gown.

Opposite: Diana attends a dinner in Bangkok, Thailand, on 4 February 1988.

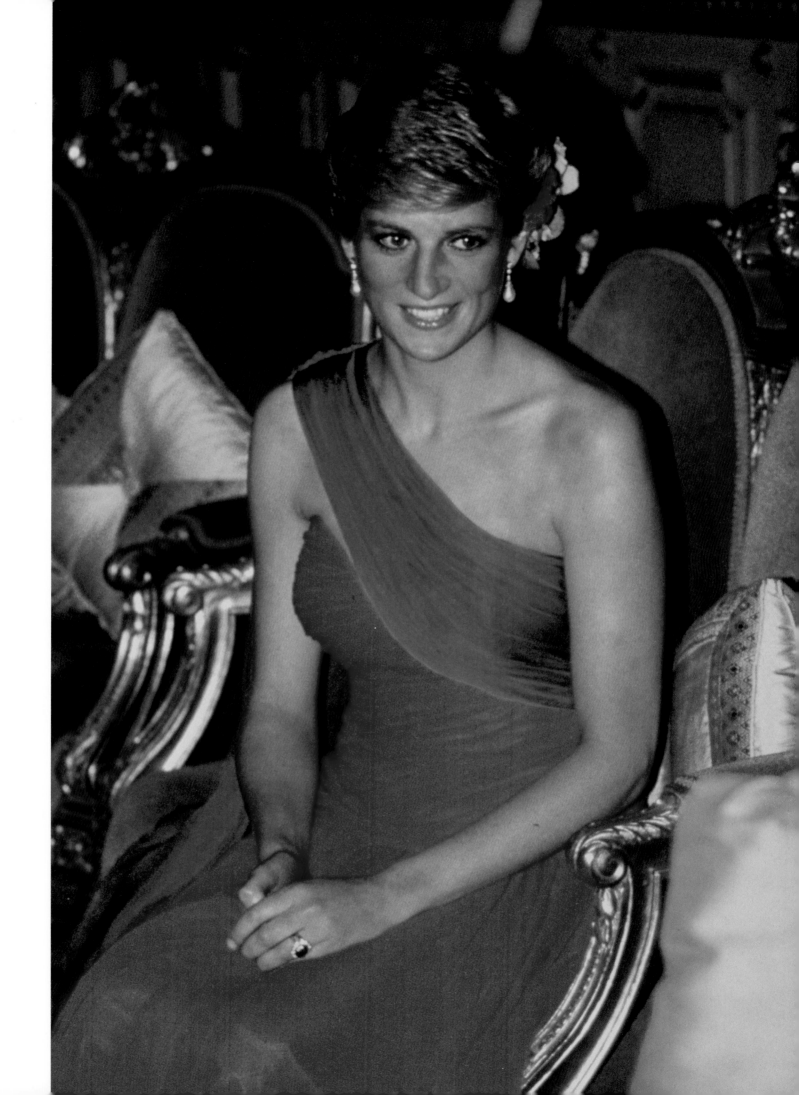

The Peach Polka Dot Dress

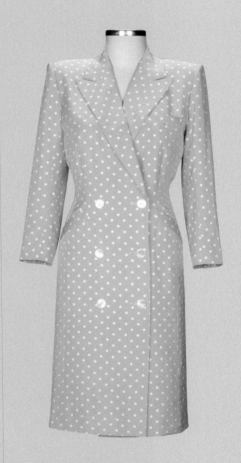

Diana first wore her Catherine Walker peach silk coat dress for the Order of the Garter ceremony with Prince Charles on 13 June 1988, accessorising it with a matching hat and pearls. She later wore it on 12 July 1988, to welcome President Kenan Evren of Turkey on a State Visit with Prince Charles, this time with a double-strand pearl choker. A year later, on 12 July 1989, on a visit to The Freeman Hospital and the Percy Hedley School in Newcastle, she paired it with a white clutch and court shoes. Then on 15 May 1991, she wore the dress with matching shoes for an event at London's Langham Hilton Hotel in aid of the International Spinal Research charity.

The dress reached £75,000 at Kerry Taylor Auctions and is now owned by The Princess & The Platypus Foundation. It is on display in the Princess Diana Museum, an interactive 3D museum.

Above: The peach silk coat dress by Catherine Walker.

Opposite: Prince Charles and Princess Diana at Victoria Station in London, awaiting the arrival of Kenan Evran, the President of Turkey, on a state visit to the UK, 12 July 1988.

Following pages: Close-up detail of the coat dress.

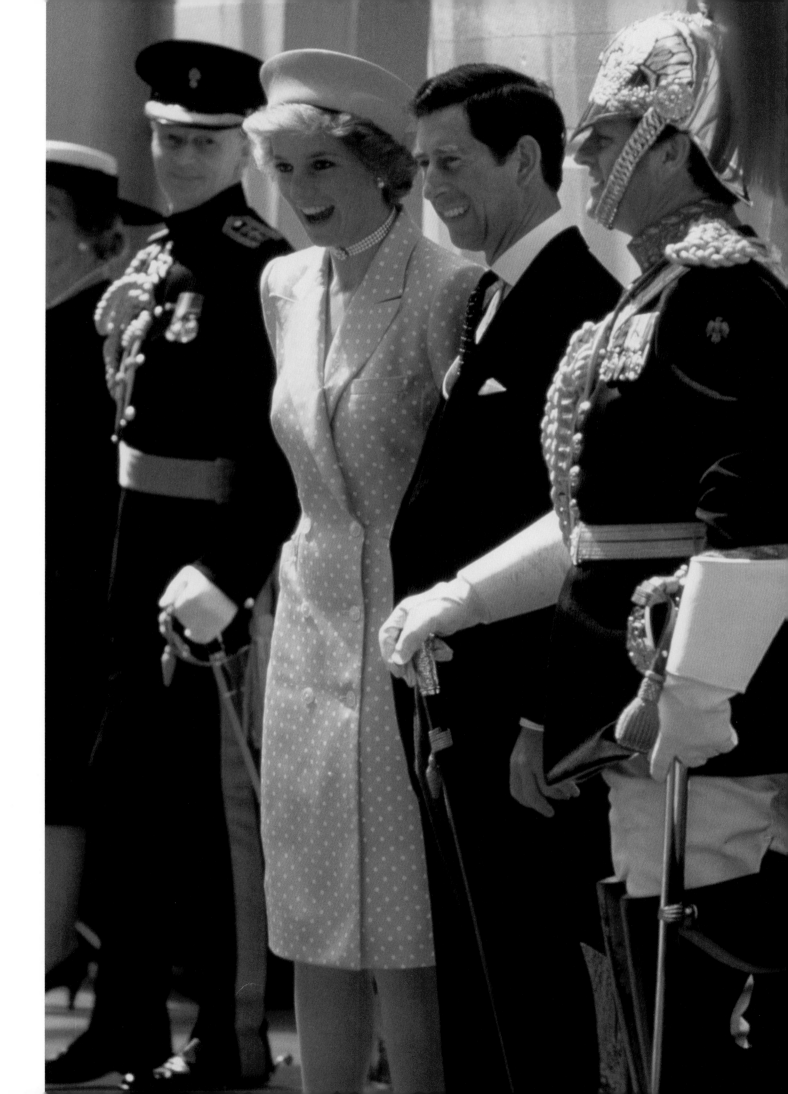

The French Gown

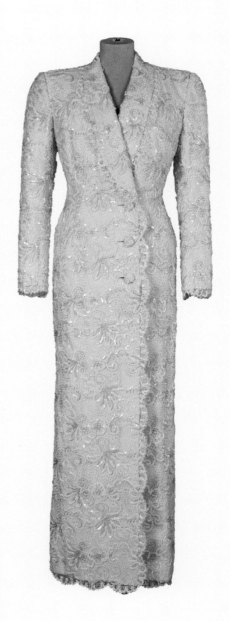

Princess Diana knew that all eyes would be upon her when she visited the fashion capital of the world and met Princess Caroline of Monaco. So, she wore a full-length Catherine Walker coat dress, in white Riechers Marescot lace, for the banquet hosted by the French Culture Minister Jacques Lang at the Château de Chambord on 9 November 1988. The silk shantung dress was embroidered with pale blue flowers and decorated with white sequins.

'I chose white lace for this commission because it was a textile common at the court of Versailles,' Catherine wrote, 'but I tailored it into a modern shape. Given the Princess's sense of panache I really do not know anyone else who could carry off this long sheath of glittering icy embroidery in quite the way she did. This reception was also attended by HRH Princess Caroline of Monaco, and there was tremendous press interest in what the Princesses would wear on this occasion. HRH Princess Caroline of Monaco was dressed by the House of Dior.' Diana later wore this gown for a visit to London's Royal Opera House in Covent Garden on 7 June 1989, for a Royal Gala Performance of *Il Trovatore* starring Plácido Domingo as the Count's rival, Manrico.

The dress was sold for £16,602 at Christie's in 1997 to Barbara O'Neill, from Rome, Georgia. The Fundación Museo de la Moda bought the dress from Kerry Taylor Auctions for £37,500, on 17 March 2011.

Above: The Catherine Walker coat dress in white Riechers Marescot lace.

Opposite: Diana attends a dinner at the Château de Chambord, France, on 9 November 1988.

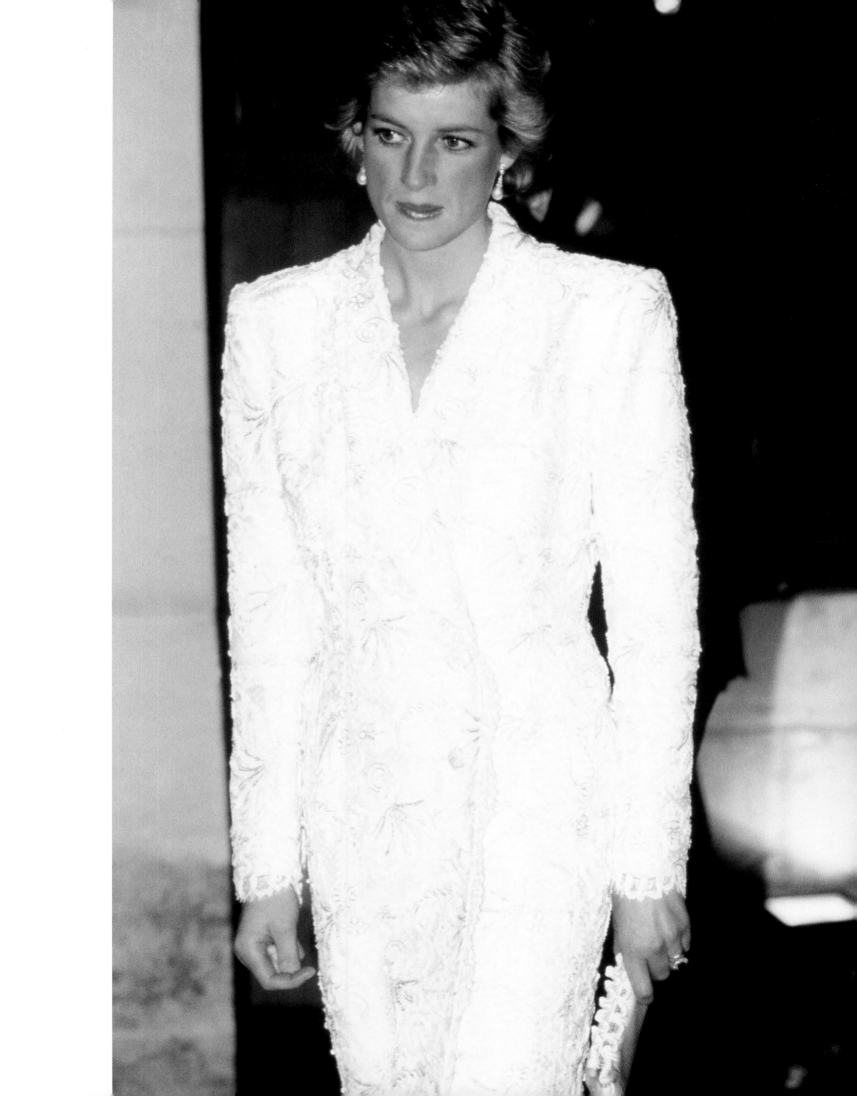

The Tulip Gown

As guest of honour at a banquet hosted by President Ibrahim Babangida and First Lady Maryam in Lagos, Nigeria, on 15 March 1990, Diana chose to reflect the colours of the national flag in a white silk chiffon halter-neck gown, printed with purple tulips and green leaves.

The dress, with its low back, folded bodice and long streamer down the back, was bought for £15,218 at the 1997 Christie's auction by Veronica Hearst, the widow of high-flying media scion Randolph Hearst. A friend of the Princess, Hearst later donated the dress to the Metropolitan Museum of Art In New York.

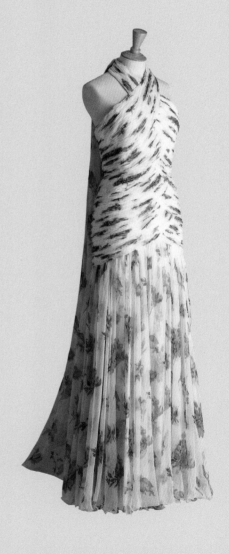

Above: The printed white silk chiffon gown.

Opposite: Princess Diana with Maryam Babangida, wife of Nigerian President General Ibrahim Badamasi Babangida.

Following pages: Diana attends a state banquet during her official visit to Nigeria on 15 March 1990.

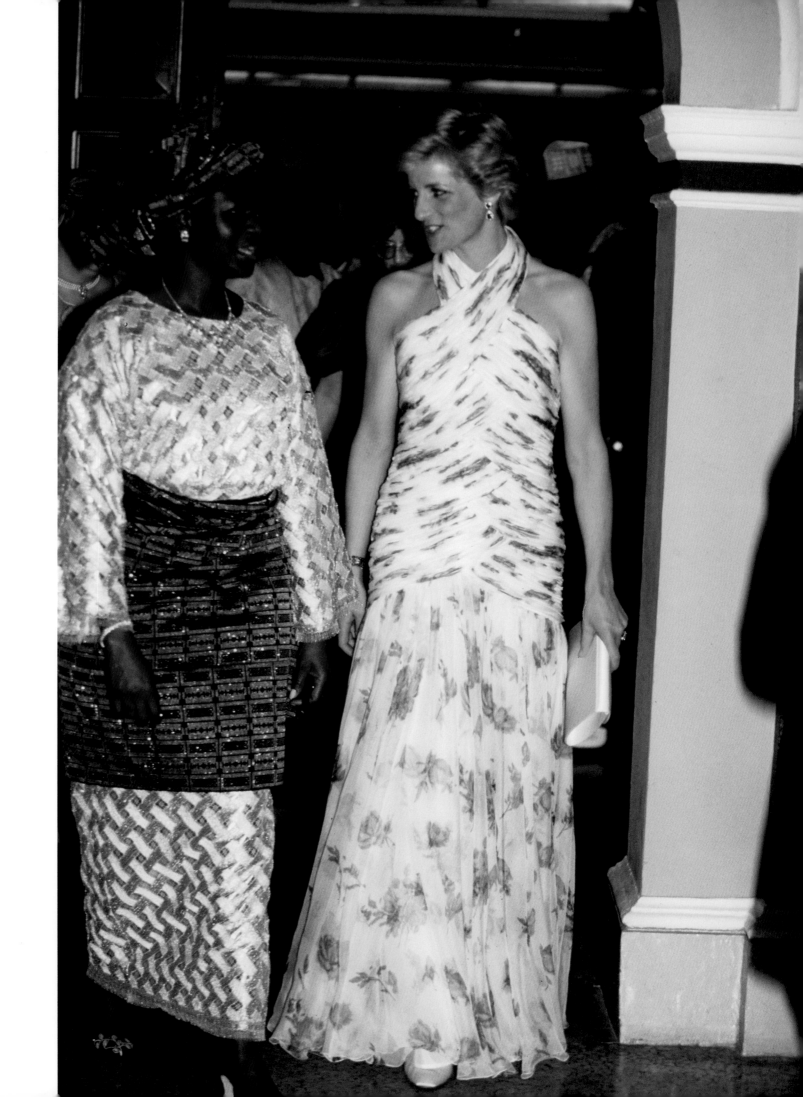

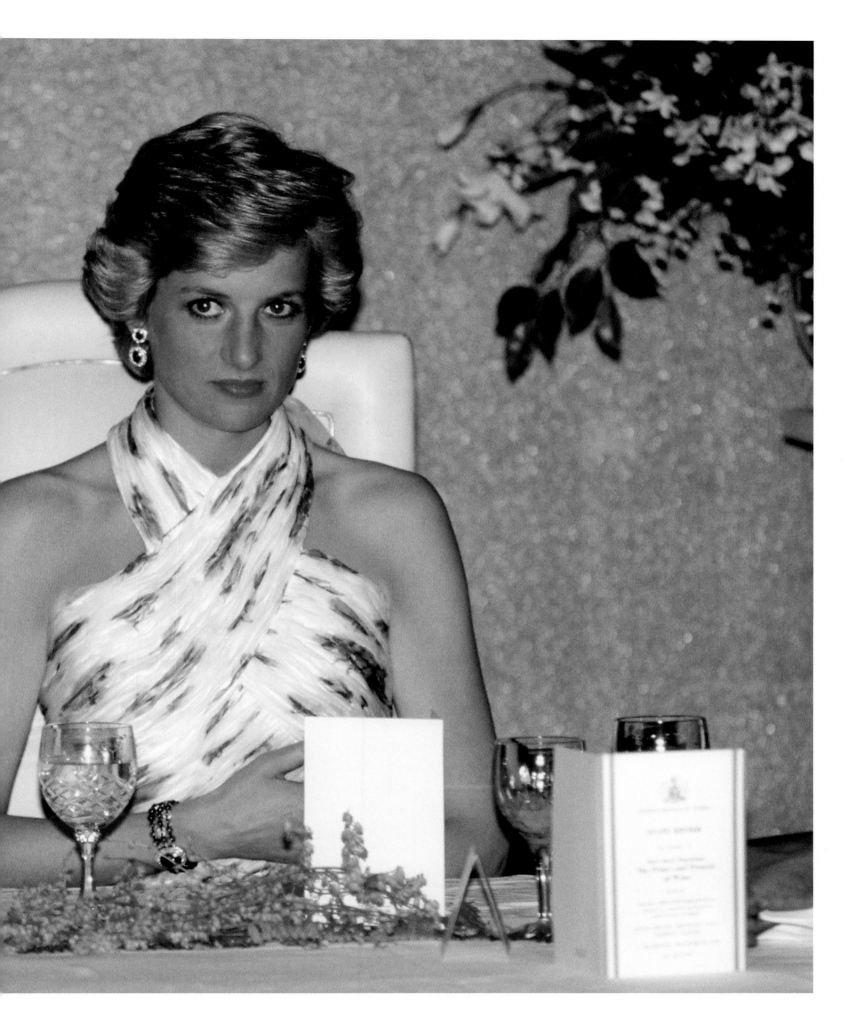

The Elvis Dress

Embroidered with 20,000 pearls and white sequins, the Catherine Walker sheath and matching bolero that Diana wore to the British Fashion Awards at London's Royal Albert Hall on 17 October 1989 sparked comparisons to 'the King'. Diana herself dubbed the gown her 'Elvis Dress', because of the upturned collar. She wore it on an official visit to Hong Kong on 10 November 1989, for the opening of the Hong Kong Culture Centre, teaming it with the Queen Mary's Lover's Knot Tiara. She later donned the dress – minus the bolero – for a state banquet hosted by Hungarian President Arpad Goncz at the Parliament Building in Budapest, on 8 May 1990. 'Whenever I saw the princess in this dress, I could not help but feel that it would not be possible for anyone else ever to wear this dress and bolero,' the designer said afterwards. 'She shone in the dress and the dress shone around her in a shimmering column of glistening pearls.'

The dress was bought for £90,827 at the Christie's auction by the American memorabilia company The Franklin Mint, which created a portrait doll of Diana wearing a replica of the dress. They donated the dress to London's Victoria & Albert Museum.

Above: The Catherine Walker dress, with matching bolero, that Diana dubbed 'the Elvis dress'.

Opposite: Diana during her Hong Kong tour, on 10 November 1989.

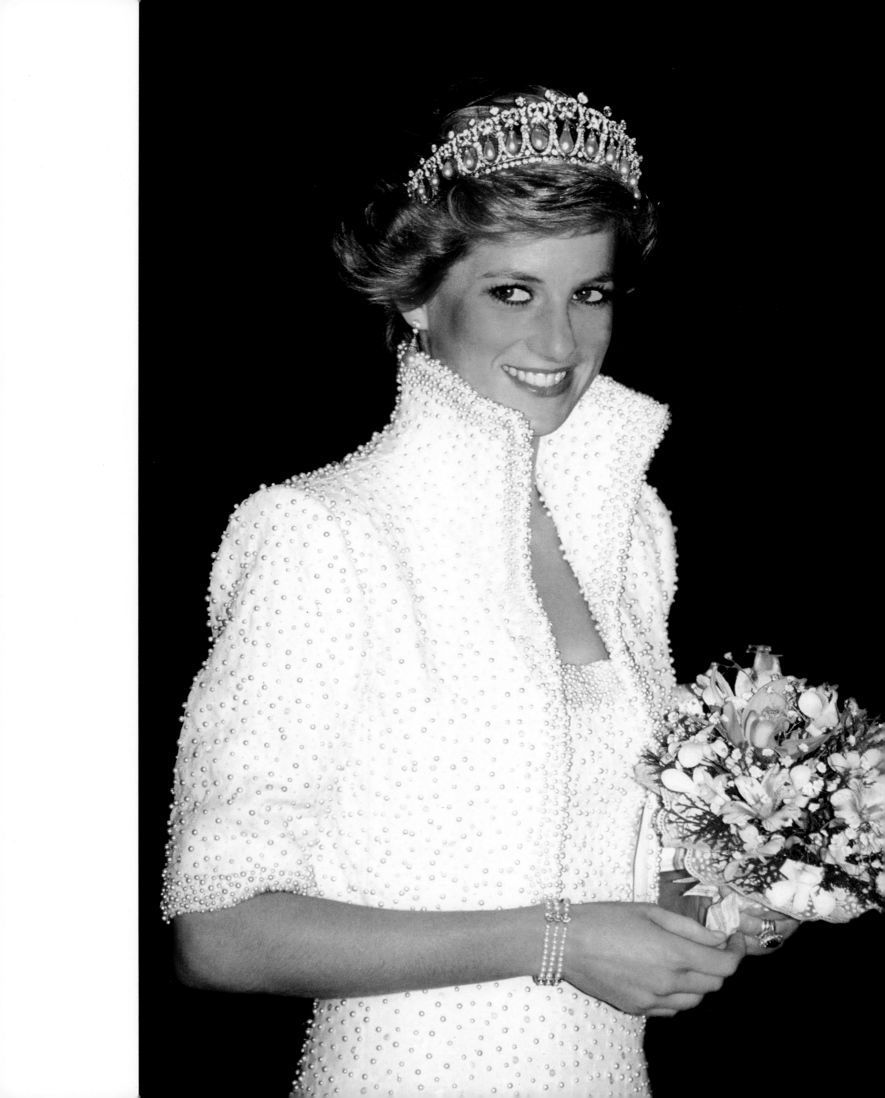

The Burgundy Velvet Gown

Diana wore her burgundy velvet dress with its ruched bodice when she attended a dinner at the French Embassy hosted by Ambassador Luc De La Barre De Nanteuil, on 6 December 1989.

The dress was bought from Christie's on 25 June 1997, by New York memorabilia collector Edward Kosinski, the founder of The Rock and Roll Trust, for £23,519. He loaned it out philanthropically before selling it at Julien's Auctions on 8 October 2010 for £98,157.37. It is now in the Fundación Museo de la Moda.

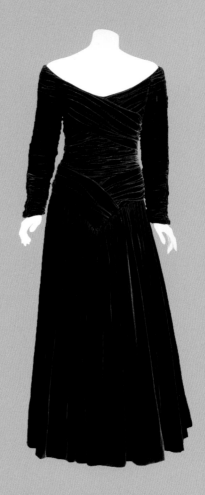

Above: The Catherine Walker burgundy velvet gown.

Opposite: Diana and Luc de la Barre de Nanteuil, the French Ambassador, in London, 1989.

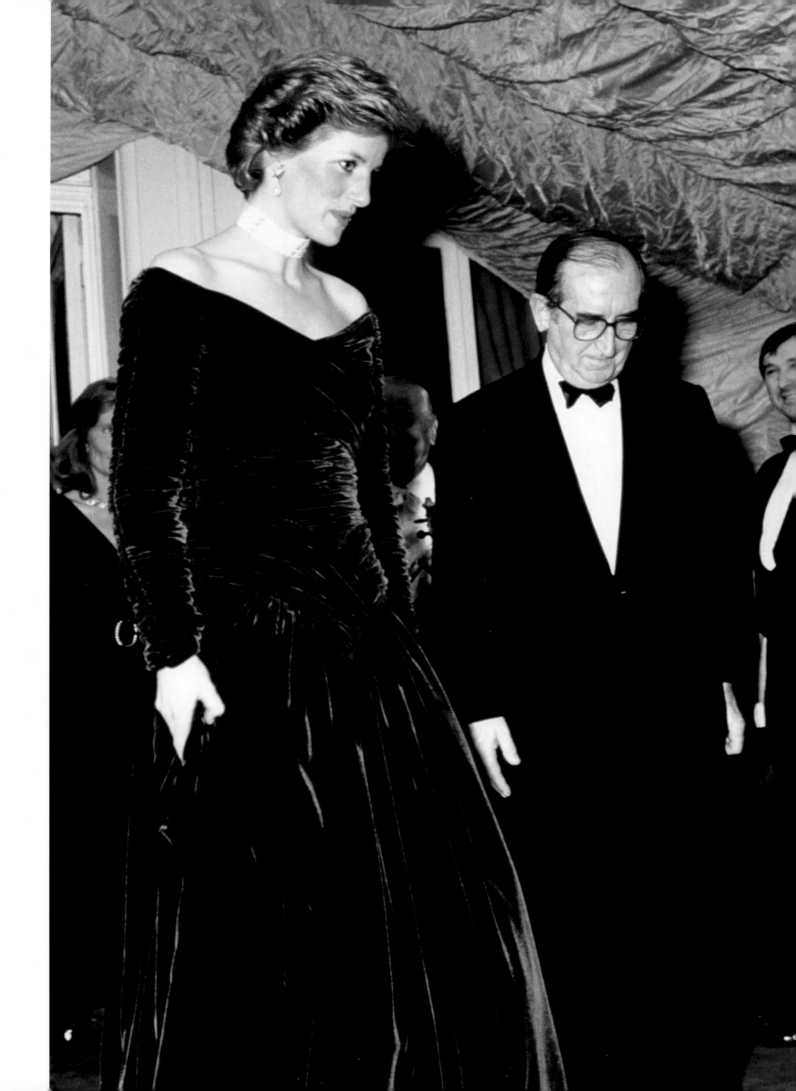

The Scottish Gown

Ordered for an evening of Scottish dancing at Balmoral, Diana loved this Catherine Walker dress with its black velvet bodice, square neckline and full skirt of green, black, and red plaid silk. She wore it on 18 February 1991 for a charity fundraiser in aid of the Royal Marsden Cancer Hospital Fund at London's Guildhall.

It was sold at the 1997 Christie's auction to Maureen Rorech for £27,669, and then re-sold by Waddington's auction house in Toronto on 23 June 2011. It is now in the Fundación Museo de la Moda.

Above: The Catherine Walker Scottish gown on display at the 'Fashion Rules' exhibition at Kensington Palace, London.

Opposite: Diana attends a charity function on behalf of the Royal Marsden Hospital Cancer Fund at the London Guildhall, on 18 February 1991.

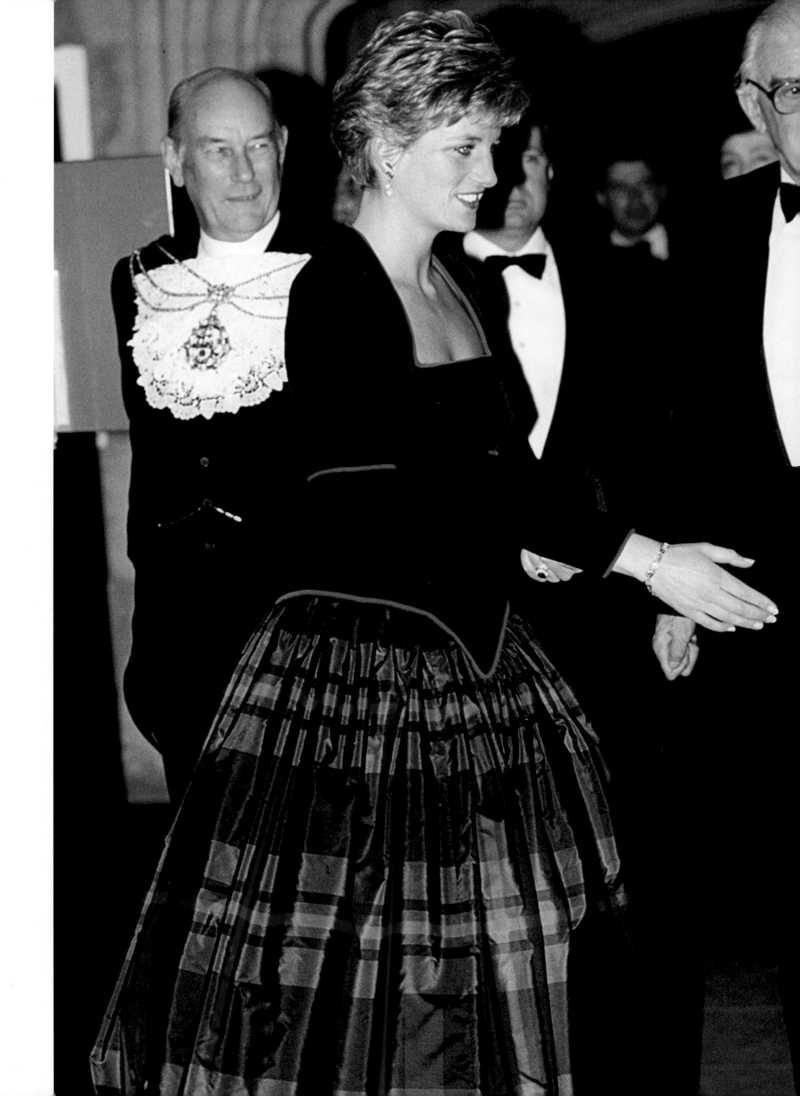

The Liza Minnelli Gown

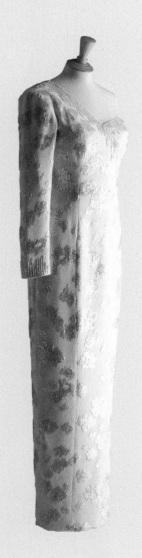

When Diana attended a banquet hosted by Brazil's President Fernando Affonso Collor de Mello at the Itamaraty Palace, on 23 April 1991, she stepped into a diplomatic nightmare. 'The Princess of Wales took great care to honour the traditions and feelings of each country that she visited,' Catherine explained in her autobiography. 'Shortly before this visit to Brazil, the national football team had lost to Argentina in the World Cup and the country was depressed about this disaster. We received instructions that in view of these circumstances we should not design anything in green, yellow and blue, which were the official colours of the Brazil team, and definitely not in blue and white, which were the colours of the Argentinian football team.' Instead, the designer and the princess chose an ivory and pink sequinned crepe one-sleeve gown.

Diana was famously photographed chatting to singer Liza Minnelli in this gown at the after-show party for the film première of *Stepping Out* at the Langham Hilton, on 19 September 1991. 'The smallest breach of royal behaviour was deserving of complaint,' noted Andrew Morton in *Diana: Her True Story*. 'After a film première, the Princess attended a party where she enjoyed a long conversation with Liza Minnelli. The following morning it was pointed out to her that it was not done to attend these occasions. The party had one happy result, however. She enjoyed the rapport with the Hollywood star, who talked at great length about her difficult life and told her simply that when she felt down, she thought of Diana and that helped her to endure. It was a touching and very honest conversation between two women who had suffered much in life and which formed the basis of their long-distance friendship.'

The dress was sold to Maureen Rorech at the 1997 Christie's auction for £15,910. It was acquired by Historic Royal Palaces for £81,250 for their Royal Ceremonial Dress Collection from Kerry Taylor Auctions on 19 March 2013.

Above: The Catherine Walker sequinned ivory and pink gown.

Opposite: Diana attends the première of *Stepping Out* at the Empire in Leicester Square, London, on 19 September 1991.

Following pages: Diana meets Liza Minnelli and Julie Walters, stars of *Stepping Out*, at the première.

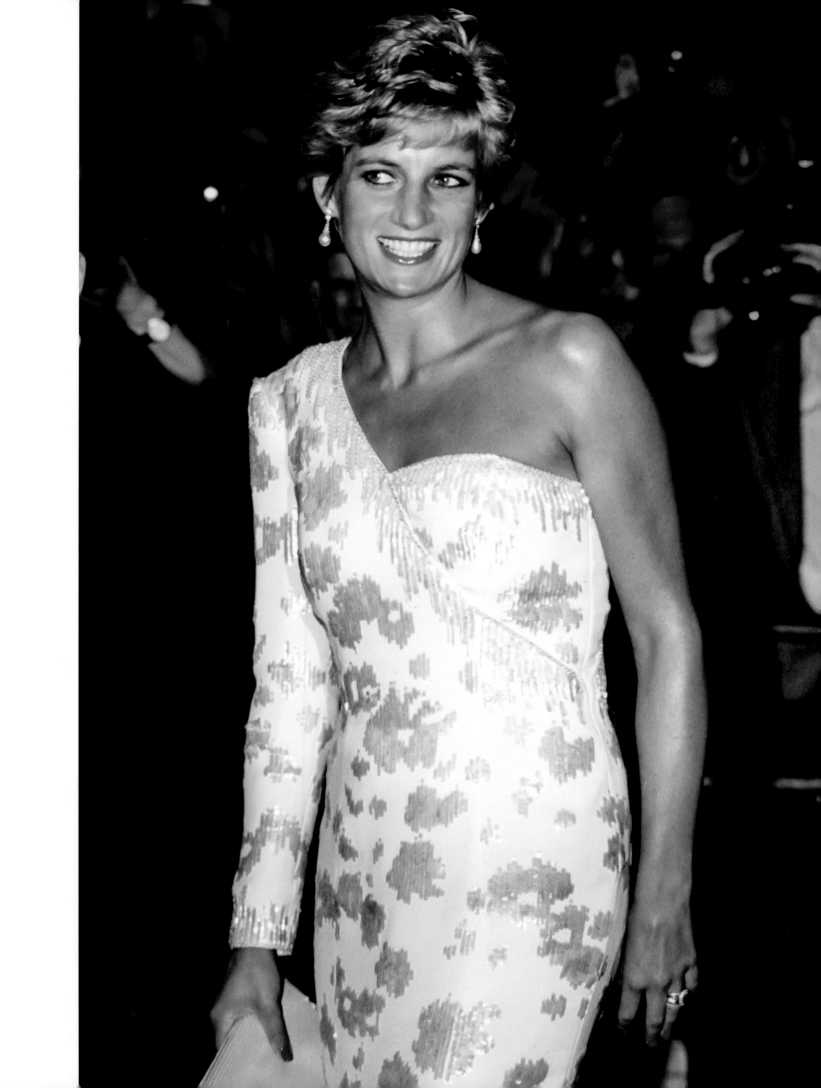

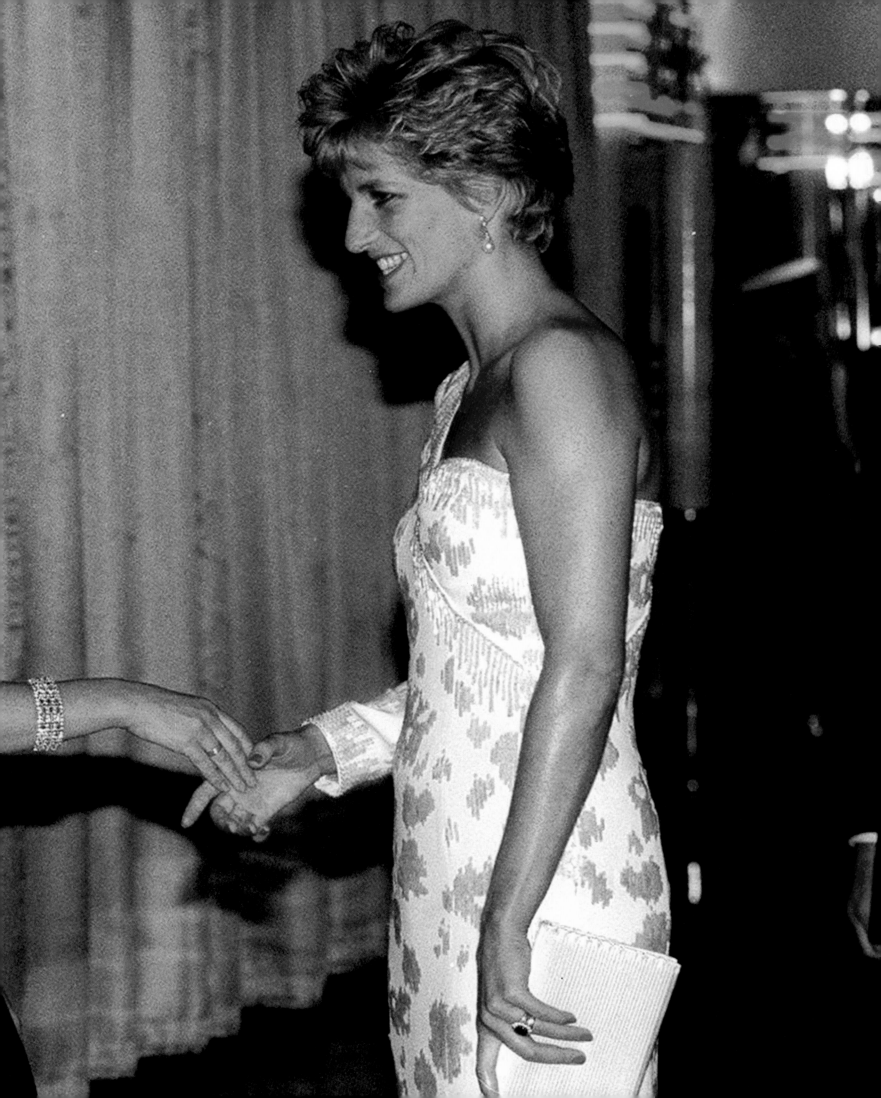

The India Dress

Designed to match her Spencer tiara, this black silk crepe empire line evening gown boasted an intricate design of diamante paste embroidery. Diana wore this dress to attend a state banquet hosted by President of India, Ramaswamy Venkataraman, in his residence at the Rashtrapati Bhavan Palace in New Delhi on 10 February 1992, during an official visit to India.

'This dress was commissioned for an official visit to India,' the designer wrote in her biography. 'The more research I did for this dress the more I became lost in the rich complex pattern of Indian culture and its hybridisation with the British influence of the Raj. I knew the Princess was intending to wear the Spencer tiara, and my daughter Marianne found a beautiful book for me on the decorative art of India, in which I came upon a sandalwood and ivory inlaid casket whose design seemed to compliment the tiara perfectly. The technical design of the embroidery drew upon this traditional pattern of marquetry, and the flatness of the stones is also particular to Indian jewellery.'

Diana wore the dress again on 4 March 1992, for the royal charity première of *Hear My Song*. It was the second dress bought from Christie's on 25 June 1997 by WE tv for £25,594 and was also taken on the shopping centre tour. People were invited to view the dress for a dollar and the £41,481 raised was matched by the cable television network. Julien's Auctions eventually re-sold the dress on 8 May 2011 for £124,443, to the Fundación Museo de la Moda.

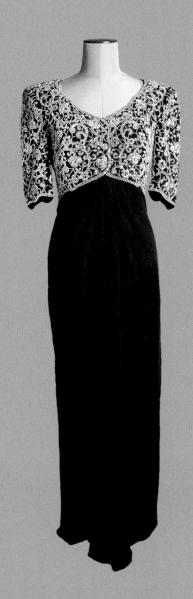

Above: The dress that Catherine Walker designed to match the Spencer family tiara.

Opposite: Diana attends a banquet in New Delhi, India, given by the President of India, Ramaswamy Venkataraman, on 10 February 1992.

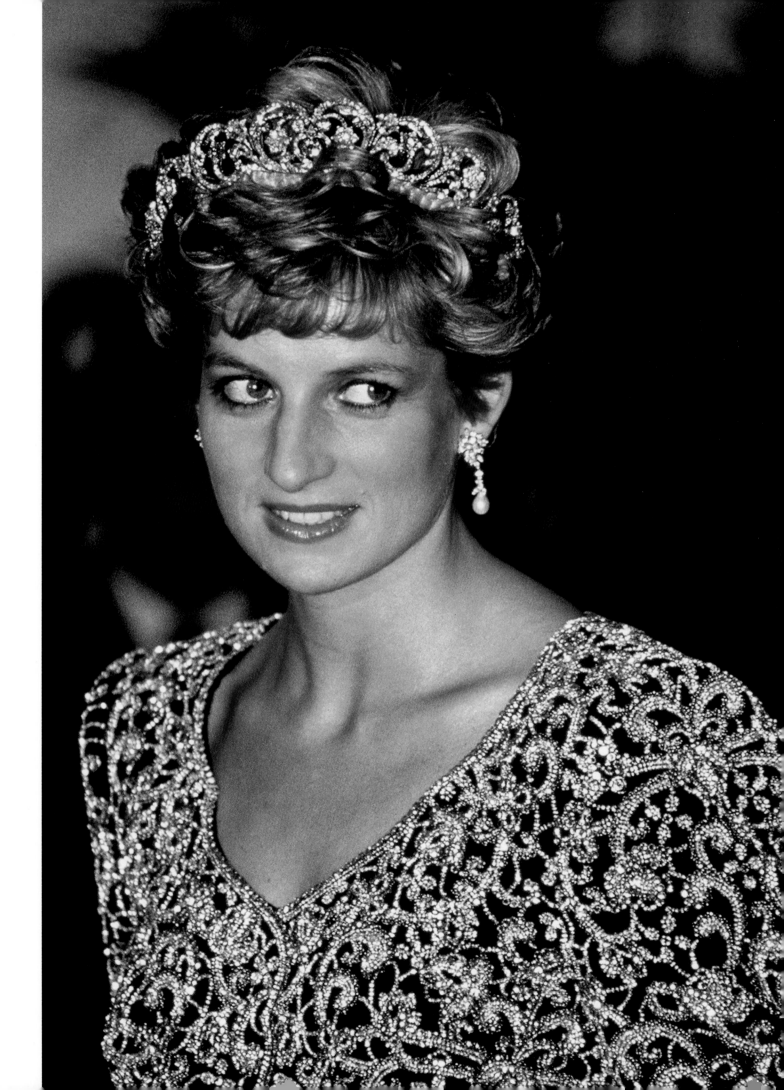

The Spencer House Gown

D iana chose a pale blue-grey Catherine Walker chiffon gown with a high-cut bodice, embroidered with simulated pearls, rhinestones and glass beads, for a reception for the London City Ballet at Spencer House on 6 May 1992. Sadly faded from exposure to the light, it sold to Franz Billen at the 1997 Christie's auction for £22,135. The Fundación Museo de la Moda bought it for £93,332.25 when it came up in Julien's Hollywood Legends Auction on 1 April 2012.

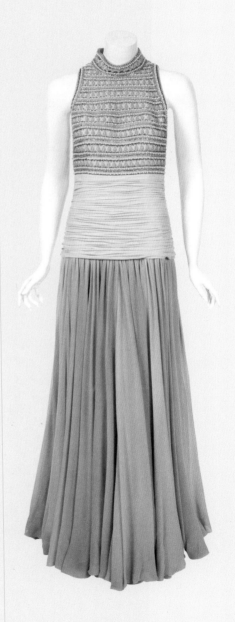

Above: The pale blue-grey Catherine Walker chiffon gown.

Opposite: Diana at a gala evening at Spencer House, London, in aid of the London City Ballet on 6 May 1992.

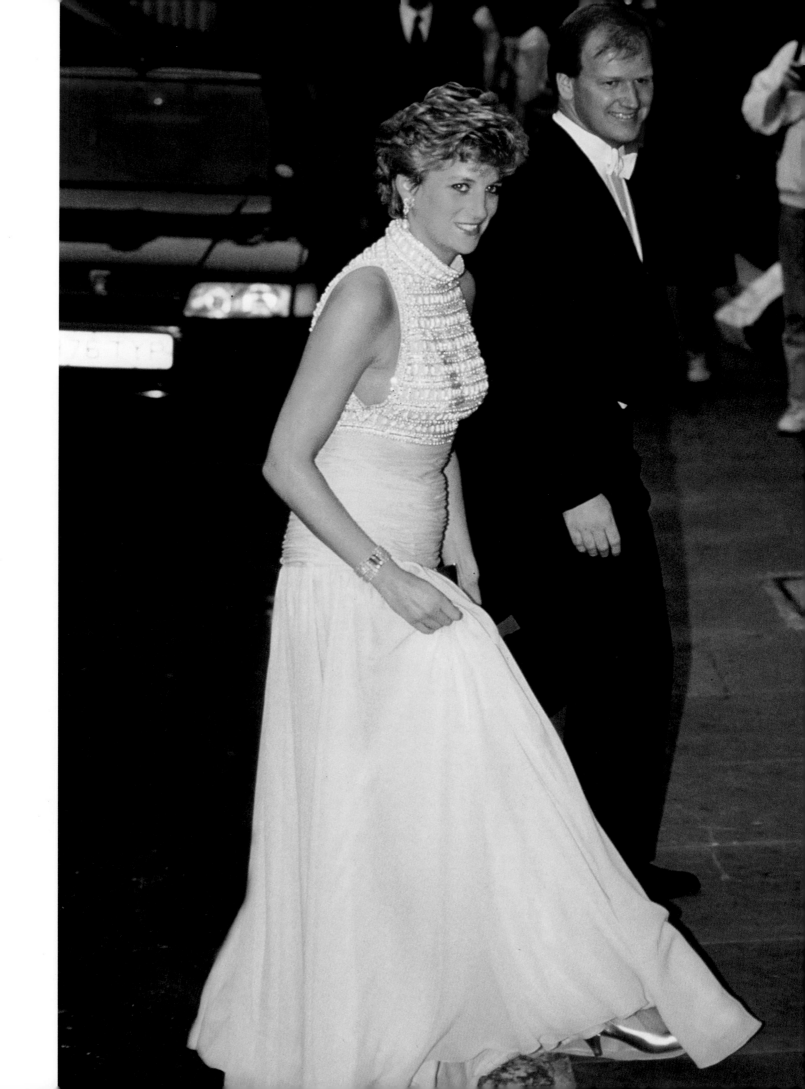

The Madame Grès Gown

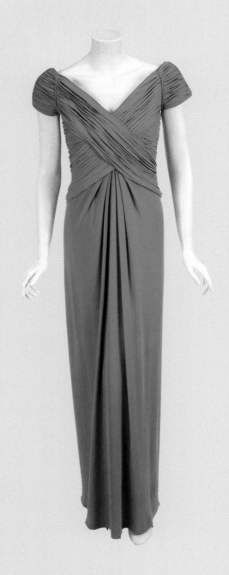

Wearing a green chartreuse Taroni silk georgette gown with a cross-over bodice, inspired by the late couturière Madame Grès, Princess Diana attended the 80th birthday party celebrations of the late conductor Sir George Solti at Buckingham Palace on 22 October 1992. She donned it again on 11 November the following year, to attend her last state banquet, given by the Yang di-Pertuan Agong, the Paramount Ruler of Malaysia, at London's Dorchester Hotel.

The dress was one of four dresses bought by Ellen Petho at the Christie's Auction on 25 June 1997 – she paid £14,526 for the Grès gown. It was then re-sold by Julien's Auctions on 6 December 2014 for £67,406.63 to the Fundación Museo de la Moda.

Above: The green Taroni silk georgette gown by Catherine Walker.

Opposite: Diana attends a banquet during the state visit from Malaysia at the Dorchester Hotel in London, on 11 November 1993.

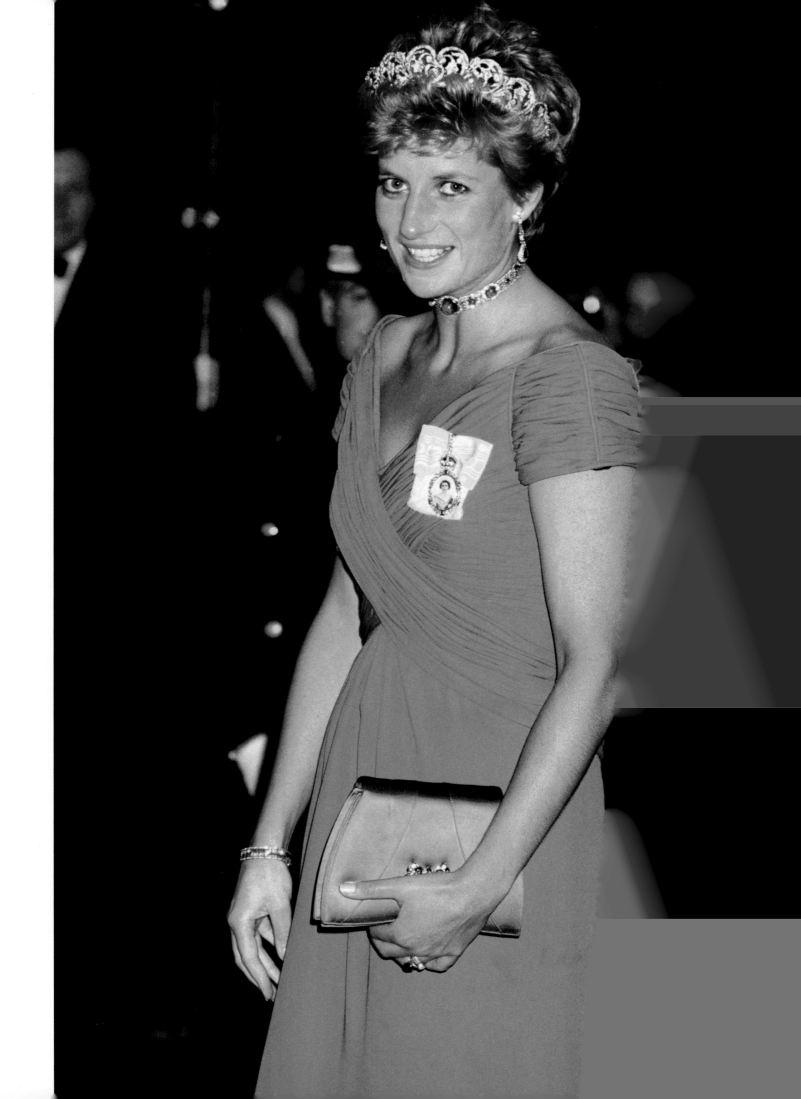

The Petal Pink Ballet Dress

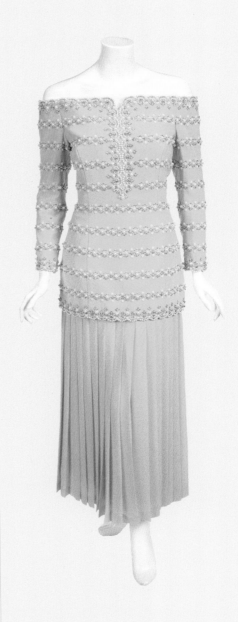

Princess Diana adored ballet and opera and was always keen to attend performances. It was a natural step for her to wear an off-the-shoulder beaded tunic and long silk pleated skirt in petal pink for a gala performance of the English National Ballet, of which she was a patron, on 19 July 1993, to celebrate the official reopening of London's Savoy Theatre. She chose the dress again on 12 October that year to attend a performance of the Puccini opera *La Bohème* at the London Coliseum.

This was one of four outfits bought from Christie's by Ellen Petho on 25 June 1997 – she acquired this two-piece suit in silk, with simulated pearls and glass beads, for £13,143. The Fundación Museo de la Moda bought it from Julien's Icons & Idols Auction on 6 December 2014, for £62,221.50.

Above: The pink silk dress with a pleated skirt by Catherine Walker.

Opposite: Diana visits the Savoy Theatre in London, on 19 July 1993.

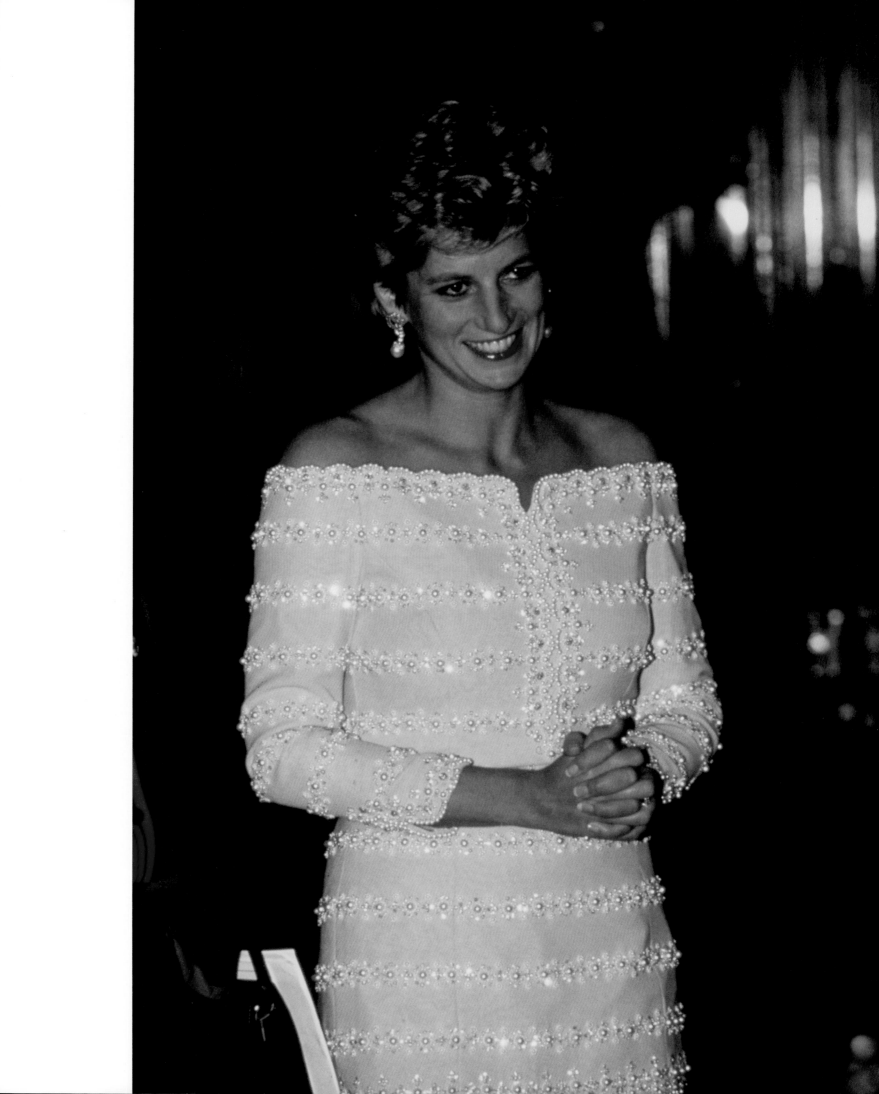

The Red Cross Gown

As patron of The British Red Cross Youth and Vice President of the British Red Cross Society, Diana was guest of honour at a Luciano Pavarotti concert on 8 May 1995 at the Royal Albert Hall, in aid of the Red Cross 125th Birthday Appeal. She chose a Catherine Walker military-style gown with a black Hussar-style bodice and pleated red silk-crepe skirt, trimmed with a soutache braid and rouleaux at the waist.

The dress was sold at the 1997 Christie's auction for £22,135, to New York art dealer James Kojima, who bought it on behalf of his cousin Akihiko Kojima, principal of the Mejiro Fashion & Art College in Tokyo, Japan. This purchase was made to celebrate the college's 60th anniversary.

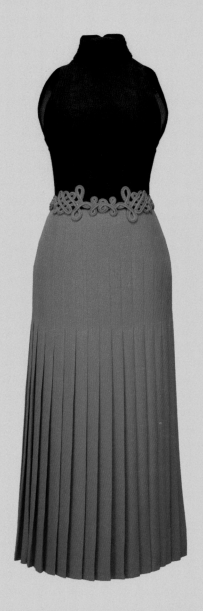

Above: The military-style Catherine Walker Red Cross dress.

Opposite: Diana arrives at the Pavarotti concert at the Royal Albert Hall in aid of the Red Cross 125th Birthday Appeal, accompanied by bodyguard Dave Sharp.

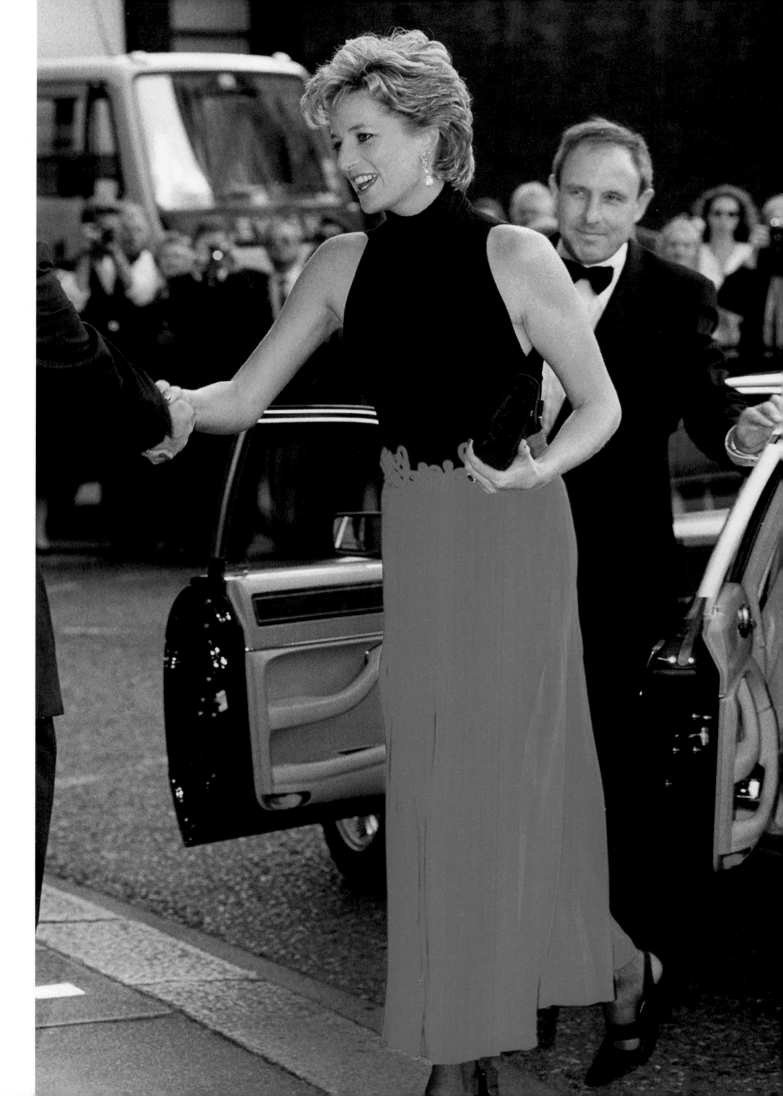

The Mughal Dress

Made for her 1992 state visit to India, where she was memorably photographed alone at the Taj Mahal, Diana's embroidered pink slubbed silk strapless dress and matching bolero was embroidered with pink and white flowers, and decorated with green sequins, star-shaped sequins, gold glass beads and gold braid, echoing Mughal embroidery motifs. The inspiration came from the lid of an Indian inlaid marquetry box found in a London market. Diana did not wear the dress publicly on the tour – the only photo of Diana in the dress was taken by Lord Snowdon for the Christie's auction catalogue.

The dress sold for £37,233 to Maureen Rorech, who took it around the world in the Dresses for Humanity tour. However, the tour ran into trouble with creditors and this dress was confiscated for five months until the debt was repaid. The dress was auctioned on 19 March 2013 by Kerry Taylor Auctions and was bought for £68,750 by William Doyle, owner of the Museum of Style Icons in Newbridge, County Kildaire, Ireland, where it is on permanent display.

The intricately embroidered Mughal dress, on display at the Museum of Style Icons.

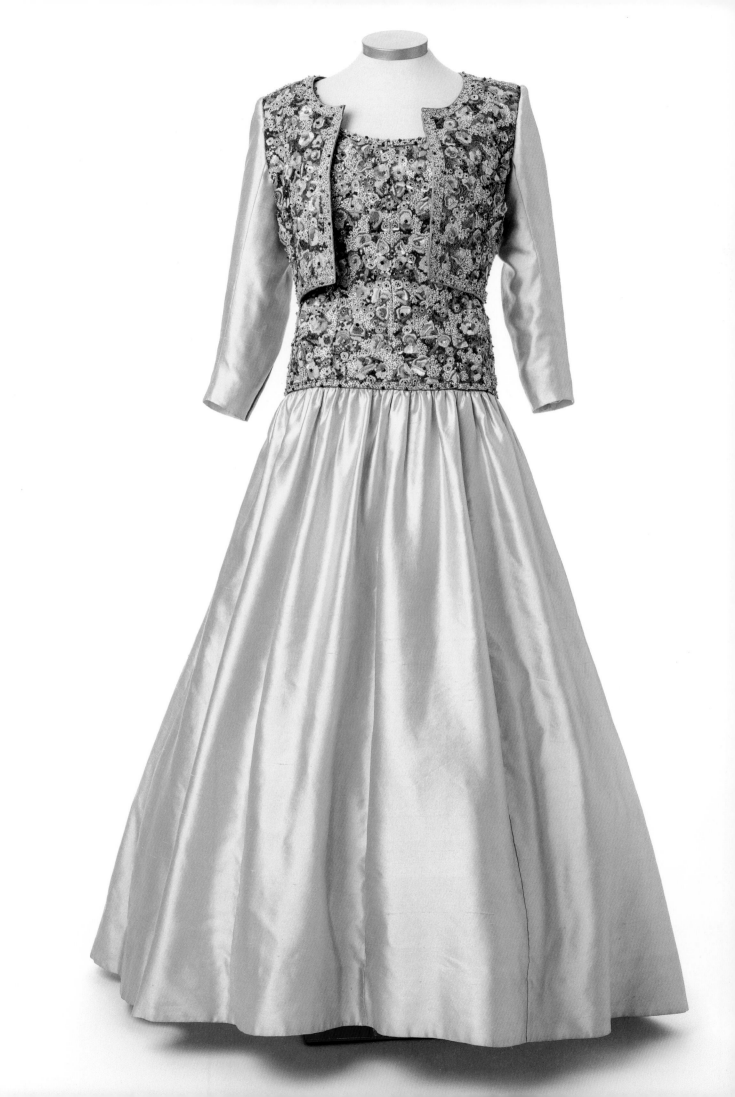

The Final Shoot

They were the last official portraits of the Princess of Wales, taken to promote the auction of her dresses on 25 June 1997, at Christie's in New York, before her untimely death. One of her favourite photographers, Mario Testino, photographed Diana wearing nine of her iconic dresses – four by Catherine Walker, three by Victor Edelstein, one by Hachi and one by Versace. These photographs were published in the July edition of *Vanity Fair* magazine, to coincide with the auction, and were later displayed at an exhibition in Kensington Palace.

'I guess photography is so much about the right moment and I was lucky to be present at the right moment in her life,' Mario wrote in the catalogue to the 2005 exhibition. 'I think I am so privileged to have been able to document her like that. She was really divine that day. She looked so happy and fresh and sure of herself. It was just laughter and laughter and laughter and laughter and laughter.'

'She was really divine that day. She looked so happy and fresh and sure of herself. It was just laughter and laughter and laughter and laughter and laughter.'

The Grey Gown

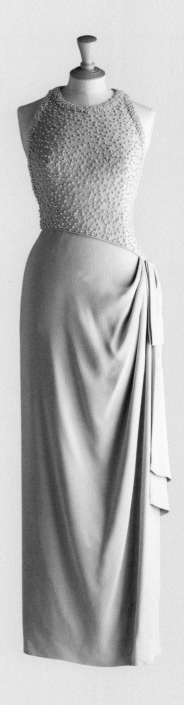

Diana chose a Catherine Walker grey silk gown, embroidered with simulated pearls, and draped like a sarong, for the *Vanity Fair* shoot. It was bought by Maureen Rorech from Christie's on 25 June 1997, for £17,985, but when she ran into financial difficulties, it was auctioned for £24,805.64 by Waddington's, in Toronto, and is now in the Fundación Museo de la Moda, in Santiago, Chile.

The grey silk gown by Catherine Walker,
worn for Diana's final photo shoot.

The Tuxedo Dress

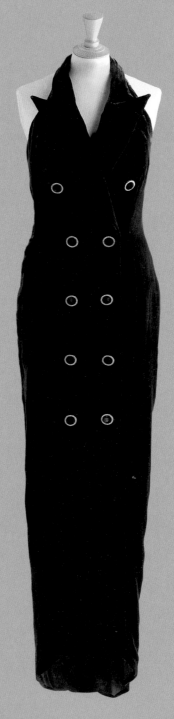

Ordered by Diana for formal dinners at Windsor, Balmoral and Sandringham, Diana also chose a dark green velvet double-breasted Catherine Walker halter-neck dress, which is reminiscent of a tuxedo, for her final shoot.

Boston businesswoman Barbara Jordan paid £14,526 for the tuxedo dress at the Christie's Auction on 25 June 1987, using part of her divorce settlement, and displayed it, alongside two other dresses, in the window of her boutique.

'I felt we had a lot in common,' she said at the time. I'm six foot tall and Diana was five foot ten. We both had two boys and marriages that fell apart. It was a binding experience. The place became a shrine. People came from all over and left flowers and messages outside the window.'

Barbara eventually sold the dress, which has velvet and diamanté buttons. Historic Royal Palaces bought it at auction in 2004 and it is now in their Royal Ceremonial Dress Collection.

The dark green velvet Catherine Walker halter-neck dress, worn by Diana to her final photo shoot.

The Ivory Gown

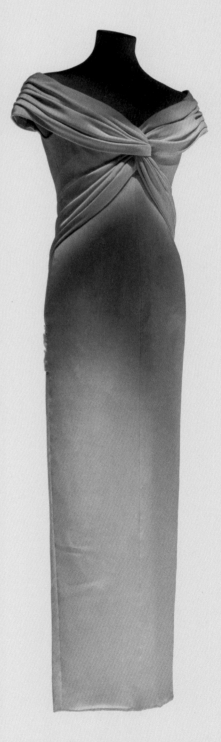

Diana ordered the ivory silk crepe gown, with its draped bodice and straight skirt, for the state banquet for the King and Queen of Malaysia on 11 November 1993, but wore a green version instead. The white gown remained in her wardrobe, until the Mario Testino *Vanity Fair* shoot.

Another dress bought by Maureen Rorech at Christie's on 25 June 1997, this time for £31,820, it was re-sold by Waddington's Auctioneers, in Toronto, for £43,886.90 to the Fundación Museo de la Moda, in Santiago, Chile.

The ivory silk crepe gown by Catherine Walker, worn by Diana for her final photo shoot.

The Gala Gown

When Diana attended the private viewing and reception for the Christie's auction in London on 2 June 1997, she chose a Catherine Walker pale blue guipure lace dress, embroidered with silver diamante. She was photographed with her late stepmother Raine, Comtesse De Chambrun, formerly Countess Raine Spencer, and designer Catherine Walker. Australian Renae Plant later bought this dress from a charity for The Princess & The Platypus Foundation, and it is now on display in her Princess Diana Museum, an interactive 3D museum.

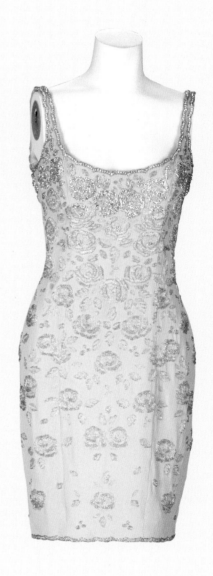

Above: The Catherine Walker pale blue guipure lace dress.

Opposite: Diana at the private viewing and reception for the Christie's auction in London, on 2 June 1997.

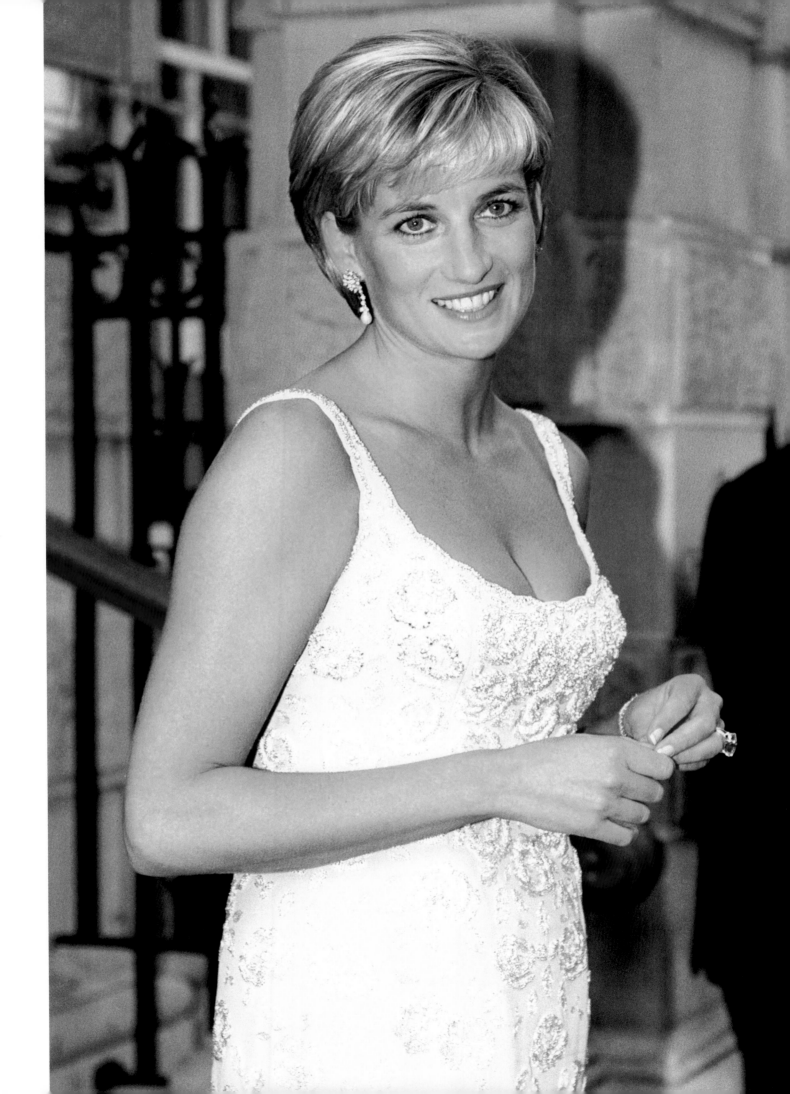

Victor Edelstein

He was described by Princess Diana as her 'favourite frockmaker' and created her most iconic dress – the navy velvet gown she wore to dance with John Travolta at the White House on 9 November 1985. But couturier Victor Edelstein had an inauspicious start to designing for the Princess of Wales, as the first dress he made for her didn't fit. *Vogue* fashion editor Anna Harvey commissioned the dress for Diana after she fell pregnant with Prince William, but Victor was not introduced to her and did not take her measurements.

'Anna asked me to make a maternity evening dress but because, I suppose, I assume they were being very, very protective of her, I didn't meet her,' he recalled. 'I must have submitted a drawing, which was approved, and Anna just gave me the measurements. I looked at them and thought: "That's impossible. These cannot be right. Having seen pictures of her, even though she's pregnant, she cannot be elephantine." I thought: "What do I do?" It was a tricky moment. "Do I use my judgement? Or shall I just follow these measurements because that's what I've been given and what else am I supposed to do?" So, I went on the latter and, of course, the dress was enormous and didn't fit her at all. It could have been the end of a long relationship. But luckily, she said: "We'll remake it after the baby," and that's what we did.'

After William was born, on 21 June 1982, Victor was invited to Kensington Palace to re-fit the dress. A stunning creation of pink organza with big tucks down the bodice and little shoulder straps, Diana wore his dress several times afterwards, including to a banquet in Brisbane, Australia, on 11 April 1983 and a trip to La Scala in Milan on 1 April 1985. 'When I first met her, I was totally overwhelmed,' Victor recalled. 'She was so beautiful and so fragile looking at that point, so sweet and so nice. I walked down the stairs afterwards and I was almost on air. I was quite overwhelmed by her. She had that effect.'

By the time Victor met the Princess, he had been working as a fashion designer for two decades, training at Alexon and gaining experience in Paris before getting a job, at the age of 21, assisting designer-of-the-day, Barbara Hulanicki, in the pattern room at Biba. 'It was wonderful,' he reminisced. 'She was a marvellous designer. I was likely working in the centre of the fashion world, because Barbara and Ossie Clarke were the two major designers of the 1960s. Mary Quant started the youthquake, but they took over.'

After leaving Biba, Victor began making clothes for private clients. He went on to design for Salvador and Christian Dior in London before opening his own couture house in 1978. He quickly captured the attention of *Vogue*, as well as clients ranging from the Duchess of Kent, Princess Michael of Kent, and the Countess of Snowdon, to actresses Diana Rigg and Maggie Smith. But it was Princess Diana who made his name. On some occasions she would sit next to him at the dress rehearsals for his couture shows at the Hyde Park Hotel, before he would return with her to Kensington Palace for fittings; on others she would pop into his shop at 3-4 Stanhope Mews and look through the collections whilst her security guard waited outside.

'Sometimes she came to the rehearsal of a fashion show because she couldn't have come to the actual show,' he recalled. 'It would have been such a performance. But she used to come to the rehearsal. Then she would go round to the back and see the dressmakers and talk to them all. She even remembered some of their names and she would say: "Which dress did you make? Oh, that was my favourite." By the time she left, they were all three feet in the air. She was so charming that she bothered to do that.

'Diana was always very friendly when I went there, but we never exchanged confidences. We talked about films or plays that we had seen or she would tell me about visits she'd done. We never had intimate conversations – thank God, because it would have put a terrible strain on one's discretion. At the last fitting for the Travolta dress – I fear it will always be called that – Diana was so pleased with it that she said: "I must show this to my husband." Off she went and came back with the Prince of Wales. It was very funny, like something out of a TV show. He was obviously about to go out because he was in full regimental dress, covered with ribbons and decorations, but he was very nice about the dress.'

Victor was even invited to Prince Charles's 40th birthday party on 14 November 1988 at Buckingham Palace – he created a pink double duchess satin gown for his wife Annamaria, who was working as an Old Masters' drawings dealer and is now a successful artist. However, in 1993, 11 years after first meeting the princess and at the height of his success, Victor stunned his clientele when he swapped couture for art, studying landscape and portrait painting with the artist David Cranswick in London before enrolling for two courses at the Charles Cecil Studios in Florence, Italy. He and Annamaria spent time in Europe before settling in the Cotswolds.

The couple was in Andalucía, Spain when they heard on the *BBC World Service* that the Princess was dead. They both attended the funeral. 'I was very sad,' he said. 'I couldn't believe it. And yet there was a sense of inevitability about it. It sounds callous but it was a marvellous opportunity for people-watching – it was packed with famous faces. I looked down the aisle as the coffin went past and saw Luciano Pavarotti cross himself and then burst out crying, his huge frame shaking.' Victor admitted that the Travolta dress was 'the one that made my name'. 'What's rather tragic about my career as a designer is, if she hadn't worn that dress to dance with John Travolta, I'd be completely forgotten about,' he said modestly. 'I'd just be a comma in the history of fashion, not even that. Designing beautiful dresses is irrelevant; it's who wore them and when that matters.'

The Travolta Gown

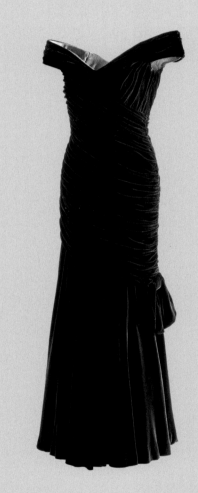

After dancing with John Travolta on 9 November 1985, at a state dinner hosted by President Ronald Reagan and his wife Nancy at the White House, the blue velvet Victor Edelstein gown that Diana teamed with a sapphire and pearl choker, converted from a brooch given to her by The Queen Mother, became one of her most iconic dresses. Travolta had not been invited to take a guest but, when Nancy Reagan took him aside during the banquet and explained that Diana wanted to dance with him, he understood the reason why. At midnight, heart pounding, he crossed the floor and asked her if she wanted to dance.

'She turned around and she did that look that she did so, so beautifully,' he recalled, 'and I asked if she would care to dance. She said she'd love to and we danced for 20 minutes to a medley of "Grease" and "Saturday Night Fever". I was on cloud nine. She has great rhythm. We did spins and turns. We did a kind of modern foxtrot and she followed me very well. "Maybe someday we'll get to do this in a less-watched situation," I said near the end. "That would be great," she replied.'

That night, Victor was woken by André Leon Talley, then fashion news director of American *Vogue*. 'On the night she wore it. André Leon Talley rang me up in the middle of the night,' remembered Victor. 'How he got my telephone number I have no idea. And he said: "She's worn this fabulous dress of yours. Now tell me: Why navy? Why velvet? Why off the shoulders." I just said: "Well you know. It was a model in my collection which she chose. The model was burgundy and she thought she would like to have it in navy." I had no idea where she was going to wear it, because every season she would order various dresses because she needed long dresses. I'm sure that when she went to Washington, she probably took two or three evening dresses with her and decided at the last moment which one she was going to wear. That's the usual royal thing.'

The dress was one of Diana's favourites. She wore it to the annual banquet of the Asian Affairs Society at the Savoy Hotel on 5 February 1986; on a state visit to Vienna, Austria, on 15 April 1986, to watch a performance of the London Philharmonic Orchestra at the Musikverein; on a state visit to Bonn, Germany on 2 November 1987; for an official portrait for the Royal Hussars by artist Israel Zohar in 1990; and to the Royal Opera House on 3 November 1991 when she met Vivienne Westwood. Six years later, she pulled it out of her closet to wear for her official portrait by Lord Snowdon and teamed it with the same necklace she had worn 12 years earlier.

It has changed hands many times since. Maureen Rorech bought the gown for £133,835 – the highest price ever raised by Christie's for a garment, beating the previous record of £120,709.71 for the white suit that John Travolta wore in *Saturday Night Fever*. The mother-of-two, who bought another 12 dresses during the sale, planned to take her collection on tour and raise money for Diana's charities. But the tour drew criticism as she paraded the dresses through dismal locations such as Disneyworld in Florida and the Flying Monkey Movie House at Mill Falls, New Hampshire. She eventually went bankrupt, and the dresses were seized as collateral. This particular dress was resold by Kerry Taylor Auctions on 19 March 2013 for £250,000 to a man as a gift for his wife. The auction house sold the same dress again on 9 December 2019, for £275,000, to Historic Royal Palaces.

Above: The blue velvet Victor Edelstein gown that Diana wore to dance with John Travolta.

Opposite: Victor Edelstein's exclusive drawing of this dress.

Following pages: Diana dances with John Travolta during a White House gala dinner on 9 November 1985, Washington DC.

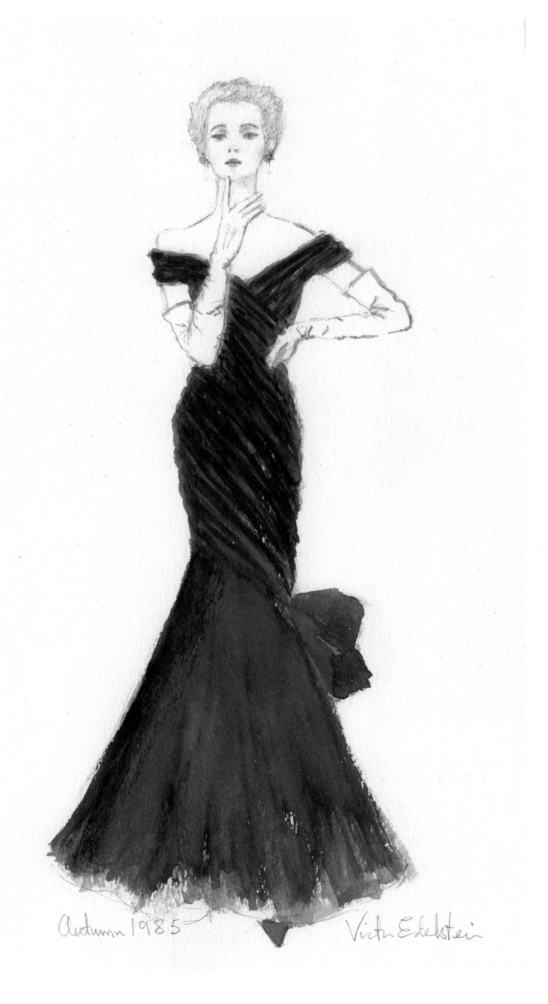

Autumn 1985 Victor Edelstein

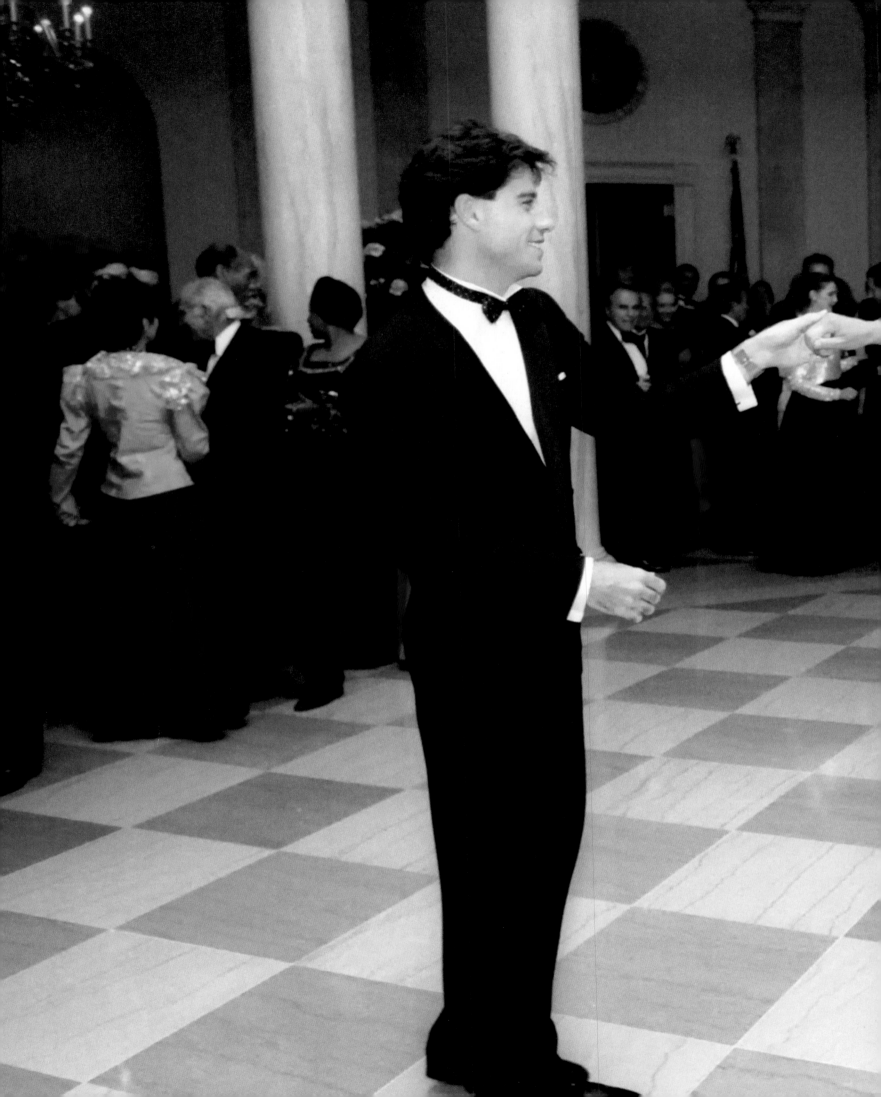

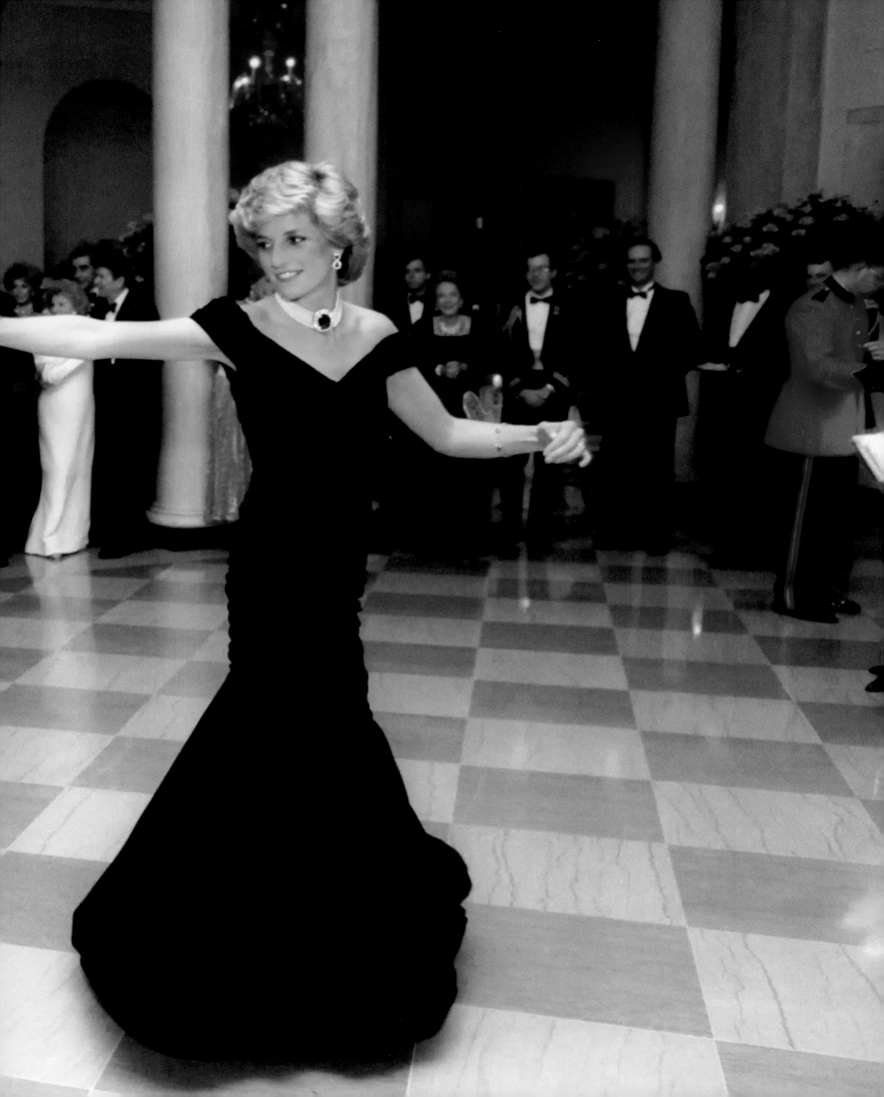

The Terence Donovan Gown

Posing for an official portrait by the late photographer Sir Terence Donovan in 1986, Diana looked regal in a deep emerald-green gown by Victor Edelstein. Inspired by the 1880s, the dress has a deep collar, small cap sleeves and self-covered buttons, and the skirt is draped, ruched and gathered into a bustle.

The dress was bought for £16,602 from the 1997 Christie's auction by New York art dealer James Kojima on behalf of his cousin, Akihiko Kojima. It is now inspiring future generations of fashion designers at the Mejiro Fashion & Art College, in Tokyo, Japan. The dress is only displayed on the first day of college and on ten-year anniversaries; it is normally kept in a climate-controlled room.

Above: The emerald-green silk Victor Edelstein gown, worn by Diana for her official portrait with Sir Terence Donovan.

Opposite: An exclusive sketch of this dress, by Victor Edelstein.

Following pages: Close-up of the skirt of this dress.

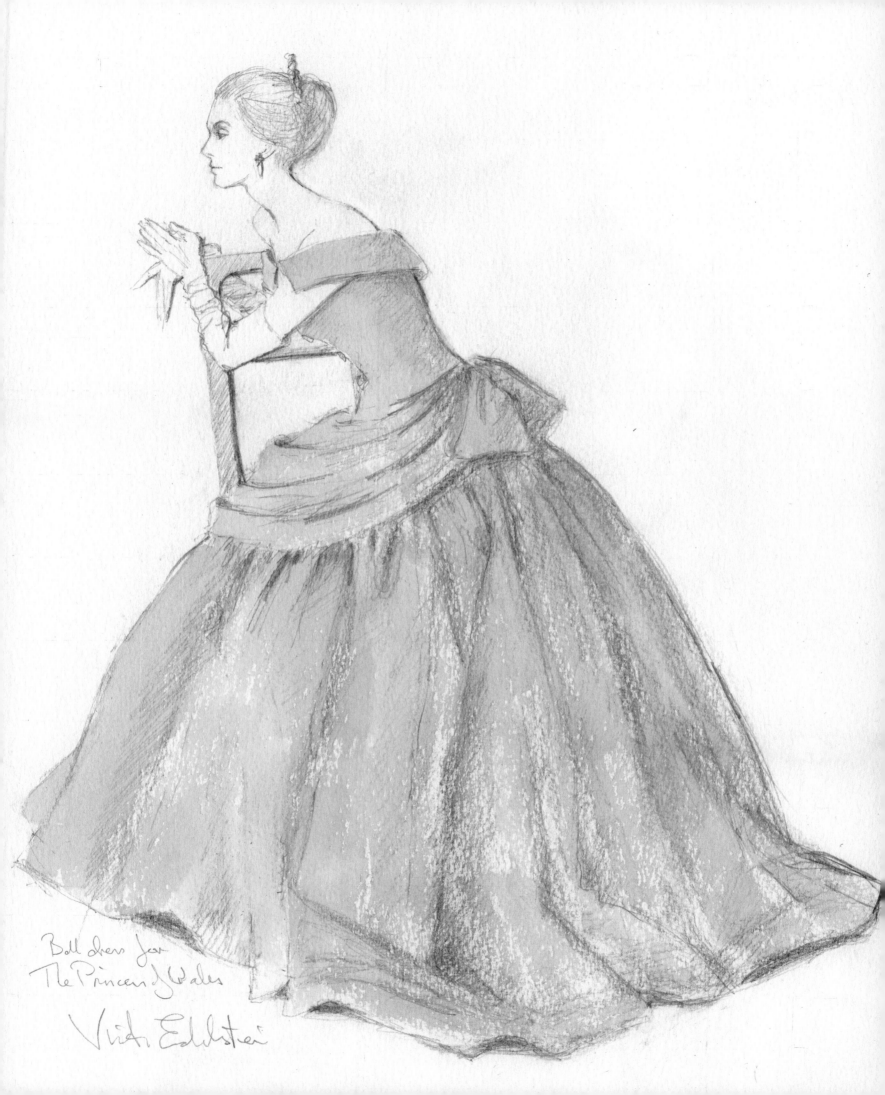

Ball dress for
The Princess of Wales

Victor Edelstein

The Spanish Dancer Dress

One of couturier Victor Edelstein's favourite dresses, Diana wore this Goyaesque Spanish dancer dress with its flounced skirt on 25 January 1987, to watch the first performance of Polish composer Krzysztof Penderecki's *Polish Requiem* at London's Royal Festival Hall. Later that year, on 6 November, she donned the black silk lace off-the-shoulder gown, layered over deep magenta silk, on a state visit to Germany for a banquet at Hamburg's City Hall. On both occasions, she teamed the dress with a string of knotted pearls.

Wedding dress designer Pat Kerr, who was a friend of the Princess, bought the gown at the 1997 Christie's Auction for £15,218. It now resides in the Pat Kerr Private Royal Collection.

Opposite: Diana at a dinner at Hamburg City Hall, Germany, wearing a black lace evening dress designed by Victor Edelstein.

Following pages, left: An exclusive sketch of this dress, by Victor Edelstein.

Following pages, right: A picture of the dress from the Christie's auction catalogue.

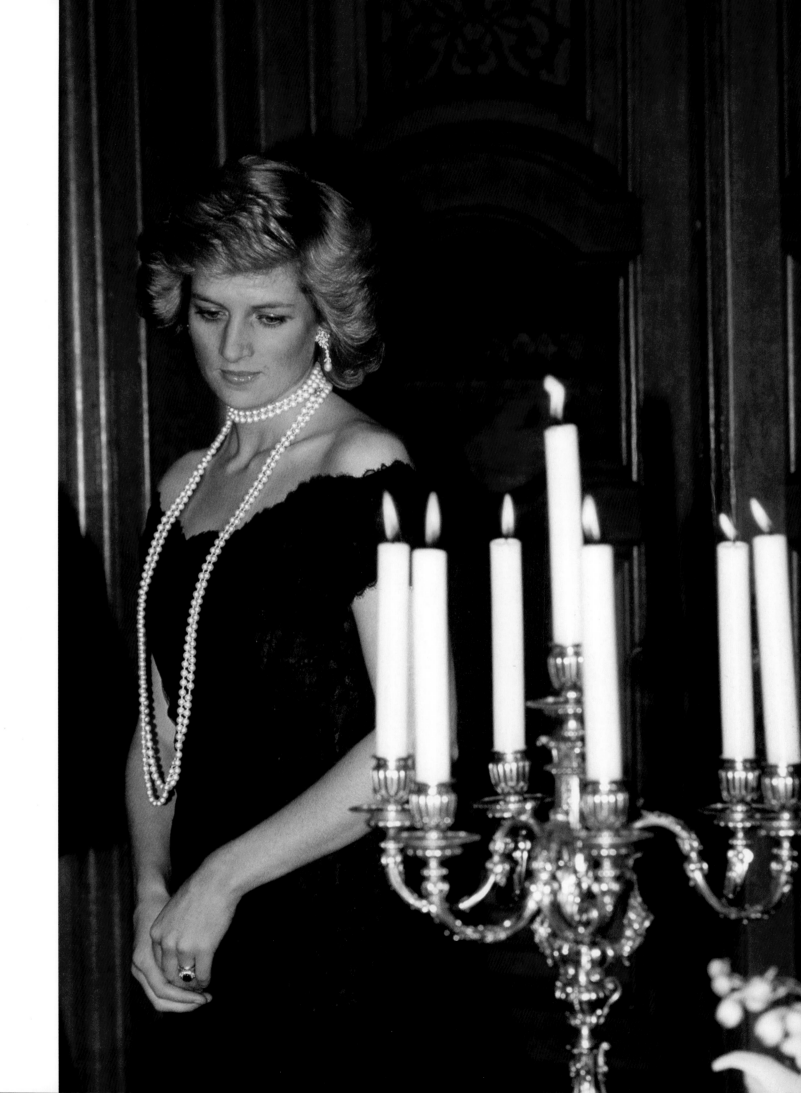

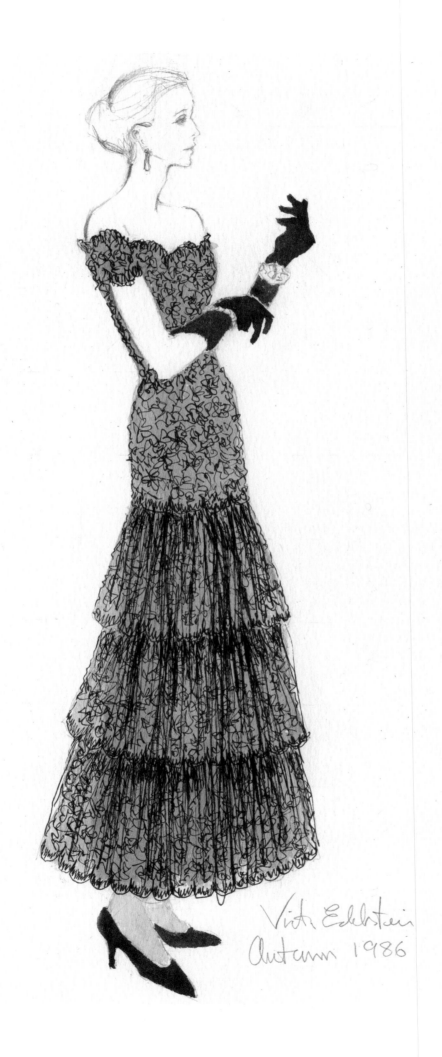

Vic Edelstein
Autumn 1986

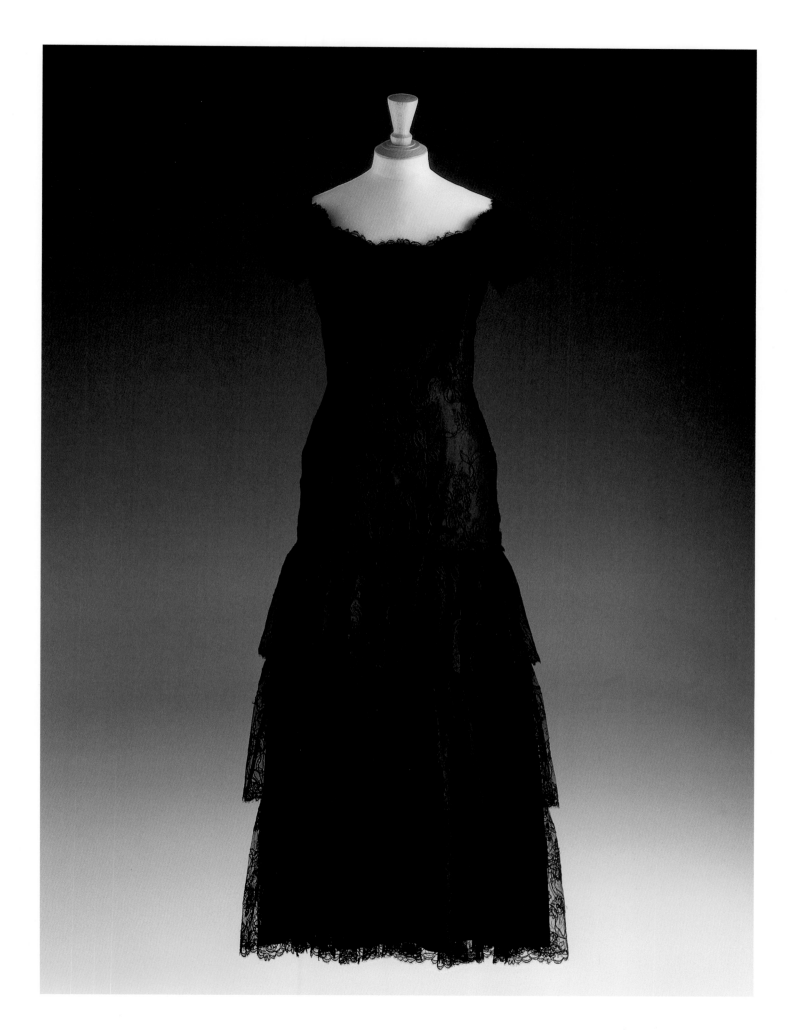

Arabella Pollen
The Ruffled Suit

Wearing a silk suit with a ruffled collar in caramel, white and primrose stripes by Arabella Pollen, and clutching a bouquet of flowers, Diana joined her husband on the balcony of Adelaide Town Hall on 5 April 1983 to wave to the crowds, who had turned out in their masses to catch a glimpse of royalty. The couple was on their first overseas tour together since their marriage and had broken royal protocol by taking William with them. The ten-month-old toddler spent much of the time with his nanny at Woomargama Station, a 4,000-acre working sheep ranch in New South Wales where President Ronald Reagan had once stayed, but his parents flew over regularly to see him during the 40-day tour.

Diana bought the dress off-the-peg from Arabella, the daughter of former Sotheby's New York chairman Peregrine Pollen, who was nine days older than the Princess. She founded her fashion label in 1980 at the age of 19 – supermodel Margaux Hemingway was a huge fan – and Diana was one of her best clients. 'I don't think she had a set sense of style,' she said, after Diana's death. 'But she raised the flag for British designers and was an enormous pull to buyers.' Now a successful author, writing under the name Bella Pollen, Arabella has excelled across two careers, counting a bestseller, an Oprah Summer Pick and a Richard and Judy Best Summer Read amongst her oeuvre.

In a typically generous move, Diana gave this ensemble to the nanny of a friend of Sarah 'Fergie' Ferguson, Duchess of York, for a Christmas present in 1987. She and Fergie, who had taken the Prince and Princess of Wales to dinner with the nanny's employer, had each donated two dresses to sell for charity – but Diana also gave the nanny this surprise gift. This nanny eventually sold the outfit at Kerry Taylor Auctions on 20 November 2017 for £45,000. It is now on display in the Fundación Museo de la Moda.

Opposite: Prince Charles and Princess Diana visit the Parks Community Centre in Adelaide, South Australia, on 5 April 1983.

Following pages: Prince Charles and Princess Diana on their official visit to Australia in April 1983.

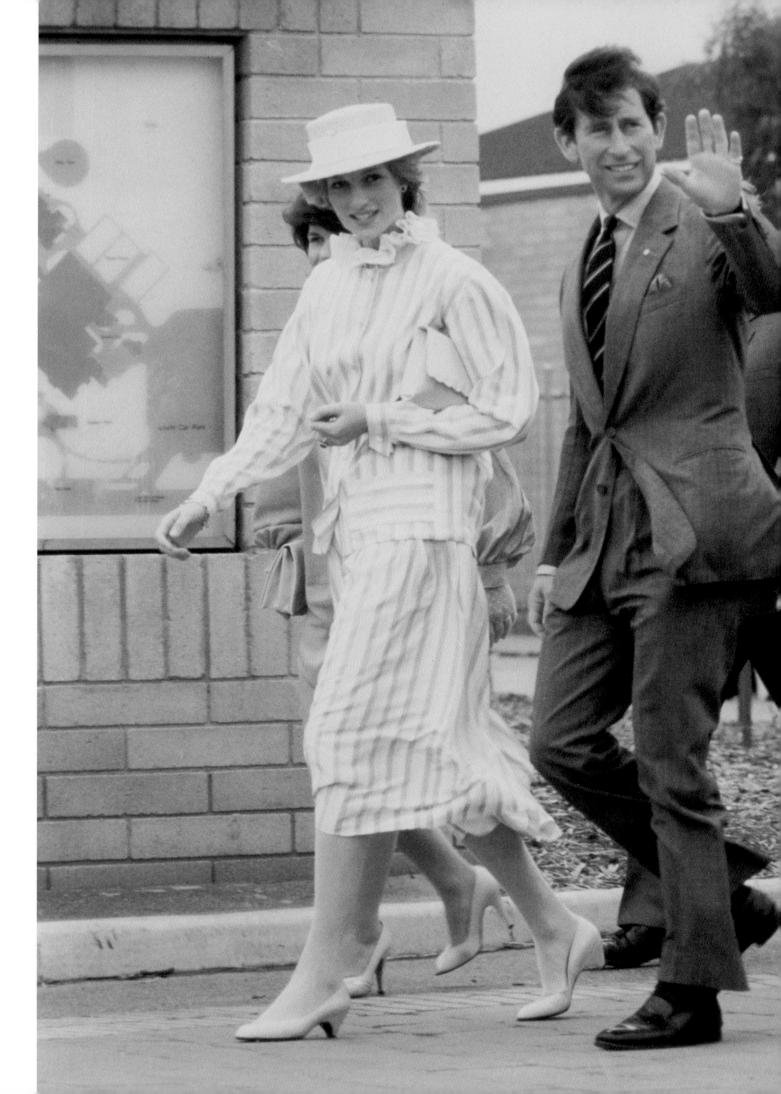

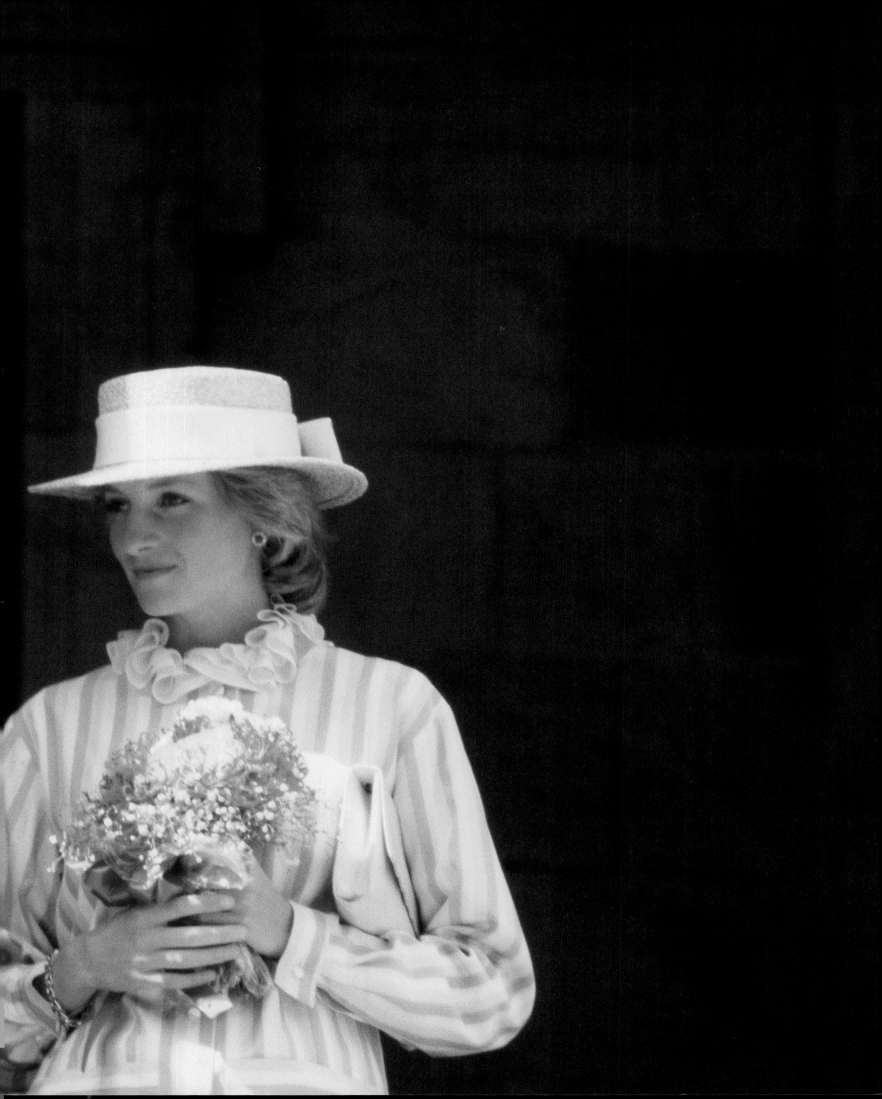

Hachi
The One-Shouldered Gown

Given to Diana by *Vogue* fashion editor Anna Harvey as a gift, Diana first wore her one-shouldered Hachi gown for a gala at the Hilton Hotel in Melbourne on 16 April 1983, during her first official tour of the Commonwealth. It was a move that sparked critical acclaim from fashion editors. Until then the princess had become known for her fairytale appearance, wearing frills, flounces, lace and ruffles. But by the time she went to Australia as a young mother and media superstar, she was exploring sleeker dresses that emphasised her broad shoulders.

The dress, which was embroidered with silver bugle beads, was one of Diana's favourites: she wore it repeatedly over the next six years before it was consigned to the back of her wardrobe. On 4 June that year, she chose the gown while accompanying Prince Charles to a ball at Broadlands, home of the late Lord Mountbatten, where they had spent part of their honeymoon. Two days later, she donned it for the James Bond film première of *Octopussy*, where she met 007 himself, Roger Moore. She later wore the dress for a gala at the National Gallery in Washington DC, on 11 November 1985; the première of *Licence to Kill* on 13 June 1989; her stepmother Raine's 60th birthday party on 9 September 1989; and the *Vanity Fair* fashion shoot with Mario Testino the month before her tragic death.

You magazine bought the dress at the 1997 Christie's Auction for £45,173. It became a prize in a competition, which was won by farmer's wife Margaret Thompson, 53, a lifelong royalist from Yorkshire. Devastated by Diana's death, she deposited it in a bank vault before deciding to sell it. 'I'll give some of the money to one of Diana's charities and then buy something to keep forever,' she said at the time. The gown was re-auctioned in on 13 December 2001 for £49,777.20, by Doyle's in New York, and was the first dress bought by the Fundación Museo de la Moda, based in Santiago, Chile.

Above and opposite: The one-shouldered dress by Hachi, and a close-up of the embroidery.

Following pages: Prince Charles and Princess Diana arrive at a gala dinner at the National Gallery in Washington DC, 11 November 1985.

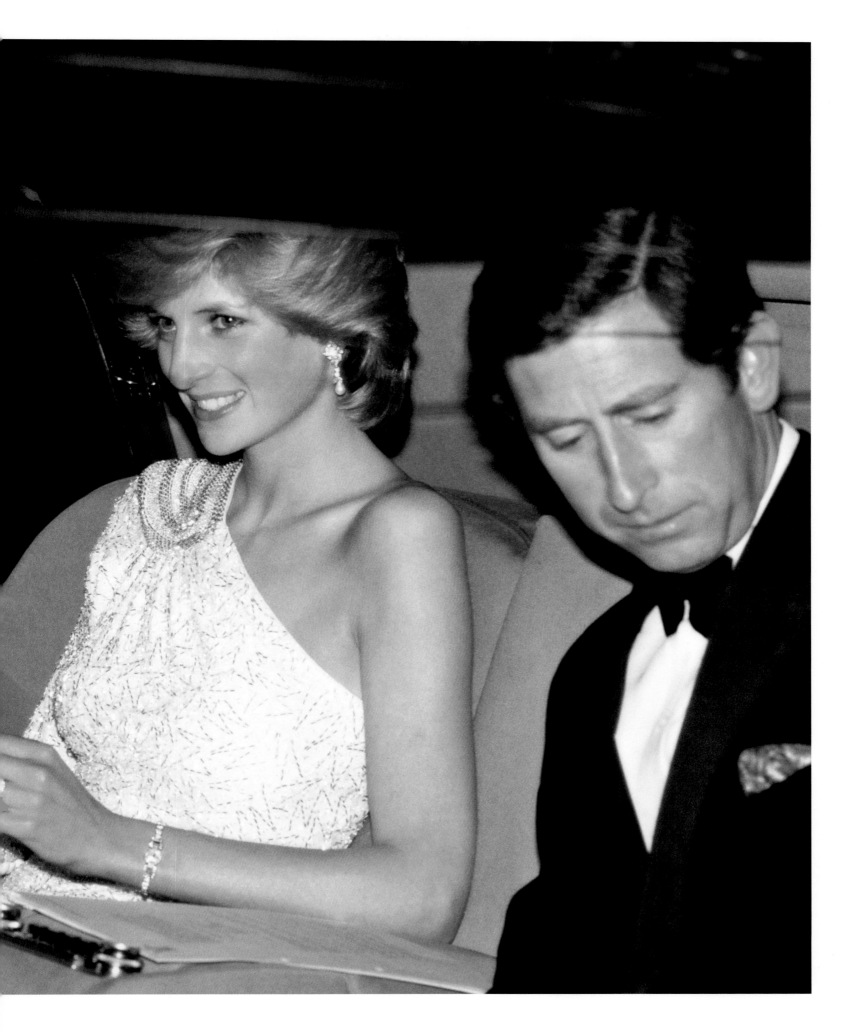

Zandra Rhodes

The first time that Dame Zandra Rhodes met Princess Diana, she had popped into her shop in London's Grafton Street with Sarah Ferguson, who was a distant cousin of the princess and a close friend – their mothers had been at school together and they had known each other since adolescence. In fact, it was Diana who played cupid between Sarah and Prince Andrew: she suggested that The Queen should invite her friend to stay at Windsor Castle on 20 June 1984 during Royal Ascot. Sarah found herself seated next to Prince Andrew at dinner and romance blossomed.

Afterwards, Diana, who was two years younger than Sarah, popped into Zandra's shop unannounced – something she had a habit of doing – and commissioned her to make some gowns. In an interview after her death, Zandra revealed that Diana was a dream to work with, although she was 'very, very shy'. 'I made her white wrap dress,' the designer revealed, and Diana needed to know that 'it wouldn't fall open and show her legs if she got out of a car because, you can be sure that when I get out of that car, there'll be people waiting at just the wrong angle to get me.'

Once, when Zandra visited the palace, Diana asked her if she still cycled – she had spotted Zandra cycling up London's Bayswater Road while she and Sarah were on their way to Ascot in a Daimler. 'She said: "Do you still go out on your bike?"' said Zandra. 'I was puzzled: how would she know I cycled? The week before I'd been cycling along the Bayswater Road in the rain, wearing a polyester knitted hat and a raincoat, looking dreadful. A car swept past carrying two girls who waved and called so I pretended not to see them. It must have been Diana and Sarah! I was mortified.'

Zandra is now the Grand Dame of the British fashion industry and is instantly recognisable with her shocking fuchsia hair: she has designed a bauble for the Buckingham Palace tree, been a guest on the TV series *Absolutely Fabulous* and the Radio 4 show *The Archers*, and has cooked sausages on *Celebrity Masterchef*.

The daughter of a lorry driver and a lecturer at Medway College of Design who met while ballroom dancing, Zandra inherited her love of fashion from her mother Beatrice, who had been a fitter at the renowned British couturier Worth. The family didn't have a television, so Zandra, who modelled for her mother's shows, would listen to the radio and sketch. She won a scholarship to the Royal College of Art in 1962 to study textile design – a fellow student was artist David Hockney. After graduating with a first-class honours' degree, in 1965, she sold her degree print to Heal's in 1965, taught herself to cut fabric and set up a print studio. 'I was proud to be a textile designer, and I did not feel I was inferior to a painter or a sculptor. It was my métier,' she wrote in her book *Zandra Rhodes: 50 Fabulous Years in Fashion*.

However, in 1969, she decided to launch her first solo collection, investing an inheritance from her mother, who died when she was 24 years old, on a trip to America. While in the New World, she was spotted by American *Vogue's* legendary editor-in-chief, Diana Vreeland. Diana hired starlet Natalie Wood to model some of Zandra's designs, including a yellow felt coat, now in London's Victoria & Albert Museum. Stardom soon followed. Her first fashion show, themed 'I Love Lilies', was held in 1972 at the Roundhouse, a hip venue in London's Camden Town. Actress Anjelica Huston walked down the catwalk, Bianca Jagger was in the audience and photographer David Bailey and model Penelope Tree threw an after-show party at midnight. To crown these achievements, in 1973 Princess Anne chose a Zandra Rhodes gown for her official engagement portrait with Captain Mark Phillips.

The clients flooded in: in 1974, Freddie Mercury and Brian May traipsed up the stairs of her attic studio in London's Portobello Road. She recreated the scene for the 2018 Oscar-winning film, *Bohemian Rhapsody*. 'They came at night because I didn't have a changing room,' she recalled, 'and I'd lift things off the rail and say: "Try it on. See how you feel moving around in it."' Two years later, social commentator Peter York, coiner of the term 'Sloane Ranger', included her in an article in *Harpers & Queen* about the artists, designers and personalities who defined the decade. By then she was dressing all the renowned beauties of the day, including Jacqueline Kennedy Onassis and her sister Lee Radziwiłł, Elizabeth Taylor, Lauren Bacall and Bianca Jagger.

Nearly half a century later, Zandra still attracts a celebrity following, including *Sex and the City* star Sarah Jessica Parker, singer Kylie Minogue, model Kate Moss and actress Keira Knightley. But her legacy is the Fashion and Textile Museum, which she opened in a huge warehouse in Bermondsey, south-east London in 2003, selling her home in London's fashionable Notting Hill district to fund it.

The Cherry Blossom Gown

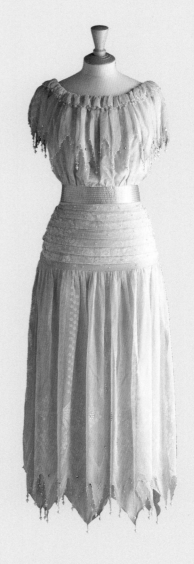

When Prince Charles and Princess Diana visited Japan in 1986, Diana ordered a gown from Zandra Rhodes to reflect the cherry blossom in flower at that time of year. After two fittings and three days, the shimmering rose and white chiffon vision of a dress, adorned with pearls, lace and beads, which had a zig-zag hem with hand-rolled edges, sparkling with rhinestones, crystal beads and pearl droplets, was delivered to Kensington Palace. However, Diana could not wait to wear it. She gave the dress its first outing on 23 July 1985, for a Torvill and Dean party. On 9 May 1986, she wore it to a state banquet in Kyoto, where she was photographed with Charles joking about who managed to eat the most with chopsticks. On 2 July 1987, she wore it to an event at Charleston Manor in Seaford, East Sussex, in aid of the London City Ballet and the Purcell School.

It was sold at Christie's on 25 June 1997 for £16,602, but the buyer then re-sold it at Kerry Taylor Auctions on 11 March 2011 for £31,250. The glamorous gown went to Historic Royal Palaces for their Royal Ceremonial Dress Collection.

Above: The rose and white chiffon gown by Zandra Rhodes.

Opposite: Diana wearing her dress by Zandra Rhodes.

Following pages: Diana wears her Zandra Rhodes dress to a state banquet on 9 May 1986 in Kyoto, Japan.

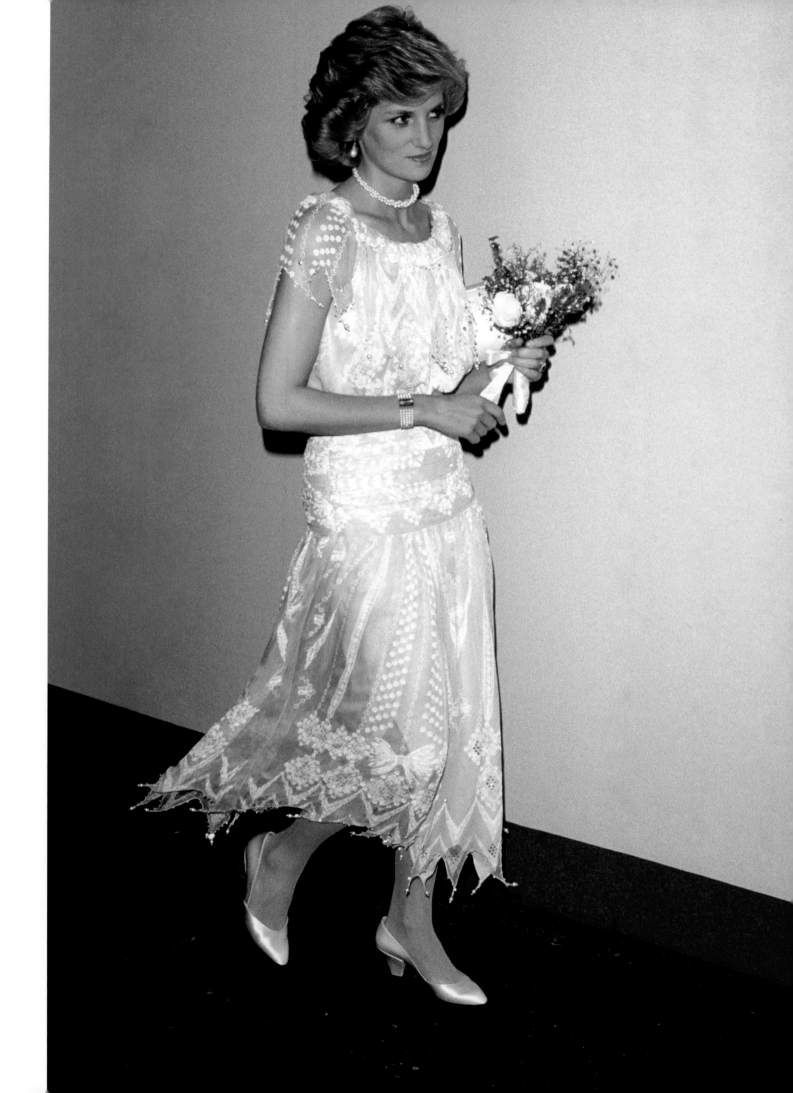

The White Silk Chiffon Gown

As patron of the charity Birthright – now renamed Wellness of Women – Princess Diana was guest of honour at its gala at the London Palladium on 24 June 1987. She wore a shimmering white silk chiffon evening dress with a tulip skirt decorated with pink glass crystals, simulated pearls and sequins.

It was bought by Maureen Rorech at the Christie's Auction for £24,902 but, after she went bankrupt, it was re-sold by Kerry Taylor Auctions on 19 March 2013, for £50,000. The dress can now be found at the Fundación Museo de la Moda.

Above and following pages: The white silk chiffon evening dress by Zandra Rhodes.

Opposite: Diana attends a charity gala in aid of Birthright at the London Palladium on 24 June 1987.

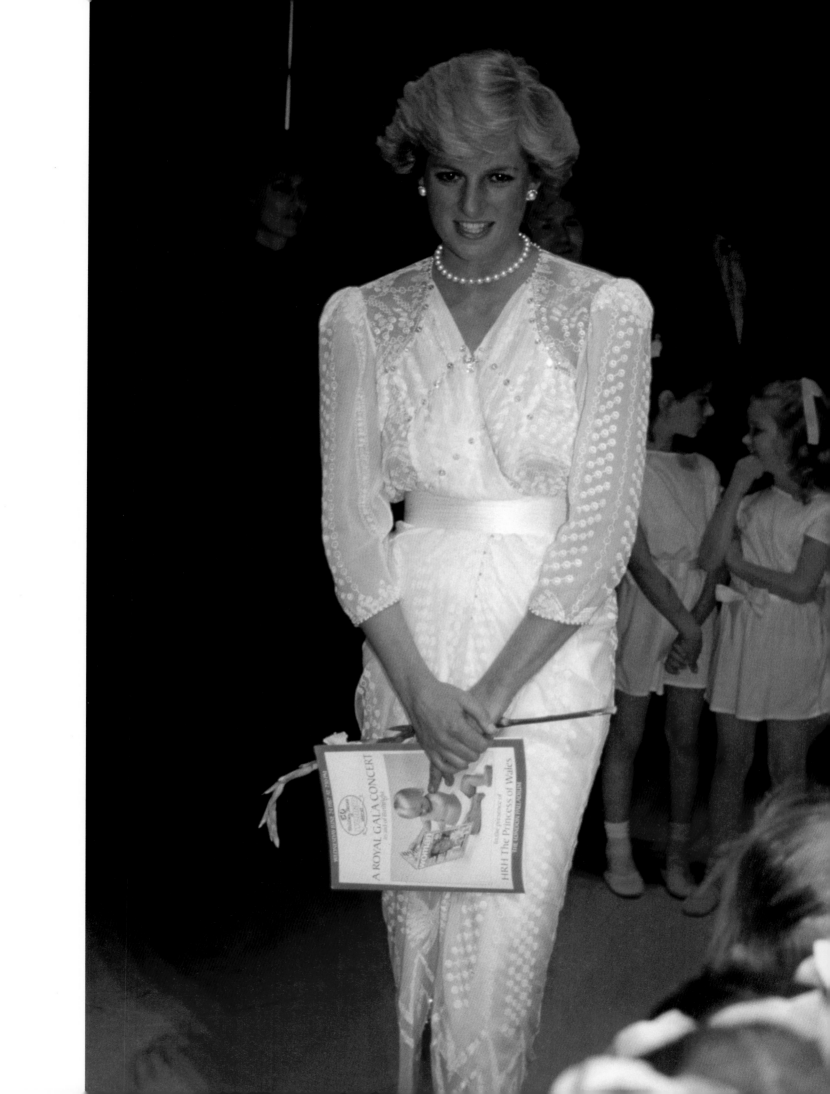

Jacques Azagury

Couturier Jacques Azagury will always remember the day he met Princess Diana. He was showing his 1985 autumn/winter New Romantics Collection at London's Hyde Park Hotel – now the Mandarin Oriental – when *Vogue* fashion editor Anna Harvey tapped him on the shoulder. Anna, who had already featured his dresses in her magazine, said, 'Jacques…I would like you to meet somebody.' 'I turned around and there she was straight in front of me,' he recalled, 'which kind of threw me. Then literally we were just talking. She had this magic of making you feel comfortable and at home within seconds. Whilst I was talking to her, she was looking at a dress, which I wasn't aware of. Then, two or three weeks later we got a call from the Palace saying: "Princess Diana would like to visit your atelier. Would that be ok?" And we were, of course, absolutely delighted. And we said: "Yes. Yes. We would love her to come," and that was really the start of our relationship. I usually take everything in my stride, but I have to admit, every time I saw Diana wearing my clothes I did get very, very excited.'

Jacques and his sister Solange were then invited to Kensington Palace to discuss the dress – a ballerina-length gown with a royal blue organza skirt and black bodice embroidered with blue stars. Diana wore it to a mayoral dinner at the Palazzo Vecchio in Florence, Italy, on 11 December 1985, and a performance by the Vancouver Symphony Orchestra at The Orpheum Theatre in Vancouver, Canada, on 5 May the following year. The dress was then stashed in her wardrobe until she sold it for £15,910 to *People* magazine at the 1997 Christie's Auction.

'Obviously the very first time Solange and I went to the palace together was quite surreal,' added Jacques. 'Going to the palace and sitting there with Princess Diana, having a cup of tea, discussing the dress…We looked at ourselves and thought, "Are we really here?" After that it was which was more convenient. Either I would go to the palace or she would come here. She loved coming to this shop and, before that, going to our workrooms in Soho. I think she liked the atmosphere of the workroom – she would always pop her head in and say hello to the workforce. But a lot of the time, time wouldn't allow her to so I would go to the palace with the dress to do the fittings and come back. I met the children a couple of times when they were just about walking and running around the room while we were trying to do fittings, and they would get taken away.'

By then, Jacques, the son of photographer Marcel and his wife Alice, had graduated from the London College of Fashion and Central School of Art – his graduate collection was snapped up by Browns – and opened his flagship store in Knightsbridge, south-west London. Specialising in eveningwear for an international clientele, he has since dressed some of the world's most glamorous women, including Helen Mirren, Elizabeth McGovern, Sheridan Smith and Amanda Holden.

But Diana was 'the highlight' – he designed at least 18 dresses for her. 'Diana was never the kind of person who took anything for granted,' he said. 'She always insisted on paying full price for the dresses she ordered – and would ring personally, two weeks after they had been delivered, to ensure I had been paid; a rare courtesy. She prided herself on being normal and didn't like standing on ceremony. Whenever I visited her at Kensington Palace, Diana would always greet me at the door instead of waiting for her butler to show me into the drawing room. She did not like conceited formality; she found it oppressive. Even though she was the most celebrated princess in the world, she was determined to remain the person she had always been – natural, kind and completely unaffected. She didn't want to be held in awe.

'I think the reason she came to me for dresses is because she had pretty much an idea of how she wanted to look, which is the way that I would make her look. None of the dresses were actually designed for her. On occasion she would change the colour – or if it was a short dress, it would go long – but it would [be] from the current collection and then we would make it for her. Intermittently, we dropped in and out making dresses for her trips, and things like that, and then I think it was right towards the end when the five of them came one after another. I call them the 'Famous Five'. That's when, I think, she really found herself. It was very much my signature and she knew that, and that's why she came to me. She told me about the auction and she said, "Jacques. I can't bear to part with any of your dresses. I don't want to get rid of those," which was lovely.'

Jacques last saw Diana the day before her 36th birthday when he went to Kensington Palace to fit her for a dress she had ordered. As Jacques recalled, 'It would be the last time I saw her alive. She was very happy, excited, and entirely relaxed. It was as if she had been liberated. She was on fine form, mischievous and full of fun. She showed me some photographs from a session with the celebrated photographer Mario Testino, which had not yet been published. "What do you think, Jacques?" she asked.

'I told her they were fantastic – and they were. It was the first time Diana was shown informally, with her hair messy and barefoot. She looked very fresh, like a teenager. Diana was thrilled the photographer had taught her how to walk like a catwalk model – and couldn't wait to demonstrate. She took the dress from me and went to change. Then she returned to the drawing room where I was waiting and paraded up and down catwalk-style, shimmying and showing how she had learned to "work a train", to walk and turn without the train getting in the way - a difficult skill. We were both giggling our heads off. She was enjoying herself with a child-like delight.'

The Famous Five
The Red Mini

When Diana flew out to Venice for a fundraiser for London's Serpentine Gallery on 8 June 1995, in the middle of her bitter divorce from Prince Charles, she was determined to outshine her rival – Camilla, now Duchess of Cornwall, who had taken refuge in the city's Cipriani Hotel when news of her affair broke. Diana chose the same hotel and was determined to look sensational, selecting a red silk georgette two-piece, which was decorated by hand with red bugle beads.

'Diana came to me a few weeks before the visit,' recalled Jacques. 'I encouraged her to wear a shorter length than usual. She was keen – but also nervous, worried that "people might not like me wearing so short a skirt". I had constant tussles with her over the skirt length – I would be hitching it higher and she would be tugging it down! We settled on a compromise – three inches above the knee. She was thrilled by the resulting publicity. "It's definitely one of my favourites now," she told me with a cheeky grin.'

The outfit was exhibited at Diana's childhood home Althorp and is now believed to be in the Royal Household collection belonging to Princes William and Harry.

Above: The red mini dress by Jacques Azagury.

Opposite: Diana arrives at the Peggy Guggenheim Museum in Venice for a reception as part of the Biennale exhibition, 8 June 1995.

Following pages: Jacques Azagury's sketches of the red mini dress.

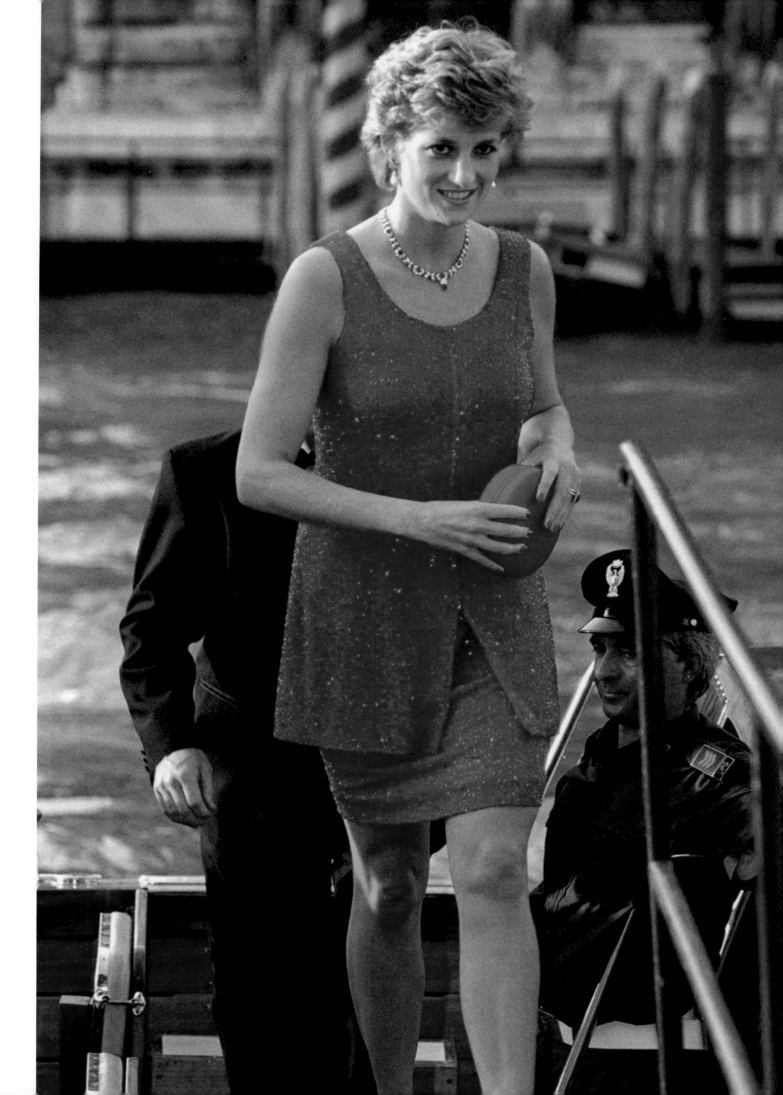

COST...

STYLE No.......

GARMENT DESCRIPTION.......

FOR LENGTH......

FABRIC 1......

WIDTH......

RIC 2. Silk crepe d...

...3.

SKETCH

The Black Fishtail Dress

After the reaction to her red Jacques Azagury number, Diana arrived at Jacques' studio looking for a 'knock-them-dead' dress for the night her infamous *Panorama* interview was screened. She chose a long silk black georgette dress with a sequinned corded lace bodice and fishtail hem, for the gala dinner and fashion show in aid of Cancer Research at Bridgewater House, on 20 November 1995. She wore the dress again on 11 December that year for an audience with world statesmen in New York to raise money for cerebral palsy, surrounded by guests such as Dr Henry Kissinger and General Colin Powell. 'I wanted her to look like a woman – elegantly sexy,' admitted Jacques. 'But even I was surprised when Diana plumped for this dress.

'She had always insisted she did not look too sensual in any dress for a public occasion – she was very aware of her position as a mother and a princess. She would particularly agonise over the depth of the neckline - she never liked to show too many curves. But this time was different. She wanted what I described as a "coming out dress" that would make an unmistakable statement. I picked two, both black, and she pounced on the georgette evening dress with very low-cut cleavage. I was startled, obviously visibly, because the princess queried: "Yes, it is a very sexy dress isn't it...but not too sexy, Jacques?" It was unlike anything she had worn before, very eye-catching, very womanly. Simply, it was a real showstopper. I saw her for a final fitting of the dress on the morning the interview was due to be broadcast. She was resolute, calm and seemed relieved. She told me: "I haven't said anything wrong. I'm just telling people the truth, the way I feel."'

The dress was exhibited at Diana's childhood home Althorp. It is now believed to be in the Royal Household collection, belonging to Princes William and Harry.

Above: The black silk georgette dress by Jacques Azagury.

Opposite: Diana attends a gala evening in aid of Cancer Research at Bridgewater House, London, on 20 November 1995.

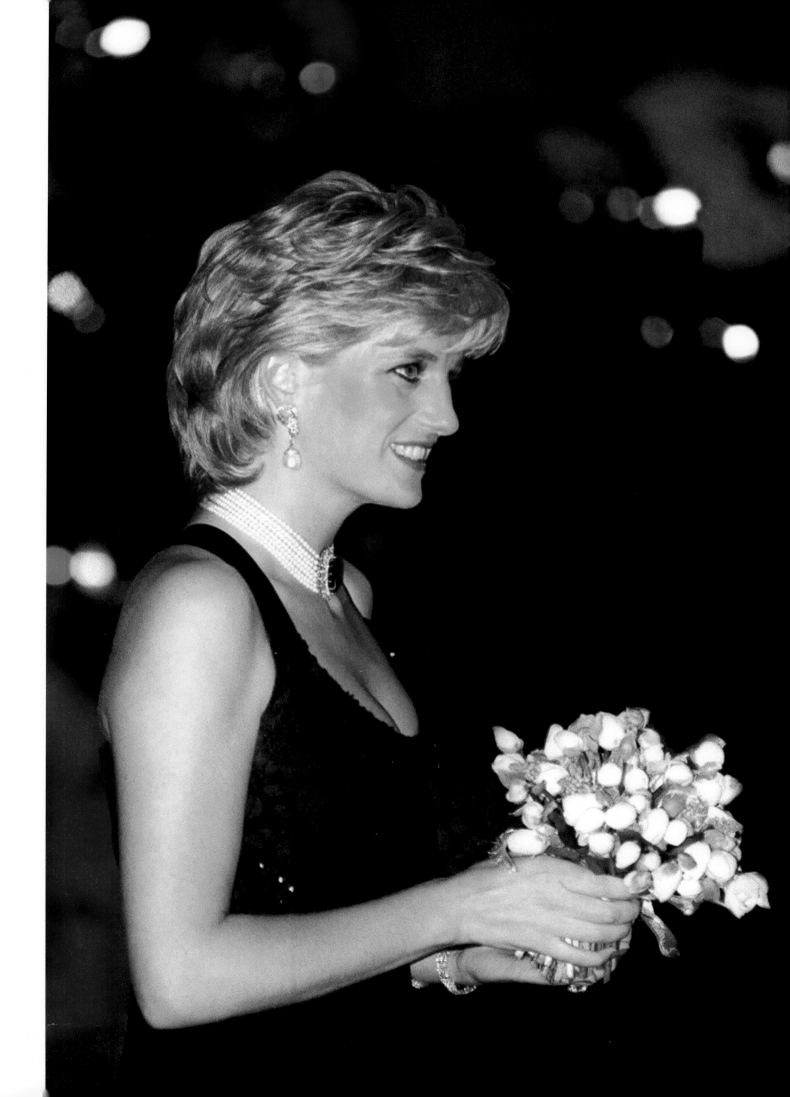

The Ice Blue Shift

One of Jacques' favourite dresses on the Princess, this ice blue silk georgette number was hand decorated with crystal bugle beads, set off by bows on the straps. Diana wore it on 3 June 1997 for a Royal Gala Performance of *Swan Lake* at London's Royal Albert Hall. 'She loved that dress so much that I thought how nice would it be if I made her a long version of it,' recalled Jacques. 'So, for her 36th birthday, I made her a black Chantilly lace dress based on the little blue dress, which I gave to her as a birthday present. She sent me a really lovely letter saying how thrilled she was to wear it. I think I worked with the Princess very well in the way that it was a very informal relationship. We regarded each other as friends, basically. She would come here; she would go into the shop – she loved going into the workroom, talking to the girls. We had a very relaxed way of working together.'

The dress was also exhibited at Diana's childhood home Althorp and is now believed to be in the Royal Household collection, belonging to Princes William and Harry.

Above: The blue silk georgette dress by Jacques Azagury.

Opposite: Diana attends the English National Ballet's Royal Gala Performance of *Swan Lake* at the Royal Albert Hall on 3 June 1997.

Following pages, left: Jacques Azagury's sketch of the dress.

Following pages, right: Detail of the straps of the dress.

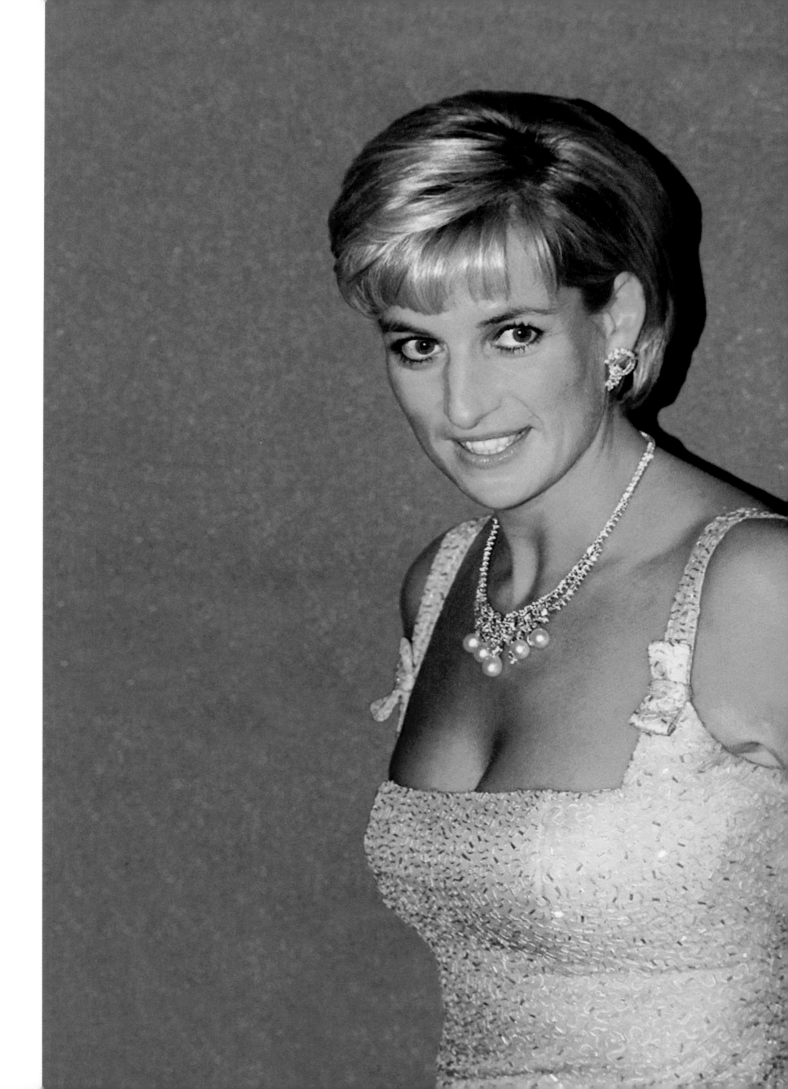

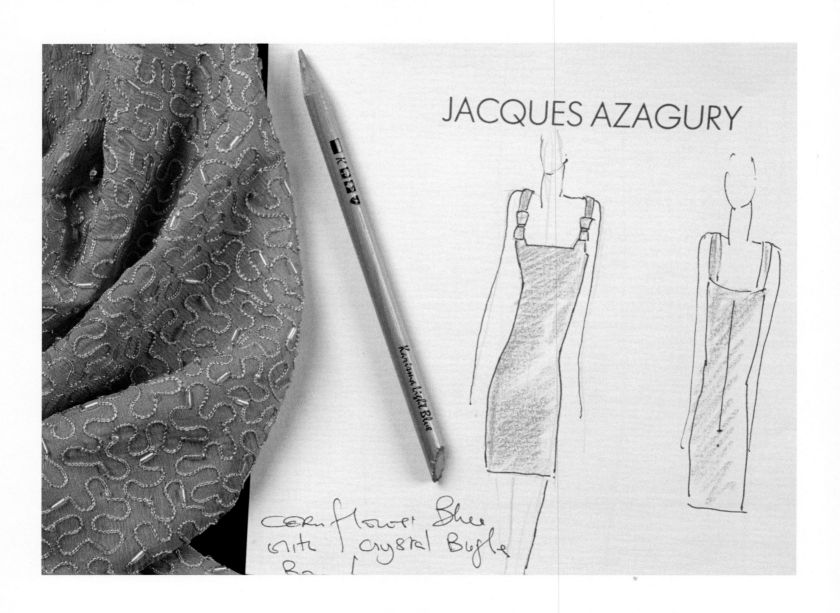

JACQUES AZAGURY

Kornano Light Blue

Cornflower Blue
with crystal Bugle
B...

The Lady in Red

Diana chose a red silk Jacques Azagury column dress for the Red Cross Gala dinner in Washington DC on 17 June 1997. She looked sensational – its hand-beaded bodice of red bugle beads, low-cut back, long skirt and matching sash, which was trimmed at the end in red bugle beads, perfectly complemented her skin tone. 'The Princess always looked amazing in red,' said Jacques.

The dress was exhibited at Diana's childhood home Althorp. It is now believed to be in the Royal Household collection, belonging to Princes William and Harry.

Above: The red column dress by Jacques Azagury.

Opposite: Diana attends an American Red Cross fundraising gala in Washington DC, on 17 June 1997.

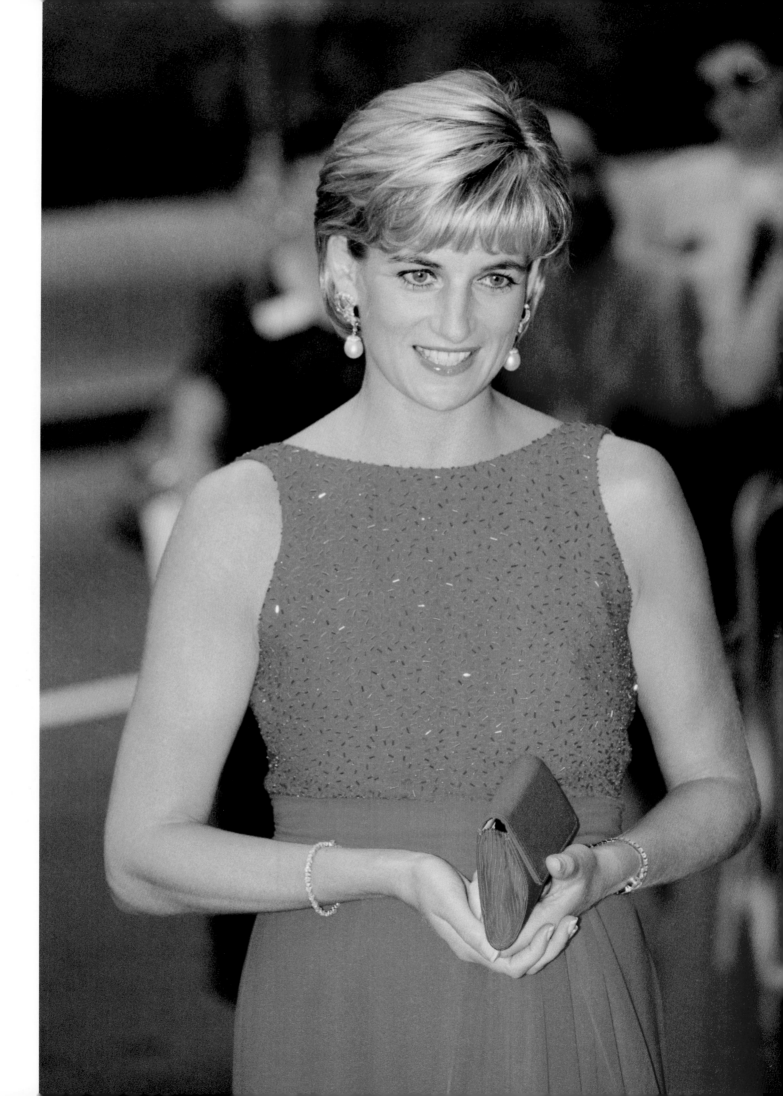

The Black Chantilly Lace Dress

When Jacques fitted Diana for the final dress he made her, on the day before her 36th birthday, he had a surprise up his sleeve. He had created a long version of her ice blue gown in black Chantilly lace, embroidered with sequins and beads. The dress was delivered to Kensington Palace for the Princess's birthday on 1 July 1997, and Diana chose to wear it that evening to a gala dinner to celebrate the centenary of the Tate Gallery. There she mingled with guests including Lady Helen Taylor and supermodel Iman.

'Of course, Diana did not realise that I was also using those sessions to ensure the dress I intended as a surprise gift to her was also a perfect fit,' said Jacques. A few weeks later, Jacques was on his way to his shop, when he spotted Diana's chauffeur parked outside. He recalled, 'Her driver climbed out holding a large parcel, wrapped with navy blue ribbon. He said: "Princess Diana has asked me to give this to you. She wanted you to have it before she left." Inside was a framed picture of her wearing three of my dresses, her favourites. It was a unique gift, one that she had prepared herself as a "going away" present. It was the last token of her affection that I ever received.'

Like the other 'Famous Five' garments, this dress was exhibited at Diana's childhood home Althorp and is now believed to be in the Royal Household collection, belonging to Princes William and Harry.

Above: The long version of Diana's ice blue gown in black Chantilly lace, by Jacques Azagury.

Opposite: Diana wears her Jacques Azagury lace dress to a gala evening to celebrate the Tate Gallery's centenary on 1 July 1997.

Following pages: Diana visits the Tate Gallery on the night before her 36th birthday, 1 July 1997.

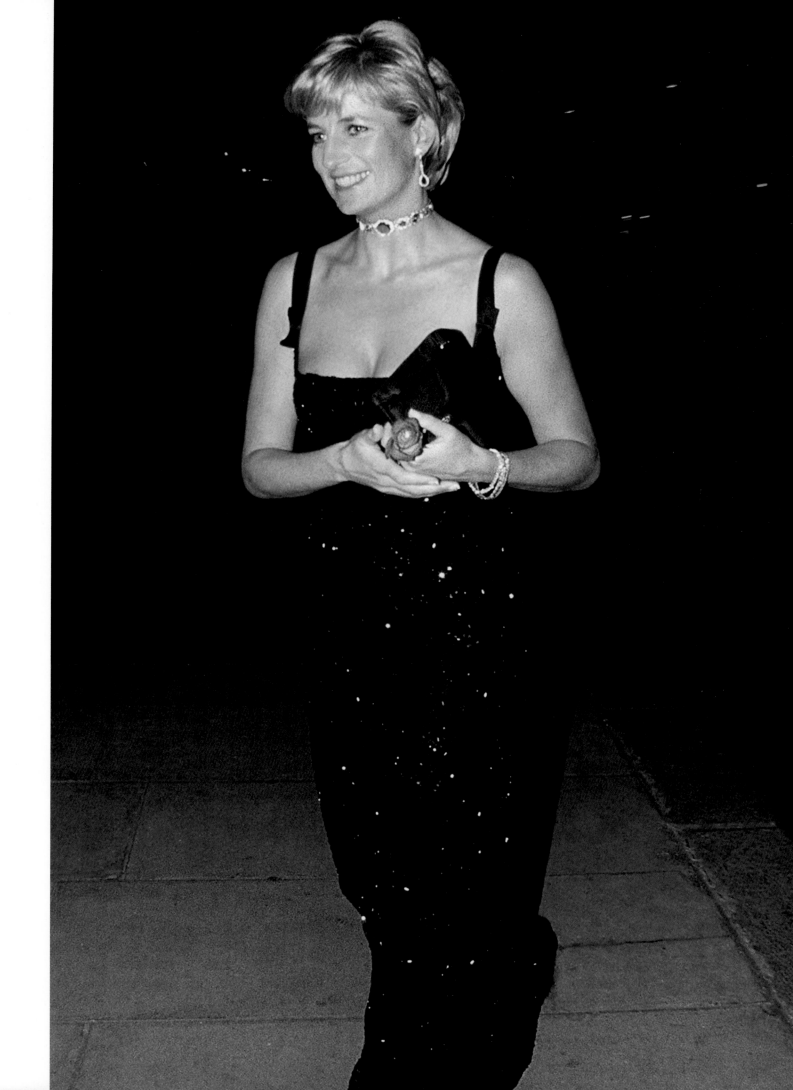

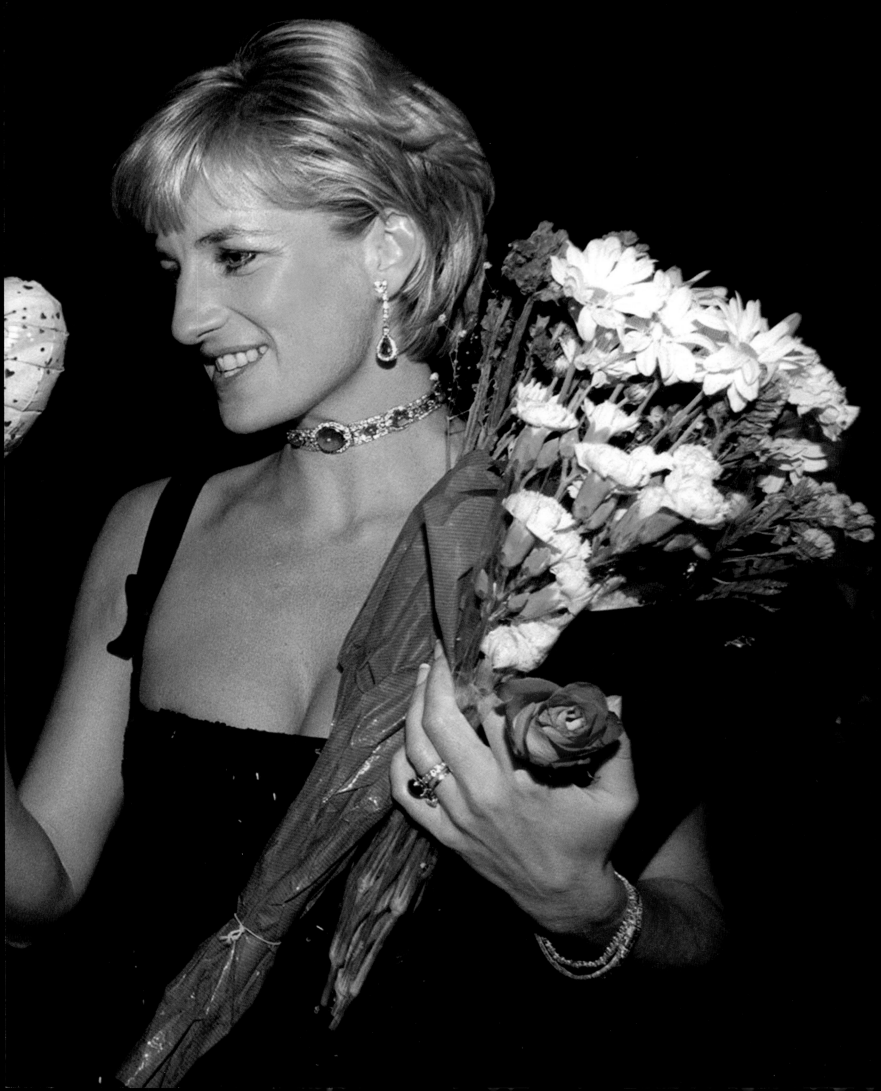

Katherine Cusack
The Blue Velvet Gown

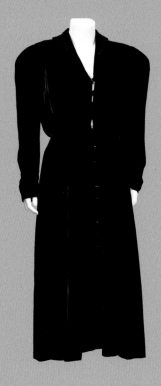

S hopping in London's exclusive department store Harvey Nichols, Princess Diana spotted a display of black velvet dresses by Katherine Cusack, which she liked. Her stylist Anna Wintour then contacted the designer, asking if she would make the frock, which had pleats to the bodice and skirt, a graduated collar couched and embroidered in blue silk, and padded shoulders, in midnight blue, in a size 12. Diana – who was president of the Royal College of Music, the oldest conservatoire in the United Kingdom – wore it to attend a choral concert at the academy with Prince Charles on 26 January 1986. She teamed the dress – a one-off for the Princess – with the sapphire choker and earrings that were a wedding gift from Saudi Arabia.

In an online interview, costumier Josie Stone, who made fashion samples for Katherine, recalled making the dress: 'I think Katherine advertised in *The Stage* and she wanted to start doing semi-couture work. I'd make her samples and then she'd have a party and invite all these quite wealthy people to her lounge. It was a beautiful Edwardian house in Grafton Square in Clapham Common. Then she managed to get into Liberty's and that Christmas the whole front had all the dresses that I'd made. It was a beautiful silk velvet in a beautiful deep blue. It had long sleeves and rouleau loops with little buttons all the way down…Katherine was over the moon. But it was real pain to make because silk velvet takes its own route. It's not the easiest of fabrics to work on because it's so soft. It is beautiful but it's not easy to make. You've got to have the right feed on your machine otherwise when you're joining the seams up, you'll lose it and it will be longer on one end.'

The dress was sold by Kerry Taylor Auctions on 9 December 2019 for £60,000 and is now in the Fundación Museo de la Moda.

Above: Diana's midnight-blue velvet dress by Katherine Cusack, for auction in London.

Opposite: Diana attends a choral concert at the Royal Academy of Music, London, on 26 January 1986.

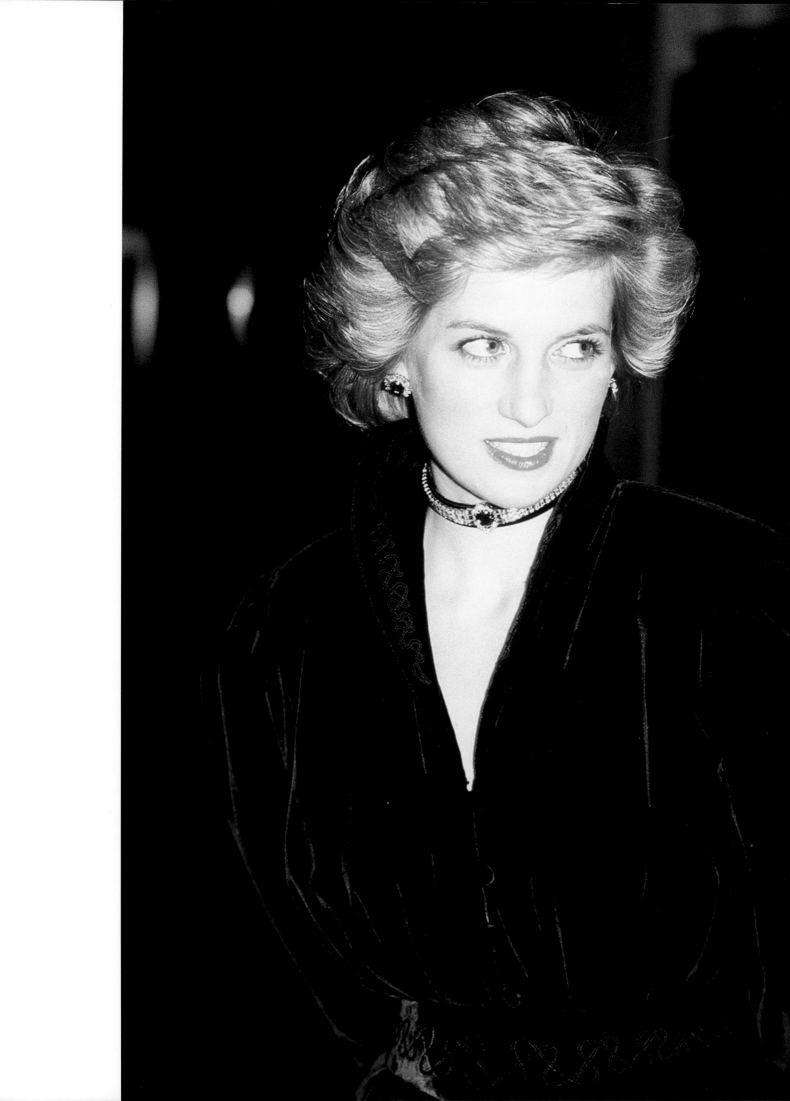

Yuki
The Diplomatic Dress

Japanese designer Gnyuki 'Yuki' Torimaru was introduced to Diana through a close friend, who knew that she was going on a state visit to Japan. Yuki presented her with a choice of three dresses – in red, white and blue, the colours of the UK flag – and she chose the royal blue number to match her engagement ring. Yuki, who was inspired by the designs of Spanish designer Fortuny and Russian illustrator Erté, spent the whole tour keeping an eye out for the dress, which was decorated with blue bugle beads at the neckline and waist. He slowly became convinced that Diana would not wear it. However, to his surprise, the princess had saved it for her final – and most important – engagement: a banquet with Emperor Hirohito. She teamed the dress at the dinner, on 12 May 1986, with a sapphire and diamond headband made from jewels which she had had reset from the Saudi Suite, setting a trend which was much copied. After Diana's death, Yuki, who also designed for Bianca Jagger and Jerry Hall, said: 'When she died, the days grew darker.'

Born in Miyazaki, Japan in 1937, Yuki studied architecture before becoming a textile engineer. He moved to London in 1964 and attended the London College of Fashion. After graduating in 1966, he trained with some of the great couturiers of the day: Louis Feraud, Sir Norman Hartnell and Pierre Cardin. He launched his own designer label collection, Yuki, at Harvey Nichols in 1972.

His diplomatic dress was auctioned by Christie's at their 1997 sale. It was bought by New York art dealer James Kojima for £15,218, on behalf of his cousin Akihiko Kojima, principal of the Mejiro Fashion & Art College. Akihiko's wife Chieko, a faculty member of the college, said: 'I picked this one because it is evidence of UK–Japan friendship...when the [Japanese] media wants to talk about Diana, this is the most famous dress because of its Japanese designer.'

Above: The royal blue evening dress designed by Yuki.

Opposite: Prince Charles and Princess Diana at a dinner hosted by Emperor Hirohito in Japan on 12 May 1986.

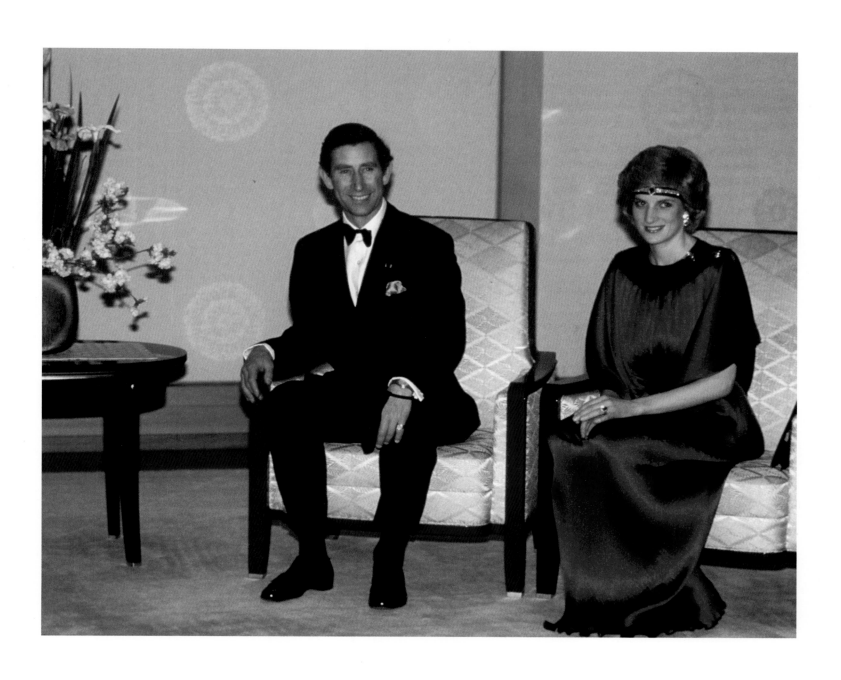

Murray Arbeid
The Star Attraction

The late designer Murray Arbeid got his wrists slapped by the Queen of Jordan when Diana wore his ballerina-length midnight blue strapless dress, adorned with diamanté stars, for a spectacular ball hosted by King Constantine of Greece on 12 July 1986. 'She wore it to King Constantine's birthday party at Claridges,' he said afterwards. 'The next morning, I got a call from the Queen of Jordan, for whom I'd made the same dress. "Don't ever do that to me again," she said. "I nearly died when I saw her because I almost wore that dress last night." I almost got thrown into the Tower, or off a minaret.

'That dress was a very, very successful dress in the collection and there are certainly more than one of them. I would like to say, many more – there are possibly 15, 20 of them still floating around. It was a very good evening dress and after all, the Princess never said: "This has got to be the only one, you mustn't make it for anybody else." Simple as that.' Diana loved the dress, which had four layers of tulle and a deep purple silk petticoat. She wore it another three times before selling it at Christie's in 1997, notably teaming it with long pink gloves to attend the première of *The Phantom of the Opera* on 1 February 1986, and to a gala performance of *Cinderella* at the Royal Opera House in London's Covent Garden on 16 December 1987. After wearing it to Paris in 1988, it remained in her wardrobe until she wore it for a shoot for the Christie's catalogue with Lord Snowdon. It sold for £29,053 to wedding dress designer Pat Kerr, a friend of the Princess, who bought three other dresses. It is now in the Pat Kerr Private Royal Collection.

Murray, who described Diana as the 'perfect client', was the son of a master diamond-cutter. He was immersed in the garment trade from his childhood in the East End, describing himself as a 'garmento'. He studied at the London Institute of Fashion before joining Michael Sherard, who ran a couture house in London after the war, as an apprentice. During the 1950s, he opened an eponymous salon for his cocktail and eveningwear in George Street, West End, with his partner, milliner Frederick Fox. The store was a success, later relocating to Bond Street, Sloane Street and Ebury Street, Belgravia.

'Others do day clothes better,' said the designer, who also dressed Princess Alexandra, Queen Noor of Jordan, Estée Lauder, and the romantic novelist Danielle Steel, 'so let them get on with it,' joking that if there were a Nobel prize for taffeta, he would have won it. The designer was well known for his sense of humour: when *Vogue* asked him to provide a dress for a photo shoot, and included only a slither of yellow chiffon with the caption 'Dress by Murray Arbeid', he framed the photograph and hung it on his wall. In 1985, he paraded his models down the aisles of a Continental Airlines flight from London Houston, describing it as 'a bit like Dallas without the sex', and at the end of his 1989 leopard-print collection, a Tarzanesque figure threw him over his shoulder and carried him off the catwalk.

Above: The navy blue tulle dance dress by Murray Arbeid.

Opposite: Diana at the première of *The Phantom of the Opera* on 1 February 1986.

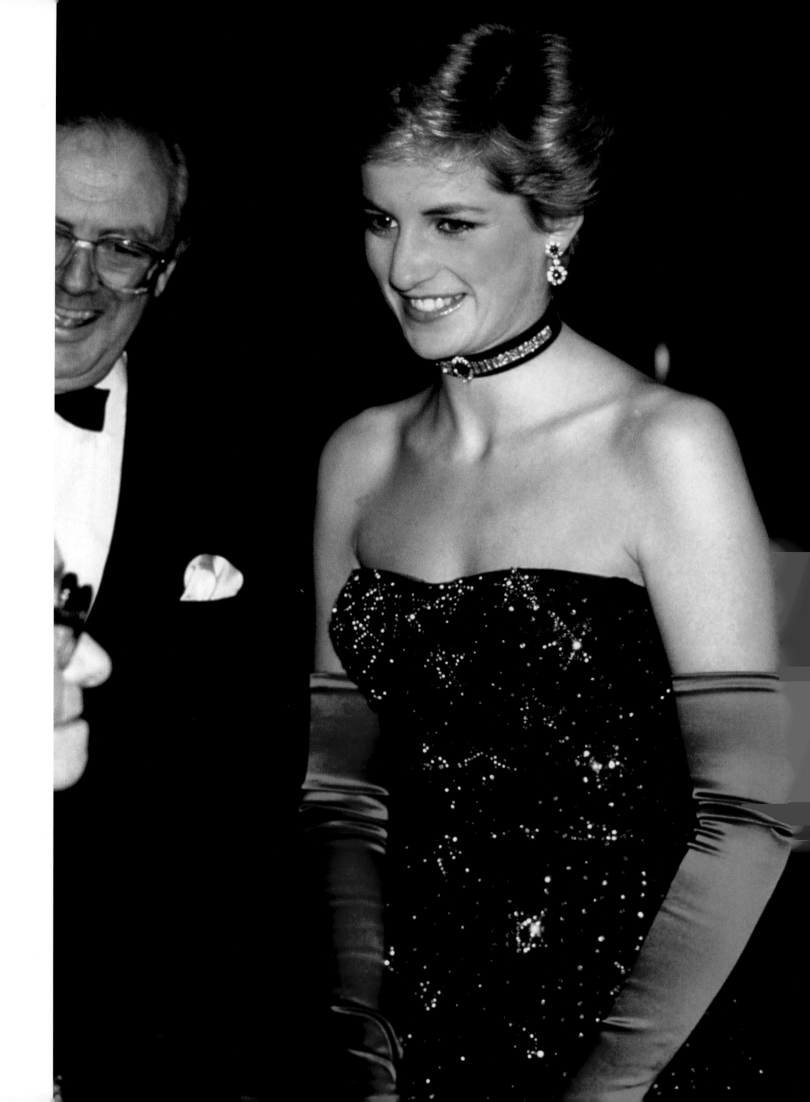

Escada

Shortly before her engagement to Prince Charles, Diana walked into the Escada shop in London's Knightsbridge and tried on an apple green evening dress. It was the start of a relationship that lasted throughout her marriage – she would exit the car, dash into the Escada store in Bond Street, rifle through the rails, pick something, pay for it and run out again. 'Long before we got to know her officially – I think it was before she became engaged – she came into our Knightsbridge shop in a green Loden coat and tried on an evening dress in apple green tulle by Nettie Vogues,' recalled Robina Ziff, who owned the store, in an interview at the time. 'She really liked it, but she said: "I must ask Daddy, because it's awfully expensive!" I'll always remember that.'

Shortly afterwards, her engagement to Prince Charles was announced. Once married, Diana chose to wear Escada, a German fashion label, for a visit to Berlin on 1 November 1987: a yellow-and-black checked coat that she donned for a welcome ceremony at the Rathaus. But her most memorable – and controversial – ensemble came from Escada's 'Safari Collection'. She chose a £685 black jacket with gold elephants embroidered on the cuffs, a £71 tie dotted with gold elephants, and a £165 belt whose buckle appeared to many to depict a pair of elephants mating, on a visit to St Mary's Hospital, in Paddington, to meet her newborn nephew Louis on 14 March 1994 – a bold choice that divided the fashion pack. The tie, which was gifted by Diana to the children of a friend in 1995, was sold on 18 June 2013 by auctioneers Reeman Dansie in Colchester, Essex, for £3,800.

'I shall never forget the Escada elephant episode,' added Robina. 'We had the whole of Fleet Street banging down the doors. At the time, I was asked to go on a television programme as everyone was saying that Diana looked like an Essex Girl in the outfit – which I couldn't do, as it would have been an indictment on all my clients. So, I decided I would have to phone the Princess and warn the Palace that there had been something of a catastrophe. Ten minutes later the phone rang and it was Diana's dresser to tell us that she had informed the boss and had been instructed to tell us please, not to worry. Apparently, Diana had said: "The only way I can stop them is to put a sack over my head!"'

Founded in 1978 by Margaretha and Wolfgang Ley, the German label's head designer was Brian Rennie, a Scotsman who left the Royal College of Art, London, in 1976. Having landed a job at Escada in Munich, he worked his way through the ranks until he became the boss, heading a team of 28 designers and jetting around the globe to dress popstars, movie stars and top models. Brian developed an interest in fashion when he was a teenager, much to the bemusement of his father Andrew, a lorry driver, and spent hours watching his mother Margaret, who was a keen dressmaker, at her sewing machine. He studied fashion and fabric in Sixth Form, getting 'a lot of stick' because he was the only boy in the class.

One of his first celebrities, in 1997, was a then-unknown Jennifer Lopez. 'I got a call asking me to design a wedding dress for a girl called Jennifer Lopez, who I had never heard of. Her agent said she was about to be a big star as she'd just made her first movie, *Anaconda*. But no designer was interested in making a dress for her because she was still unknown. So, I decided to go for it, and it's my creation she wore when she married her first husband, the Cuban waiter Ojani Noa.'

The orders poured in. After Joan Collins opened the company's Sloane Street branch in 1987, Brian dressed *LA Confidential* star Kim Basinger for the 1988 Oscars; dressed Welsh stunner Catherine Zeta-Jones for the Glamour Awards in New York in 2005; designed a dress for *Thelma & Louise* star Geena Davis when she picked up a Golden Globe in 2007; and became a friend of actress Jane Seymour after flying to meet her on the set of *Dr Quinn, Medicine Woman*. However, in 2010, Brian left Escada to head up a design team for bra queen Michelle Mone's new Ultimo Collection – a range of evening dresses available exclusively from Debenhams. Within eight months, the partnership was over – Brian ditched Ultimo for German label Basler and moved back to Munich.

The Pink Suit

Diana wore her pink Escada suit for three public appearances: on 18 May 1989, when she addressed a Silver Jubilee Symposium on 'Alcohol and Drugs at Work', held by the charity Turning Point at London's Whitbread Brewery; for the Push 2 wheelchair race on 1 July 1989; and on 15 May the following year, for a visit to Westminster Hall for The Abbeyfield Society Annual General Meeting.

The Princess & The Platypus Foundation bought the suit for £3,370.33 from the Mid-Hudson Auction Galleries in New Windsor, New York, on 7 August 2021. It is now on display in the Princess Diana Museum, an interactive 3D archive.

Above: The pink Escada suit.

Opposite: Diana wears the pink Escada suit.

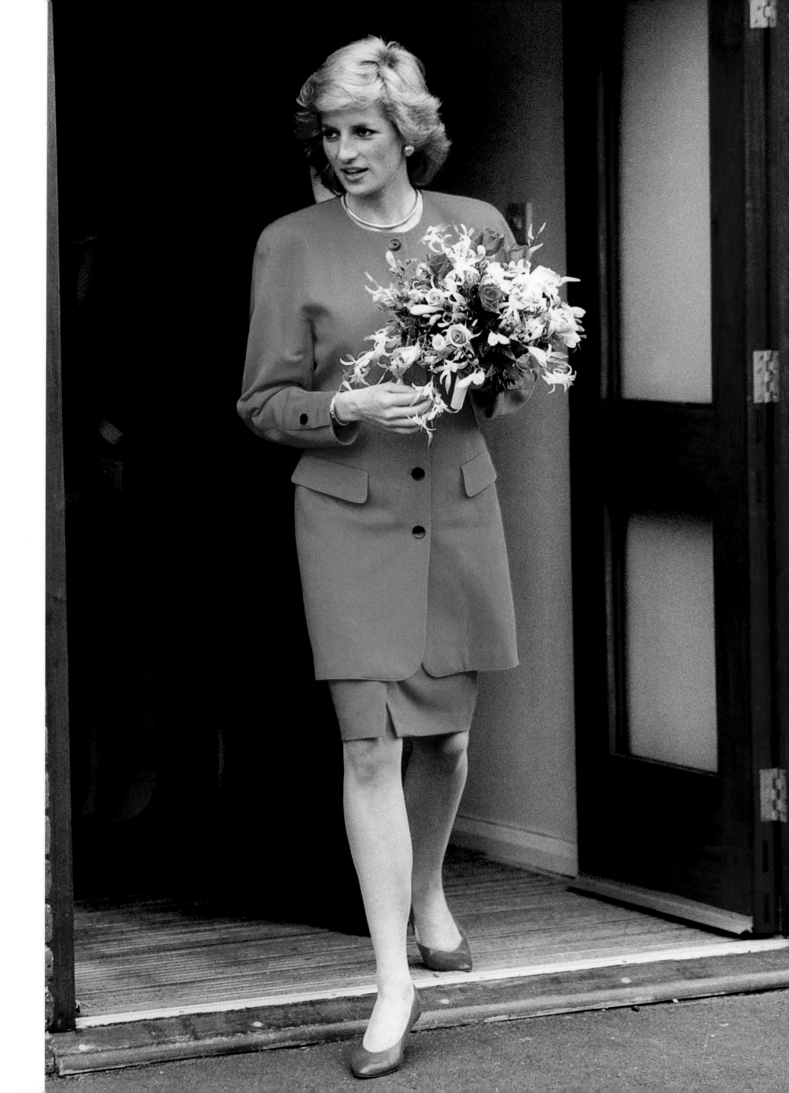

Chanel

Diana's relationship with Chanel was complicated. Its logo, two intertwined Cs, the initials of its founder Coco Chanel, initially reminded her of her husband's mistress, now Duchess of Cornwall: Camilla had given Charles a pair of cufflinks with entwined Cs, similar to the Chanel logo, and he wore them on their honeymoon. 'I said: "Camilla gave you those, didn't she?"' she said in a taped conversation with her voice coach Peter Settelen, which was broadcast in the Channel 4 documentary *Diana: In Her Own Words*. 'He said: "Yes, so what's wrong? They're a present from a friend." And boy, did we have a row. Jealousy, total jealousy. And it was such a good idea, the two Cs, but it wasn't that clever.'

However, as her marriage drew to a close, Diana embraced the French label, wearing a navy Chanel suit and matching bag in the same blue as her sapphire engagement ring to visit a school in Newcastle on 9 December 1992 – the day that Prime Minister John Major announced her separation from Prince Charles. After her divorce was finalised on 28 August 1996, Diana championed Chanel; the sleek, elegant and timeless creations suited her new lifestyle, free from the constraints of her life as a royal. She chose a pale blue tweed suit with a matching pillbox hat, reminiscent of style icon Jackie Kennedy, for Prince William's confirmation on 9 March 1997.

Detail of Diana's red Chanel coat.

The Red Coat

It was Princess Diana's first tour to the fashion capital of the world and Diana consulted her stylist, *Vogue* fashion editor Anna Harvey, about her wardrobe. The pair agreed that there was only one possibility – Chanel. Her personal hairdresser Richard Dalton, who was responsible for some of her most iconic looks – the string of pearls down her back; the jewelled choker she wore as a headband – agreed. So, when the Princess arrived at Orly Airport, Paris, on 7 November 1988, she teamed a red Chanel coat from the designer's fall/winter collection with a matching hat and one of Chanel's signature quilted bags. 'We had a chat and I said it would be wonderful to step off the plane wearing a French designer,' Anna said afterwards. 'Chanel was the obvious choice, so that was the beginning of the relationship.' Later, Hayat Palumbo, a very elegant woman, took Diana to the couture salon in Paris, and she ended up with a few suits.

Diana gifted her red coat to a member of her Kensington Palace staff, who later donated it to charity. The coat was bought by The Princess & The Platypus Foundation, and it is now on display in the Princess Diana Museum.

Above: A rear view of Diana's red coat from Chanel.

Opposite: Diana arrives at Orly Airport in Paris, France, on 7 November 1988.

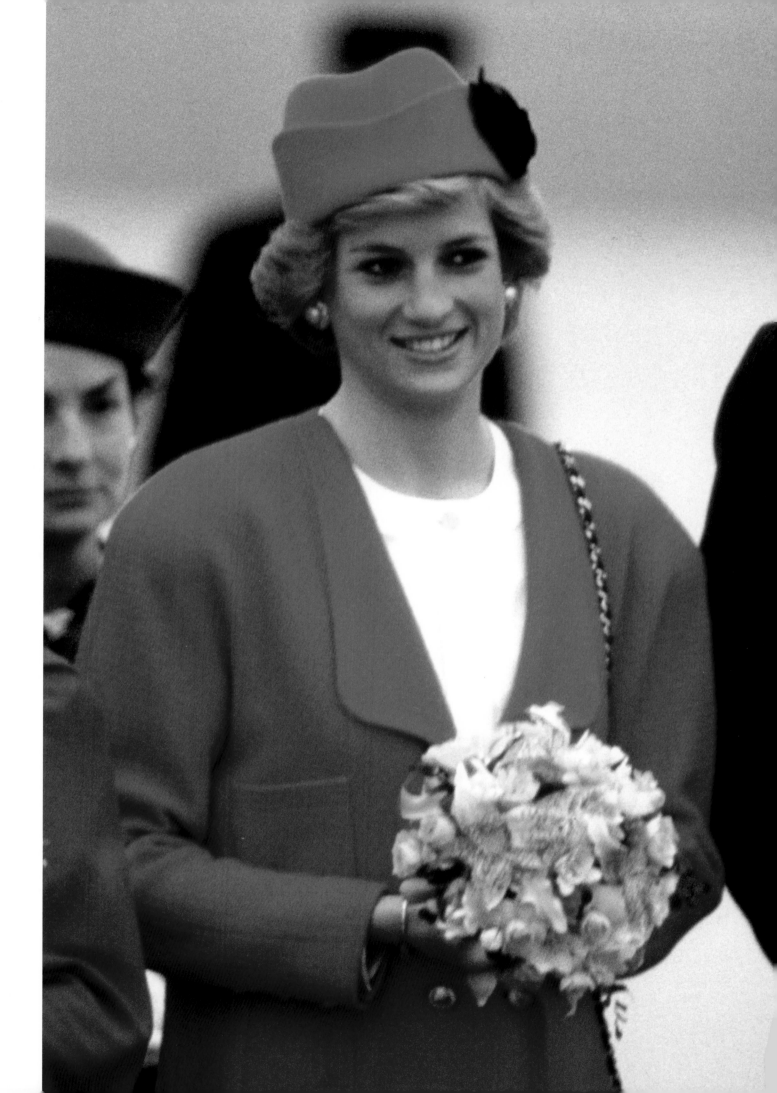

The Mint Green Suit

Diana loved her mint green Chanel suit. She wore it on Valentine's Day, 1997, to open a new renal unit at London's Great Ormond Street Hospital, and again while shopping in New York on 23 June 1997, teaming it with a white Chanel bag. She was in the city for the Christie's auction — however, that shopping trip was the final time she would wear the label: within three months she was dead.

When Diana's older sister Lady Sarah McCorquodale was clearing Diana's wardrobe, she gifted the suit to the personal valet of her late father, Lord Spencer. The valet had been helping her categorise it, for his wife. When his wife died in 2018, he sold it and it ended up in a charity store. It is now owned by The Princess & The Platypus Foundation, and it is on display in the interactive 3-D Princess Diana Museum.

Above: The mint green Chanel suit.

Opposite: Diana opens the new renal unit at Great Ormond Street Hospital, London, on 14 February 1997.

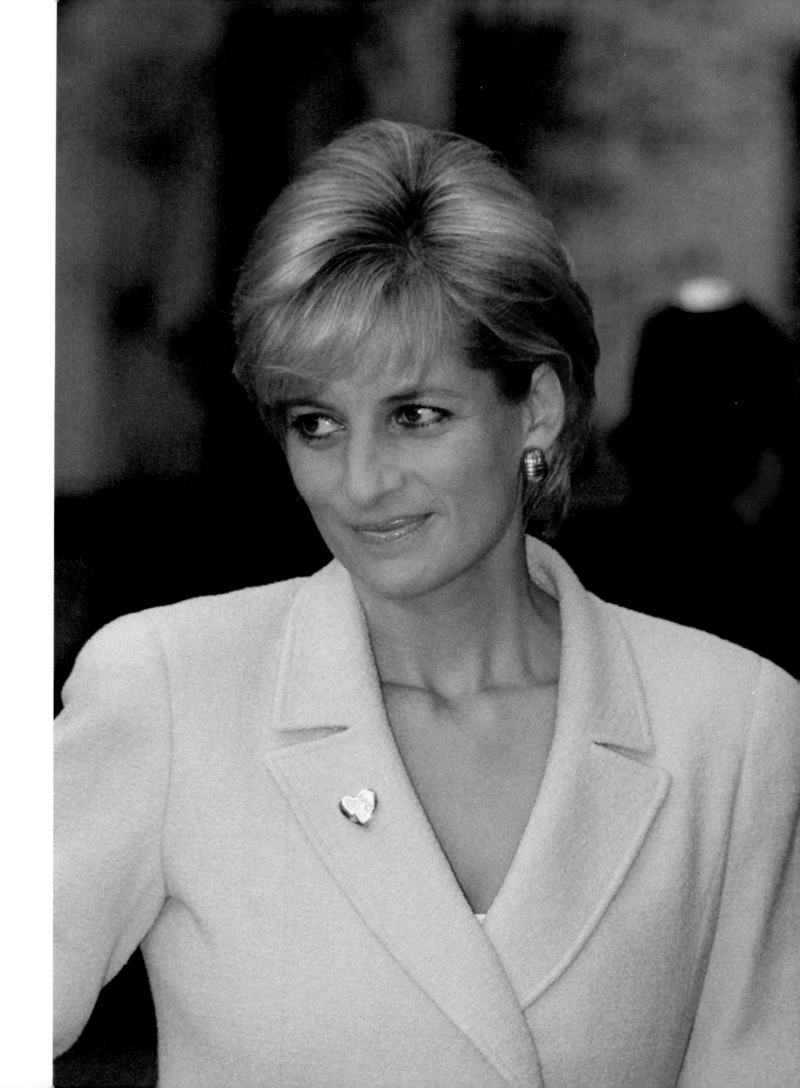

Tomasz Starzewski

The date was 16 September 1989, and couturier Tomasz Starzewski was attending the wedding of Charles, 9th Earl Spencer, at the family seat Althorp in Northamptonshire. A friend of the groom, he had designed the wedding dress for model Victoria Lockwood, who went onto become mother of Charles' eldest four children: Lady Kitty Spencer, twins Lady Eliza and Lady Katya, and the heir apparent, Louis, Viscount Althorp. The stunning garment, which was created in champagne French lace and Russian sable fur, was inspired by a Spencer portrait. After watching the ceremony, in which Prince Harry was a pageboy, Tomasz was introduced to the Princess of Wales.

She went on to regularly visit his first shop, opened in 1990, and bought outfits from him every season until her death. 'I had a little shop on the Old Brompton Road,' recalled the designer, who has also dressed the Duchess of York, the Duchess of Cornwall, and the Countess of Wessex. 'It's a hamburger joint now. It had a lot of privacy, so she left her private detective outside the door, wandered in, browsed and tried things on. I approached Racheal Barnes from Hardy Amies – The Queen's couturier – who was old school and knew the whole protocol. We knew how to deal with the Princess of Wales.'

Tomasz remembers vividly the first time Diana popped in: 'She bought straight away,' he said. 'I remember her buying a white jacket with multi-coloured buttons with a navy skirt and a mint and coral wool crepe dress with a horizontal pleated skirt. She wore the suit in public but not the dress. We were never told when she was coming. She would just appear. I think that's from the security point of view. Appointments and fittings were set in the diary. She only ever bought Ready to Wear. If it looked good, she would buy. There was never room for error. If she put it on and it fitted, she would buy. But if it didn't look good, she would not touch it because of the mistakes of the past. She wasn't prepared to take that risk. I think I only ever fitted at Kensington Palace twice. It was an attractive apartment, with a wonderful staircase leading up to the formal rooms. And the portrait at the top of the stairs was of her in an organdie blouse. I think it's one of the most beautiful portraits of her.'

Tomasz' most 'symbolic' outfit for the Princess was the pale pink suit. She wore this outfit when she visited Japan on 6 February 1995, in the wake of the Kobe earthquake, to speak at Tokyo's National Children's Hospital. Capturing the hearts of the nation, she spoke a few words in Japanese: 'Nihon no mina sama, mata koreta koto ureshi to omoimasu' ('Honourable people of Japan, it is lovely to be here again'). The Princess, who was undertaking her most important foreign trip since her withdrawal from public life, had undergone coaching lessons to master the phrase phonetically. She then rehearsed the speech on her personal stereo during the 12-hour flight to Tokyo.

'For a British designer to be supported by the Princess of Wales it was a fantastic thing because it was very clean, very correct, and very supportive,' added Tomasz, who also designed for Baroness Thatcher, Joan

Collins and Stefanie Powers. 'That was the wonderful thing that she only publicly wore British. There would be clothes that would be chosen specifically for a foreign trip that had to be correct in the colour and style for the country. I think there was an understanding that you support Britain.'

By the time Tomasz met the Princess, he had been designing for more than a decade and was renowned by his transatlantic clientele for his exquisitely tailored suits and block colours. Born in London of Polish parents, he was inspired to become a fashion designer by his grandmother, who was a couturière in pre-war Poland, and his mother, who was a skilled seamstress. He trained at London's prestigious St Martin's School of Art, studying in the year below designer John Galliano. However, after he and some of his fellow students were failed in their second year, they hired out the ballroom at Mayfair's Park Lane Hotel and put on a fashion show, gaining sponsorship from the *Financial Times*. Their gambit paid off and the show gained critical acclaim, leading to backing for the next show from society bible *Harpers & Queen*.

That year, Tomasz set up his eponymous label, which was quickly snapped up on both sides of the Atlantic. He opened a first-floor studio in London's Fulham Road and began selling to Bergdorf Goodman, Neiman Marcus, Bloomingdale's and Saks Fifth Avenue. He later moved to Old Brompton Road, and finally to Pont Street in 1990, opening the first new couture house in London for 40 years. He moved to Sloane Street in 1996 and is now based in nearby Ebury Street, in London's Belgravia. 'I've always had a very Upper East Side Park Avenue clientele,' he explained. 'Very chic, very Paris led, very couture. They looked to Paris – to Yves Saint Laurent or Chanel.'

In a poignant twist, Diana chose to wear a white Starzewski suit with a blue trim for her final public engagement with Prince Charles: the VJ Day commemorations on 19 August 1995. The dress was later displayed at her childhood home, Althorp. 'We did the last public engagement for Princess Diana and then the first public engagement with the Duchess of Cornwall,' recounted Tomasz.

The Cocktail Gown

Ironically, the cocktail dress that put Tomasz on the map was not bought from his shop but from boutique owner Lucienne Phillips, who exclusively supported upcoming British designers at her shop in London's Knightsbridge. When the Princess wore the £980 rose pink dress with horizontal black silk faille ribbons for the première of the Puccini opera *La Bohéme*, on 14 September 1991, the telephone rang off the hook. 'That's the dress which changed my career,' said Tomasz. 'Lucienne called me afterwards and it became her biggest seller. She sold more than 300 of those dresses in the end.'

The dress is now in the Fundación Museo de la Moda.

Diana attends *La Bohéme* at Sadlers Wells
Theatre in London, on 14 September 1991.

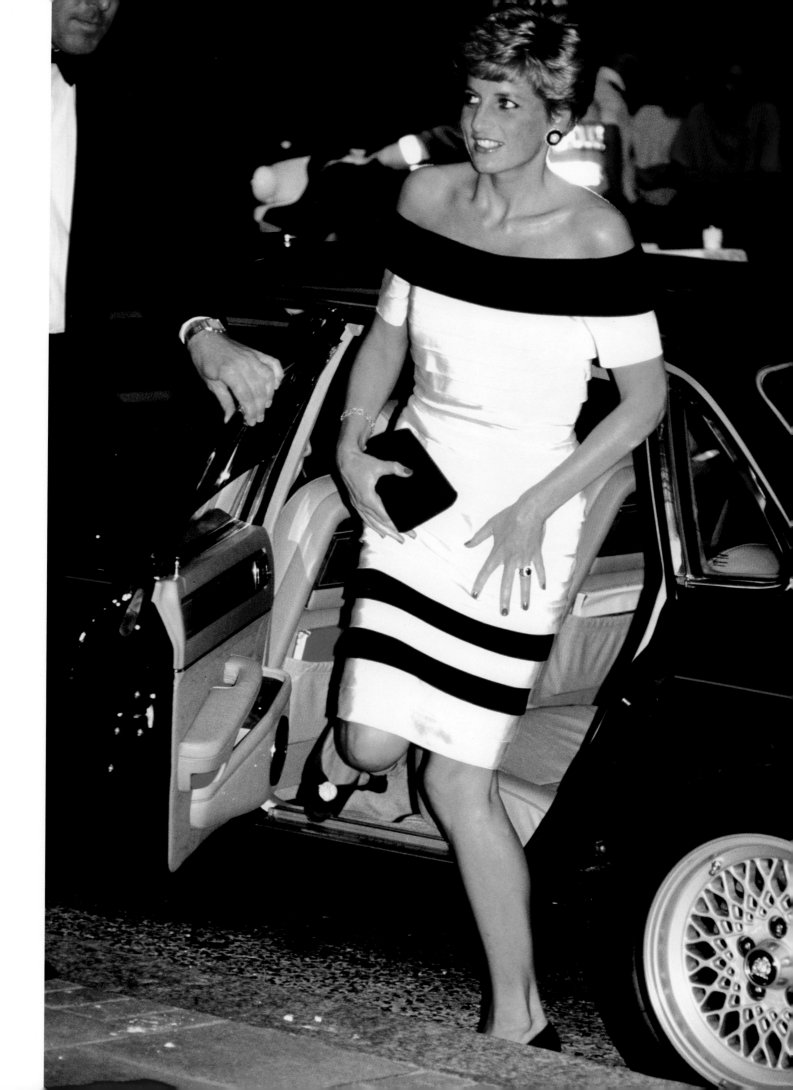

Versace

After Versace's iconic couture show in July 1991, in which supermodels Linda Evangelista, Cindy Crawford, Naomi Campbell and Christy Turlington walked the catwalk at the Ritz Hotel in Paris, lip-synching to George Michael's hit 'Freedom', Gianni's sister, Donatella, received an unexpected call from *Vogue* fashion editor Anna Harvey. Anna was helping Diana explore a new look after her separation from Prince Charles. Until then, Diana had followed royal convention and worn British designers – apart from on royal tours when she usually honoured the host country.

'Donatella stayed in Paris after the couture show to shoot the clothes for an ad campaign', author Deborah Ball wrote in her book *House Of Versace: The Untold Story Of A Genius, Murder, and Survival*. 'She and the photographer were scanning the Polaroid test shots when Sam McKnight, the London based celebrity hairdresser she'd hired to do the models' hair, pulled her aside. "Listen, Anna Harvey would like you to send her some of the Polaroids," he said. "She wants to show them to someone important. She can't tell you who it is, but trust me, she's a very important person."'

Donatella knew Harvey quite well. Perplexed, she gathered up a number of photos, including one of an eggshell blue column dress made of heavy silk and decorated with a swirly pattern of gold-tone studs and coloured strass and slipped them in a FedEx package. Once Harvey received them, Donatella's assistant wheedled the name of the mysterious lady out of her: Diana, Princess of Wales.

Donatella instantly picked up the phone to tell Gianni. Gianni was thrilled. 'What are you talking about?' he said, his voice rising in excitement. 'You must be kidding.' Shortly afterwards, Diana appeared in *Harpers & Queen* magazine, in an image by French photographer Patrick Demarchelier. This was the start of a friendship between Gianni and the Princess. 'The pictures, showing a relaxed, sexy Diana, shorn of jewellery and wearing the sleek gown, were an instant hit – for her and for the gown's designer,' added Deborah.

Over the next six years, the duo formed a close friendship, meeting frequently at Sir Elton John's home in Windsor. Gianni Versace was the first foreign designer patronised by the Princess after her separation. He paid tribute to her by naming an £185 bag The Lady Di, and she regularly visited his shop in London's Bond Street. They spoke every week and he slept with a photo of her and her sons by his bedside. Calling her a 'fashion icon', he added, 'When she puts on one of my gowns, she gives it class and wears it like no other.'

Gianni created a series of glamorous but classic outfits for Diana, including the outfit she wore for lunch at the Elysée Palace in Paris on 25 September 1995, for tea with the French President Jacques Chirac and his wife Bernadette; the short black dress she wore for a charity première of the Tom Hanks film *Apollo 13*, on 15 September that year; the white silk dress she wore for a Pavarotti concert on 18 September; the outfit she

wore when arriving in Buenos Aires, Argentina on 6 November; and the dress she wore on 14 November for lunch at Los Olivos. She also wore an electric blue one-shouldered Versace gown when she met popstar Sting at a charity ball, in Sydney, Australia on 30 September the following year.

However, the pair temporarily fell out over Gianni's book *Rock and Royalty*, a coffee table book for which Diana had written the foreword. She withdrew her endorsement of the book – which included photographs of the royal family juxtaposed with images of semi-naked men in bondage gear – and dramatically pulled out of the book launch, a £500-a-head charity gala to raise money for Elton John's AIDS Foundation, because she did not want to embarrass The Queen.

In her foreword, Diana had written: 'Gianni Versace is an aesthete, in search of the essence of beauty, which he captures with grace and ease.' But, in a statement, when she pulled out of the gala, she said: 'I was assured the book would not contain material which would cause offence and I therefore signed the foreword. Earlier this week I saw a copy for the first time. I am extremely concerned that the book may cause offence to members of the Royal Family. For this reason, I have asked for my foreword to be withdrawn and I will now not attend the dinner on 18 February, which is intended to mark the book's launch.' A mortified Gianni, who claimed he did not intend the book 'to cause a scandal', immediately cancelled the 650-guest dinner and dance 'to protect' Diana' and donated the money he would have spent to Elton John's charity. Following his apology, two months later, the designer called on Diana at Kensington Palace to show her his spring/summer collection.

Within four months, both the designer and the Princess had been brutally and tragically killed.

Gianni, who memorably dressed Liz Hurley in her safety-pin frock for the première of *Four Weddings and a Funeral*, was shot at point-black range at the gates of his mansion in Miami's South Beach by the serial killer Andrew Cunanan. Diana had spoken to him before she went on holiday in the south of France with her boyfriend Dodi Al Fayed, son of Harrods owner Mohamed Al Fayed. Told the news by her staff at Kensington Palace, she said: 'I am devastated by the loss of a great and talented man.' United in grief, Elton sent a private jet to take her to the funeral on 22 July 1997 and, in a midnight blue Versace shift dress, Diana memorably put her arm around his shoulder as he sobbed for the man he first met when shopping at Versace's flagship store on Via Monte Napoleone in Milan.

Six weeks later, she too was dead.

The Patrick Demarchelier Gown

The first dress that Versace designed for the Princess was a figure-hugging shimmering blue-green silk gown with a décolletage neckline, embellished with a swirling geometric motif of gold-tone studs and pyramids, and encased faceted glass in shades of blue topaz, aqua marine and white. Diana wore the dress for a 1991 photo shoot with photographer Patrick Demarchelier for *Harpers & Queen* and it was used on the cover of the magazine's November 1997 edition *Harper's Bazaar*, 'Diana: A Tribute To A Princess', which commemorated Diana's death.

For the next 18 years, the dress remained hanging on a label which read 'Princess Diana'. It was finally sold by Julien's Auctions in their Hollywood Legends sale on 26 June 2015. Bought for £165,924 by collector Renae Plant and her husband Livinio for The Princess & The Platypus Foundation, it is now on display in the Princess Diana Museum.

'On the day of the auction, I was nervous, as Livinio and I once again set a budget limit we felt good about,' recalled Renae. 'We sat in the back row with our daughter Ilan, who came with us. We gave her the job of holding up the paddle for each bid. There was a bidder on the phone and slowly but surely it came down to just the two of us. The dress was quickly going up in value. The bidder on the phone suddenly asked if the bid increment could be reduced and the auction house politely declined. We had one last bid as we reached our maximum budget. Livinio and I looked at each other and both agreed: "One more go!" We signalled Ilan and she put our paddle up. The phone bidder stopped...SOLD!! And we owned the dress! We were ecstatic! Especially when we found out we were bidding against Historic Royal Palaces.'

The Versace blue-green silk gown that Diana wore for her shoot with Patrick Demarchelier in 1991.

Christina Stambolian
The Revenge Dress

In September 1991, Designer Christina Stambolian was working at her boutique in Beauchamp Place, on the other side of the road from Caroline Charles and Bruce Oldfield, when Princess Diana strolled in with her brother Earl Spencer. The siblings had been out for lunch that Saturday at Diana's favourite restaurant San Lorenzo, and were meandering back towards Kensington Palace, when they decided to do some shopping. That shopping trip led to the creation of one of the most talked-about dresses in history: the black silk crepe cocktail gown with an asymmetric ruched bodice and side sash, which Diana wore on 29 June 1994, the night that Prince Charles admitted having an affair with Camilla Parker Bowles on national television.

Combining the dress with her favourite sapphire, pearl and diamond choker, which matched her engagement ring, and scarlet nails, Diana stepped out at a *Vanity Fair* dinner at the Serpentine Gallery in London's Hyde Park. Her gown was christened by the American press the 'Revenge Dress'. The *Telegraph* newspaper dubbed it 'the pièce de resistance', describing it as 'the brave, wicked, historic little "Serpentine Cocktail", possibly the most strategic dress ever worn by a woman in modern times'. 'This was the devastating wisp of black chiffon with which Diana flipped her husband clean off the front pages the morning after his damaging televised interview,' journalist Sarah Mower added.

Christina, who was born in Greece and trained in Athens before setting up shop in Beauchamp Place in 1983, vividly remembers the day that Diana walked into her shop. She had already met the Princess at San Lorenzo, which was next to the boutique – 'I was in the ladies and she was coming in'. Now, finally, she was a customer.

'It was 2 o'clock on a Saturday afternoon in September,' recalled Christina. 'I thought that the woman looked familiar. We all laughed when we realised it really was her. Diana bought a black-and-red short day dress, a yellow silk blouse and a small cream sleeveless blouse, which added up to about £400. Then she said: "I want a special dress for a special occasion. It doesn't matter if it is short or long. It has to be something special." We sat down and I drew a few sketches on a piece of paper. The dress was revealing, quite short and showed quite a bit of leg and flesh. Diana was not sure about it. She thought it was a bit risky. I said: "Why not be daring?" But she wanted everything more covered up, longer and the neck higher. I told her she had good legs and she should show them. The dress was brave and revealing.

'She asked her brother and he said: "Do what you think is right." Finally, she said "yes" to the style – then we moved on to the colour. I had black in my mind, but she wanted cream. To me, Diana was a black and white sort of person. That was the way she was – there were no grey areas. I thought of black for the colour. I thought of her in a sophisticated way. I didn't like her in the pale pinks and blues with lots of beading.'

Diana arrives at the Serpentine Gallery in Hyde Park, London, in her 'revenge dress'.

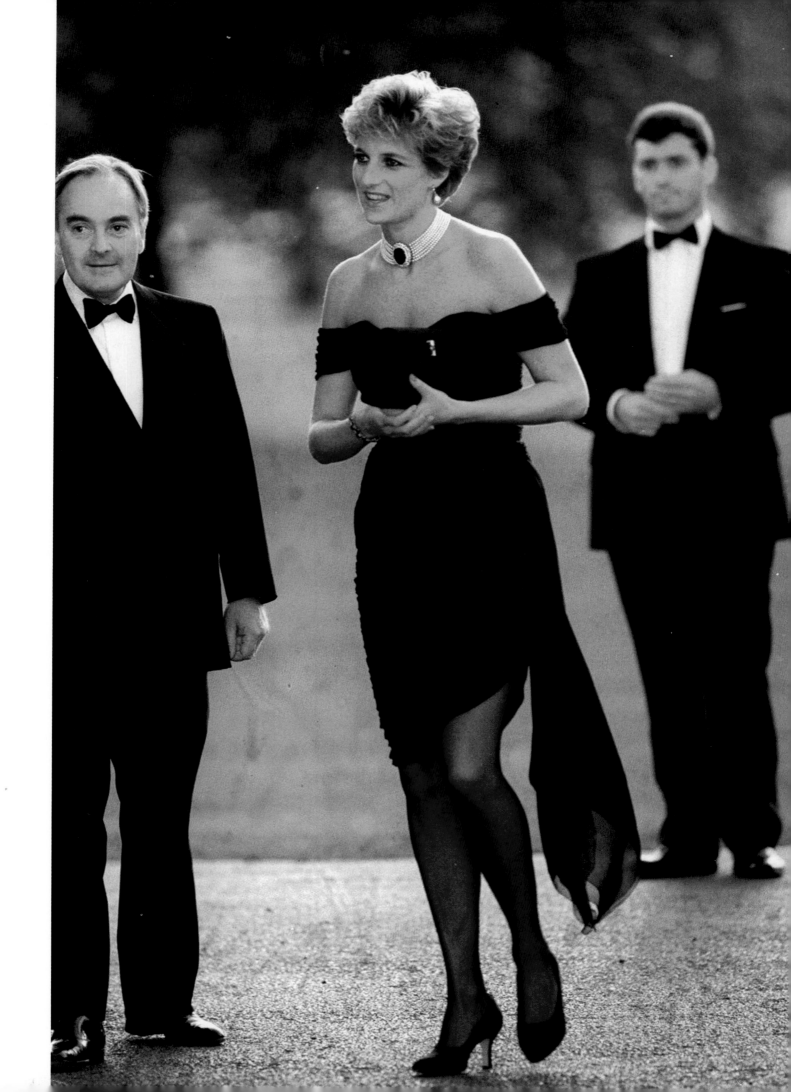

Two dressmakers took more than 60 hours to make the dress as the finely pleated bodice had to be hand-pinned and sewn, while the chiffon skirt had to be carefully draped. 'Two weeks later she came back with a man for a fitting,' said Christina. 'I wasn't there; I don't know who the man was. We had to take the sleeves in a little but otherwise there was nothing that needed altering. Diana was not at all shy. She didn't feel self-conscious about getting undressed.'

For three years, the hand-stitched dress with its flirtatious hem hung unworn in Diana's wardrobe. Christina began to fear that it might never be seen in public. 'Three years went by and she hadn't worn it,' she said. 'I was very disappointed. Then I realised she had been waiting for the right occasion. She looked like a beautiful black bird in it.'

It was after society magazine *Tatler* labelled the Princess an 'Essex girl' in its April issue that she pulled it out of her wardrobe. In an article by an unnamed writer, accompanied by photographs of actress Linda Robson, *EastEnders* stars Gillian Taylforth and Letitia Dean, and model Mandy Smith, all wearing outfits once worn by Diana, the magazine cruelly compared Diana's wardrobe to that of *Birds of a Feather*, a sitcom set in Chigwell, Essex. 'What does she think she is doing?' it asked. 'She has traipsed from South Ken, via Southfork to Southend, where she looks horribly at home. She has dismissed her bodyguards, relinquished her public duties and, so it would appear, mislaid her style advisers. Left to her own devices, she shows a bewildering penchant for all things Chigwellian. Is Essex set to be the next royal county, or will the fashion police arrive in the nick of time to snatch Diana from the clutches of the white cowboy boot? There are times when Diana gets it right, when she can be marvellous, but we have endured some terrifying taste blunders. Take the appliqued jumpers, the court shoes with jeans, the almost permed marmalade hair and flesh-coloured pop-socks. Will the real Diana please sit down, turn off *Birds of a Feather*, forget the Queen Vic and dress like a princess.'

Then a story leaked that Diana was planning to wear Valentino to the Serpentine Gallery. She was furious. 'She went to Valentino to get a dress for that particular date she had at the Serpentine,' explained Christina. 'Then Valentino rang all the newspapers saying: "She's coming out with my dress tomorrow." She heard that and Diana said: "There's no way I'm going to do him a favour. I'm going to wear another dress."' Instead, she and butler Paul Burrell chose Christina's black dress. Referring to one of Diana's favourite ballets, *Swan Lake*, Christina said, 'I was thrilled to see Diana wear it on that night of all nights. She chose not to play the scene like Odette, innocent in white. She was clearly angry. She played it like Odile in black. She wore bright red nail enamel, which we had never seen her do before. She was saying: "Let's be wicked tonight."'

Sadly, by the time the gown had catapulted Diana – and Christina – onto the front pages, her backer had pulled the plug. 'He closed down in one night,' she complained. 'I was so furious. He threw everything away,

including the pattern. At that time the dress hadn't been worn yet by Diana.' Christina did not have a chance to sell Diana any more dresses. However, they did meet once more at the reception for the Christie's auction in June 1997, when Diana whispered to her: 'By the way, that little black dress – I had a job to squeeze into it.' 'What she meant was she wore it after two years and had put on weight,' explained Christina. 'In fact, she looked in the photographs a bit squashed into it. But she had beautiful shoulders and good legs.'

The dress, which Christina sold for £900, went under the hammer at Christie's four years later and was bought for £44,511 by Scotsman Graeme Mackenzie and his wife Briege, who owned the Body Shop franchise in Scotland. They planned to exhibit it to raise money for Scottish charities. After the princess's death, the couple, from Bridge of Wier in Renfrewshire, wrapped it in tissue paper and put it in a bank vault. 'The only noble thing to do was not to use it,' said Mackenzie at the time. 'It would have been inappropriate.' Since then, it has appeared fewer than a dozen times in public and has raised more than £39,000 for the charity Children 1st. It has graced luncheons in Aberdeen, balls in Stirling, evening functions in Elgin and fashion shows at Bo'ness and Edinburgh.

'The notoriety of the dress was part of the reason why we were interested in buying it,' admitted Graeme. 'It has an intrinsic value because she wore it only once and she wore it on that particular night. It's a little bit of history. We were lucky enough to meet the Princess at the auction preview in Christie's in London and told her our intentions of using the dress to raise money for charity. At the time charities were complaining that the National Lottery was impacting on their donations. I thought the dress would be a way of attracting people to events and that its fame could only help that aim.'

However, it has not been seen in public for many years. A replica, which Christina made in 2010, is in the Museum of Style Icons in Newbridge, County Kildare, Ireland. 'The replica was made later on,' explained Christina. 'I was staying in Greece and I had nothing to do so I thought: "I'm going to make that dress again." I knew the dress very well, so I made a very, very, good copy.'

Following pages: Christina Stambolian's sketches for the 'revenge dress'.

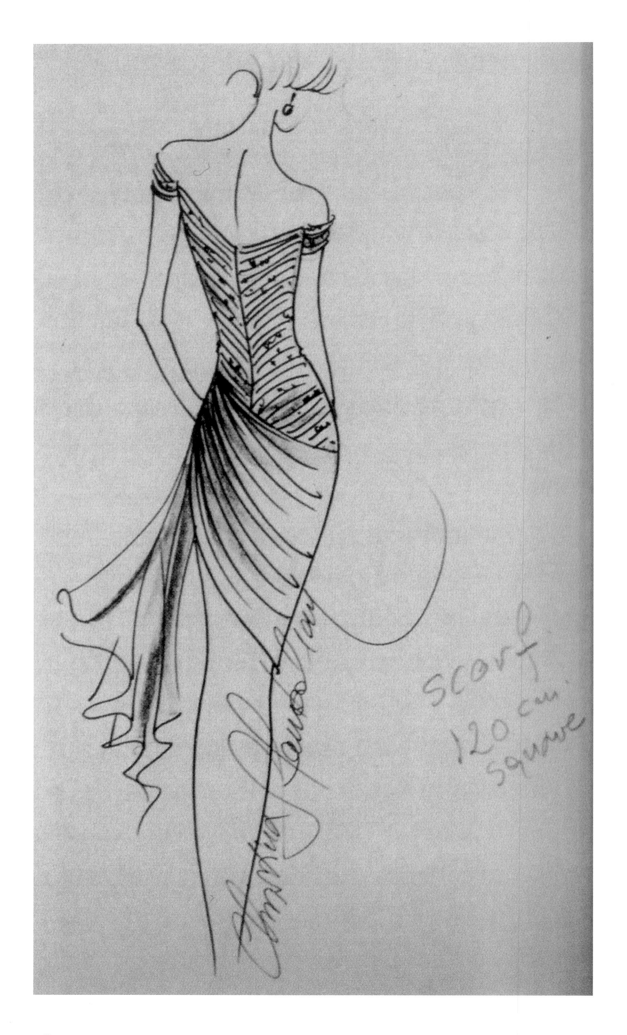

scarf
120 cm.
square

"DIANA"

Diana's Legacy

Since the Christie's auction, two months before her death, Diana's dresses have been distributed around the world. Historic Royal Palaces has gradually been acquiring them at auction for their Royal Ceremonial Dress Collection – they have bought 13 to date – and the Fundación Museo de la Moda, a fashion museum in Santiago, Chile, has pledged to donate its collection to Britain as its legacy. 'I was born in the same year as Princess Diana,' said founder Jorge Yarur Bascuñán. 'I have always been a fan. She was such a charismatic personality and so stylish. Everybody could relate to her. She was an icon.

'I remember her getting out of the car in that Emanuel black dress in 1981. She was 20 years old at the time and I fell in love with her. I know Prince Charles didn't like the fact that she was wearing black. But she was wearing a dress that all the girls of her age were wearing. After she got married, she became more formal, and then after the divorce she became much more stylish. The first dress I bought was the Hachi gown in 2001. It was the first dress I saw for sale. We now have 26 dresses in the museum. I have an agreement with Kensington Palace that one day they will return to Britain. I think it's right that they should do so. Chile is not the right place for the Royal Collection. It belongs in Britain. It has to be saved for the country. I'm not doing it for the money. It's the history that's important.'

Diana's enduring wardrobe has equally inspired a new generation of fashionistas: both the Duchess of Cambridge and the Duchess of Sussex have been photographed in ensembles which paid a nod to their late mother-in-law.

The Duchess of Cambridge during day four of Royal Ascot at the Ascot Racecourse, on 17 June 2022.

Acknowledgements

'To Those Who've Gone'

I would like to thank the following designers for their insight into the wardrobe of Diana, Princess of Wales: David Sassoon, Victor Edelstein, Jacques Azagury, Thomas Starzewski and Christina Stambolian. My grateful thanks for photographs to the Fundación Museo de la Moda, The Princess & The Platypus Foundation, The Museum of Style Icons, Julien's Auctions and Christina Stambolian. Also David Sassoon, the late Bill Pashley, The First Light Trust and Trinity Hospice, Bruce Oldfield, Catherine Walker & Co., Victor Edelstein and Zandra Rhodes for allowing us to feature their dresses in the Historic Royal Palaces collection. Thanks to all of the designers who created the wonderful dresses that are featured in this book, and a special thanks to Victor Edelstein for the exclusive drawings he created especially for my book.

Museums

Fundación Museo de la Moda
Santiago
Chile
Jorge Yarur Bascuñán opened the Fundación Museo de la Moda in 2007 as a tribute to his parents Jorge Banna, a lawyer, and Raquel Bascuñán, who had a keen interest in fashion. The museum now owns more than 20,000 costumes, sketches, accessories, and decorative arts pieces, including the largest collection of Princess Diana's dresses in the world. He plans to donate them to Historic Royal Palaces on his death.

The Royal Ceremonial Dress Collection
Historic Royal Palaces
London
England
Created in 1989, after amateur historian Aubrey Bowden donated her collection of court uniforms to Historic Royal Palaces, the Royal Ceremonial Dress collection now contains 10,000 items of historic dress, from the 16th century to the present day, including clothing worn by King George III, Queen Victoria, The Queen, Princess Margaret, and Princess Diana.

The Princess Diana Museum
https://www.theprincessandtheplatypus.org
Inspired by a meeting with Princess Diana, on 12 April 1983, at the Yandina Ginger Factory in Queensland, Australia, when she was 12 years old, curator Renae Plant founded The Princess & The Platypus Foundation – named after the clay platypus that Diana dropped. She met the Princess a second time, as an 18-year-old when Diana visited at St Andrews Cathedral, in Sydney, on 31 January 1988, and shook her hand. Renae has since created The Princess Diana Museum, an interactive 3D museum, to showcase one of the largest collections in the world of Diana's artefacts.

The Mejiro Fashion & Art College
Tokyo
Japan
To celebrate the 60th anniversary of the college, New York art dealer James Kojima, cousin of the principal of the Mejiro Fashion & Art College, Akihiko Kojima, who had lived in London, acquired three dresses from the 1997 Christie's auction. The dresses are displayed on the first day of college and on ten-year anniversaries but are normally kept in a climate-controlled room.

The Museum of Style Icons
Newbridge Silverware
Newbridge
Co Kildare
Ireland

The Museum of Style Icons opened in 2007 after the acquisition of Audrey Hepburn's Hubert de Givenchy little black dress from the 1963 movie *Charade* – and has become respected by collectors around the world. It now houses the final toile for Princess Diana's wedding dress; the Helen Rose dress worn by Grace Kelly in the film *High Society* – the last film she made before her marriage to Prince Rainier of Monaco – and the jacket worn by Marilyn Monroe in the film *The Prince and the Showgirl*.

The Pat Kerr Private Royal Collection
Anglophile Pat Kerr met Princess Diana when she lived in London's Regent's Park with her husband John Tigrett, a Tennessee entrepreneur who was a partner of financier Sir James Goldsmith, father of Princess Diana's confidante Jemima Khan. She has been collecting antique lace and textiles for the past 40 years and has more than 1,000 pieces, including a handkerchief belonging to Charles I, a Queen Anne purse and four of Diana's dresses. She is now launching the Pat Kerr Private Royal Collection to exhibit her dresses in the United States.

The Metropolitan Museum
New York
USA
Based on two iconic sites in New York City – Fifth Avenue and the Met Cloisters, the Met, which was founded in 1870, has a collection dating back more than 5,000 years – it has the largest collection of Egyptian art outside Cairo – and is one of the most famous museums in the world. It currently owns two of Princess Diana's dresses, which were sold at the 1997 Christie's Auction.

The Victoria & Albert Museum
London
England
The world's leading museum of art and design, the V&A houses a permanent collection of more than 2.3 million objects, spanning more than 5,000 years of human creativity and is one of the greatest resources for the study of architecture, furniture, fashion, textiles, photography, sculpture, painting, jewellery, glass, ceramics, book arts, Asian art and design, theatre, and performance. The museum also owns Diana's famous Elvis Dress.

Image Credits

Editor: Bryn Porter
Designer: Craig Holden
Reprographics: Corban Wilkin

MIX
From responsible sources
FSC® C014767

Printed in Belgium
for ACC Art Books Ltd., Woodbridge, Suffolk, UK

www.accartbooks.com

ACC ART BOOKS